Film Technology in Post Production

Film Technology in Post Production

Second edition

Dominic Case

AMSTERDAM • BOSTON • HEIDELBERG • LONDON • NEW YORK •OXFORD
PARIS • SAN DIEGO • SAN FRANCISCO • SINGAPORE • SYDNEY • TOKYO

Focal Press is an imprint of Elsevier

Focal Press
An imprint of Elsevier
Linacre House, Jordan Hill, Oxford OX2 8DP
30 Corporate Drive, Burlington, MA 01803

First published 1997
Reprinted 1998, 1999
Second edition 2001
Reprinted 2003, 2004, 2005

British Library Cataloguing in Publication Data
A catalogue record for this book is available from the British Library

Library of Congress Cataloguing in Publication Data
A catalogue record for this book is available from the Library of Congress

ISBN 0 240 51650 8

Photographs on page 63 courtesy of Jane Read

For information on all Focal Press publications
visit our website at www.focalpress.com

Working together to grow
libraries in developing countries

www.elsevier.com | www.bookaid.org | www.sabre.org

ELSEVIER BOOK AID Sabre Foundation
 International

Typeset by Florence Production Ltd, Stoodleigh, Devon
Printed and bound in Great Britain by Biddles Ltd., www.biddles.co.uk

Contents

7

Preface to the second edition

When the first edition of this book was written, non-linear editing was still a new technique, video was generally mastered onto one-inch analogue tape and digital effects were restricted to a few big-budget science fiction films.

It has taken less than 5 years for the scene to change on every front. Digital cameras have been used for both low-budget and blockbuster feature films, while film stocks and processes offer an ever wider range of effects. Video grading techniques have become available for a film finish, while television is becoming digital, widescreen and high definition.

The new user-oriented digital applications draw attention to the technology and techniques of traditional film production and post production. In the digital era, it is easier than ever to become a film-maker, and consequently more important than ever to use the technology to get the best possible results.

The second edition includes expanded coverage of the new film technologies and interfaces, especially film scanning and recording, digital soundtracks, video formats including digital television, and the impact of digital image capture, digital intermediates and digital cinema. Also, all the sections on traditional film technology have been updated and reorganized to focus attention on the processes: in particular, Super 16, bleach bypass, negative matching, telecine transfers and the care of release prints.

Film Technology in Context

Introduction

Until a few years ago, film post production appeared relatively straight-forward. There were progressive advances in technology, but for many years there were no fundamental changes. The transition from Moviola-style upright editors to Steenbeck-style flatbeds, for example, made little difference outside the editing room. Sound quality improved dramatically, and mixers had more tracks to mix, but this was evolutionary rather than revolutionary.

As a result of this relatively stable history of consolidation, traditional film technology and post production methods, although familiar and well-worn, are far from simple. There exists a complex web of relationships: any loose ends had long since been tied up and taken advantage of. Nevertheless, the methods used for the lowest-budget short film were essentially the same as those that had evolved for major feature films.

The parallel development of video as a motion picture production medium had some small effects on film post production methods. However, people entering the video industry learned a different technology and methodology, without the core that had been common to all modes of film making.

The third wave of image technologies – digital imaging – has had much greater impact. Although video brought interactivity – the instant replay – it retained many of the characteristics of film handling. Digital technology is infinitely more interactive still, and has cast off most of the linear, format-dominated constraints of both film and video. Digital imaging has now established itself as a clear alternative to film and to video in all three phases: image capture, post production and even exhibition.

Most importantly, the interface between all three technologies has improved dramatically, so that it is now practical to switch from film to video or digital images and back for any phase of production or post production.

As a result, film-makers recently have seen an ever-widening array of formats chosen for shooting both television and cinema productions. They have seen the rapid adoption of non-linear (electronic) editing into conventional film productions, the choice of sprocket, multi-track or digital sound editing, the increasing use of film-resolution digital effects, and an increasing variety of release formats. What was once a single pathway now presents a wide range of alternative methods at every stage. Often, a combination of technologies may confer the best advantages on the production in question.

Many traditional film-makers have been left behind in the revolution. Many others, experienced in video or digital imaging, find themselves dealing with film for the first time.

This book describes the arcane properties and procedures of film post production for both these groups of people, and highlights how it interfaces with the convergent yet still very different electronic media.

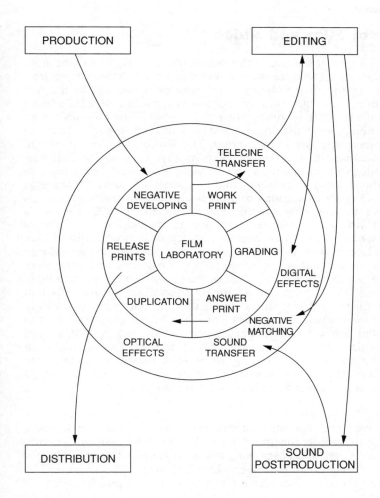

PRODUCTION

EDITING

TELECINE
TRANSFER

NEGATIVE
DEVELOPING

WORK
PRINT

RELEASE
PRINTS

FILM
LABORATORY

GRADING

DIGITAL
EFFECTS

DUPLICATION

ANSWER
PRINT

NEGATIVE
MATCHING

OPTICAL
EFFECTS

SOUND
TRANSFER

DISTRIBUTION

SOUND
POSTPRODUCTION

THE ROLE OF THE FILM LABORATORY
The film laboratory is at the centre of many stages of film production.

Origins of Film and Video

The cinema began at the end of the nineteenth century, when a number of quite separate techniques were brought together. Projected pictures, in the form of the magic lantern, had been demonstrated in the late seventeenth century, but were handicapped by the lack of a sufficiently intense light source. Still photography had started in the mid-nineteenth century, although exposure times at first were as long as an hour, making moving objects impossible to capture. The illusion of movement had been demonstrated in a variety of Victorian toys such as the Zoëtrope. In 1877, advances in photography allowed Eadweard Muybridge to combine these ideas to analyse motion, when he used 24 cameras to capture a couple of seconds of a horse's trotting movement.

Eastman's flexible photographic film, patented in 1899, allowed a number of workers in several countries to develop motion picture cameras capable of taking successive pictures on a single strip of film. In Edison's laboratories, Dickson developed a camera which used 35 mm film – the standard that is still in use today. The pictures so taken were shown in a peep-show viewer – the kinetoscope – and often accompanied by synchronized sound on a coupled Edison phonograph. The film ran continuously, and was lit by momentary flashes from a revolving shutter in front of a lamp. Four years later, the Lumière brothers in France demonstrated the cinématographe, a combined camera, printer and projector, which used a claw mechanism for the first time so that each frame of film was stationary during exposure or projection. Frame rates were variable until the introduction of sound-on-film in 1927, when 24 frames per second became an international standard.

Video

Television was first operated commercially in the 1930s in London, although Baird had demonstrated cross-Atlantic transmissions as early as 1928. Baird's mechanical scanning system was soon dropped in favour of the all-electronic system developed by Zworykin.

Right from the start, film was a common source of programming for television, not only as a new way of showing movies, but also because early TV cameras were restricted to the studio: TV news coverage was on film for many years. Film was furthermore the only means of recording TV programmes (using the kinescope) until Ampex introduced the first practical videotape recorder in 1956. Recording was developed primarily for time-delayed transmissions of complete programmes: videotape editing initially relied on physical cut-and-splice techniques. However, tape editing by re-recording segments onto a new master tape soon became practical, giving birth to the video post production industry.

Digital imaging

Digital image technology has entered the moving image business quite distinctly in several different areas, using electronic means to reproduce images at higher resolution or with more tonal accuracy than conventional analogue video systems, which suffer in these regards when

12

compared with film. Many of the techniques find their origins in computer science, and the rapid growth in the processing power of integrated circuits has meant that, in time, almost anything has become possible. Digital video effects were in use by the late 1970s for television commercials, and the technology was first applied to film resolution images by 1990. Projected video images have also been possible since the 1970s, but the first major feature presentation, using digital technology to achieve a brighter and more stable image, was not possible until 1999.

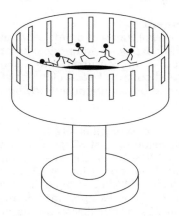

1

2

MOVING PICTURES
(1) The nineteenth century Zoëtrope: as the cylinder spins, each image is seen momentarily through a slit, giving the impression of continuous motion. (2) A digital image work station: mechanical systems give way to digital electronic systems, but motion is still depicted by a rapid succession of still images.

Origins of film and video

Different in almost every detail.

Film and Video: the Differences

Unlike videotape, film offers a visible image. Videotape simply records an electrical signal: the technology required to create or replay this signal is incorporated in the camera, tape recorder and monitor. Advances in technology invariably require replacement of much of this equipment. By contrast, film quality is governed by extremely sophisticated chemistry within the emulsion of the film stock. Most technological advances are therefore delivered with the next roll of film.

Intermittent movement
Film is photographed a full frame at a time, normally 24 per second. The film is stationary during exposure and projection of each frame. In video, the picture is scanned, or broken down into a sequential form, varying with the brightness and colour of each element of the image. The electronic signal is recorded on continuously moving videotape.

Frame rate
Cinema photography and projection are universally at 24 frames per second (fps). PAL television runs at 25 fps. Each frame is scanned twice: first the odd-numbered lines, then the even-numbered ones; each half-frame is called a field. Transferring film at 24 fps requires the system to repeat some fields twice to fit the PAL signal rate, which complicates the relationship between film frames and video frames; 24 fps film can be transferred to tape at 25 fps, but discrepancies arise in running speed and shot duration, as well as sound pitch. In NTSC the situation is worse, as 24 fps film must be made to fit video at approximately 30 fps.

Resolution
Video frames consist of 576 lines (PAL) or 487 lines (NTSC) from top to bottom; 35 mm negative can resolve at more than 3000 lines vertically. Film images are in a random grain pattern rather than regular lines.

Contrast
Film negative can record a brightness range of 1000:1. The image projected on a cinema screen is around 100:1. However, a well set-up home TV receiver cannot display more than around 20:1. TV shooting therefore requires much flatter, low contrast lighting on set.

Aspect ratio
Film is normally projected in an aspect ratio of 1.85:1, with Cinemascope at the much wider 2.35:1. Conventional television is 1.33:1, although new standards will change this to 16 × 9 or 1.77:1, and so shots require different framing for TV and for the cinema.

FILM AND VIDEO: THE DIFFERENCES

Film can be seen with simple technology, is front-projected, has a different-shaped frame and a contrasty image. The image is normally seen by a large audience, all together, in a dark room. Video is different in every one of these respects and many others.

Film versus Video – or Film with Video

As video production moved out of the studio, and video editing and effects became possible, the two media became competitors. Electronic Field (or Film) Production (EFP) was introduced, and the arrival of the domestic video cassette together with the decline in cinema attendances led many people to the premature claim that 'film is dead'.

Video systems developed rapidly. Low cost off-line editing systems produced Edit Decision Lists (EDLs) defining every edit in terms of the video timecode. The EDL is subsequently used to carry out the same edits 'on-line' on corresponding broadcast quality tapes with matching timecode. Off-line video editing was fast and relatively cheap, but less flexible than film editing. However, digital compression and cheaper memory made disk-based non-linear (or random access) computer editing systems available around 1990.

Meanwhile, film technology was quietly advancing with faster and sharper film emulsions. Then the introduction of machine-readable Keykode film edge numbers, and of software to relate EDL timecodes to the original negative edge numbers, made it possible for negative matchers to conform negative to a video edit. It is now possible to originate on film, edit using video techniques, and return to film for 'on-line' finishing and distribution. Almost overnight film post production, virtually unchanged in half a century, has been revolutionized.

Over the same period, improvements in telecine transfer, particularly in image steadiness, meant that film origination could be followed by video post production for television programmes and commercials. (Video effects using film material had previously been handicapped, as titles and composited images drew attention to the slightest unsteadiness.) The application of digital image techniques to improve the results of tape to film transfers has allowed video productions to be returned to film, albeit at the reduced resolution of television.

Video is in turn giving way, as a post production medium, to higher resolution disk-based digital images, and film now turns to a relationship with yet another well-developed industry (computer graphics).

The effectiveness of any technology is measured by its cost, its quality and its convenience. In general, improvements in any one of these factors are at the expense of either or both of the others. In origination, video is characterized by low cost and film by high quality. In post production, video scores in convenience: digital technology is even more convenient, but more costly. For distribution, video once again scores in convenience and low cost, but film retains the highest quality. The different needs of any particular production are likely to lead to a different combination of technologies every time.

See also page 20.

	FILM	DIGITAL	VIDEO
1895	35 mm motion pictures		
1900	in-camera effects		
	close-ups, editing		
1910			
1920			
	16 mm		
	sound on film		
1930			
	Technicolor		
			TV broadcast
1940			telecine
			kine recording
	Eastmancolor		
1950			
	Cinemascope		
	3D		2" videotape
1960			colour TV
	flatbed editing		on-line editing
			timecode
1970	super 16	computer graphics	off-line editing
	stereo sound		
	video assist		domestic VCR
	motion control		1" videotape
1980		digital video effects	
	faster stocks		
			D1 etc
			digital telecine
1990	disk-based non-linear editing		all-digital post prod
		MPEG	
	digital effects for film		
2000	digital camera, digital projection		

CONVERGING TECHNOLOGIES
Film technology has progressed steadily over 100 years, while television technology has evolved quite independently. Digital imaging has permeated both systems to blur the distinctions between all three.

The child of a mixed marriage.

Digital Film

Techniques of compression, whereby the amount of data required to reproduce an image can be reduced by a factor of tens or even hundreds of times with 'acceptable' loss of image detail, have been used in non-linear film editing for some years. However, production and exhibition have continued to use film because of the remarkably high quality of images obtained at full film resolution. More recently, data capacity and the speed of processing data have increased sufficiently to bring digital images up to match the resolution of film images.

Digital imaging technology has emerged in the film industry in three separate fields: film production (image capture), post production and cinema distribution.

Digital image capture
While a number of theatrically released features have been shot on compressed video formats such as DVC-Pro, the 24P format is generally regarded as the first serious contender that approaches 'cinema quality'. The image format is 1920 × 1080 pixels, with 24 frames recorded each second. The 'P' refers to progressive scanning, as distinct from the 'interlace' of conventional television, whereby two half-resolution fields are recorded one after the other to make up one full frame. This format is the most compatible with current film standards, and the cameras are often fitted with lenses normally used for film to obtain more film-like operation and performance.

Digital post production
This technique describes productions, typically shot on film for theatrical release, which are completely digitized after editing, primarily for colour correction, to an extent not possible with conventional film processing or duplication. Adjustments may include colour desaturation, contrast alteration or secondary colour correction. While, in the digital format, digital special effects can be carried out, this is not the primary purpose of digitization. Finally, the corrected images are recorded out to film for conventional printing. While this technique was initially prohibitively expensive, it is rapidly approaching the budgets of more and more films.

Digital cinema
Digital projectors are now capable of matching the visual quality of a typical film release print. The image device may be an LCD chip or a mirror chip, consisting typically of an array of two million microscopic mirrors, each tilted by the digital video signal to control the brightness of one pixel projected onto the screen. Various programme delivery systems (e.g. satellite, DVDs) and programme storage devices have been suggested. Proponents of this system offset the high equipment cost against the potential savings when release prints are no longer required, but a business model that shifts the cost away from distributors to exhibitors is not as straightforward as this.

PHASE OF PRODUCTION	PHOTOCHEMICAL (FILM)	DIGITAL
Image Capture	• Much greater resolution and tonal depth on original negative. • Less depth of field (creative control). • Longer archival keeping properties. • Universal standard. • Upgrade comes in compatible new filmstock.	• Smaller, lighter cameras in lower resolution formats. • Tape is cheaper than film. • Instant replay for review and editing. • No scanning costs for digital effects.
Editing	• Work print always matches negative – fewer sync errors. • Frequent software changes – retraining needs.	• Flexible editing – try alternative cuts. • Preview effects. • Same systems for film and TV editing.
Grading and effects	• Low cost of equipment and service (Colormaster, optical printer). • Film scanning and recording very costly.	• Greatly increased range of effects and colour correction possible. • Preview effects and colours before final output.
Distribution and exhibition	• Established lab infrastructure for release prints. • Established film projectors in every theatre. • Universally compatible release print formats. • No established universally compatible digital system yet. • Low operational cost and maintenance for theatres. • Extremely high cost of replacement technology. • Image quality still at least as good as best digital images.	• Big cost saving in electronic distribution compared with 35mm release prints. • Steadier images with less wear and tear. • Rapid alterations to program make-up (different adverts etc).

DIGITAL AND FILM SYSTEMS COMPARED
Digital technology provides an alternative to traditional methods at every stage of production and post production. Each system is suitable for some projects and not others.

Deciding the best course for your production.

Post Production Pathways

Film versus Video Production

When comparing the relative costs of shooting on film with shooting on tape, there are many factors to be taken into account. Neither course is invariably less expensive than the other; indeed, cost is only one aspect of the decision to be made.

Choices between the various film formats are discussed later in this book. The tape choices lie between the smaller, more portable formats such as DVCPRO or Digibeta, and the higher quality but less portable 24P HD camera (digital camera).

Image quality

Without any doubt, both 16 mm and 35 mm film are capable of capturing more image information, both in terms of colour depth and image resolution, than any current video format. Equally certainly, much of this extra information is lost, either at the point of capture, by the blur of moving images, or in duplication stages, or, in the case of film shot for TV, by the reduced colour gamut of television screens.

Both film and video have certain 'artefacts': characteristics of less-than-perfect reproduction that draw attention to the nature of the format. Grain, motion blur and particular colour or tonal characteristics are typical of film. Reduced tonal depth, jagged edges, moiré patterns and edge contours give images away as video originated.

Production style

It is common though not universal to shoot film productions with a single camera. This allows for more elaborate lighting set-ups, and therefore takes longer. Typical video productions are shot in a TV studio with several cameras covering different angles of a scene simultaneously. While this saves time and money and works well with the flatter lighting favoured by television, it limits the creative use of lighting, and results in a noticeably different production style on the screen.

Production costs

24P camera rental costs are higher than film camera costs, and the additional monitor equipment increases the difference. The lower costs of tape stock compared with film clearly offset this, but the degree of offset depends on the shooting ratio and the speed of the production.

In some types of production (e.g. documentaries) the relatively low cost of videotape stock allows for much higher shooting ratios. While this may allow more opportunities to capture uncontrolled material, it is important to remember that more material flows on to require more editing time, both digitizing and selecting scenes for inclusion. The high cost of transfer from digital to film negative for a film finish will often swing the costs back towards film origination.

Preservation

Camera negative is a long-lasting archival medium compared to video-tape. While this may not appear to be a concern at the time of production, any other time is too late. However, it tends to be impractical to preserve all the camera material shot on a film-for-TV production.
　　See also pages 16, 200.

	*** SAMPLE FIGURES FOR ILLUSTRATION ONLY ***					
CLIENT:	BEANMAN PRODUCTIONS					
TITLE:	SILVER IN THE SAND					
24 mins STV finish 10:1 ratio						
Shoot 6 days						

	16 mm film			HD camera		
Item	amount	unit cost	total	amount	unit cost	total
16mm camera hire	6 days	1,000	6,000			
Video assist package	6 days	500	3,000			
Film stock	9,000 ft	160/400	3,600			
Processing	9,000 ft	0.25	2,250			
Telecine transfer	6×90min	400/hr	3,600			
Tapes	6D+6SP		1,000			
HD camera hire				6 days	3,000	18,000
HD monitor				6 days	250	1,500
Tape stock				8 ×30 min	100	800
Transfers to Beta				8	80	640
TOTAL			19,450			20,940

24 mins film finish 10:1 ratio						
Negative matching	20 hrs	62	1,240			
Interpos & dupe neg	2200ft×2	2.50	11,100			
Hi def film transfer				1440 sec	25/sec	36,000
TOTAL			12,340			36,000

COMPARING COSTS
THESE FIGURES ARE FOR ILLUSTRATION ONLY (no currency is stated!). Sample figures are shown for film blow-up or TV finish. A simple comparison is not the whole story: other things may change on a digital shoot, for example the number of days or the shooting ratio. Full quotes and estimates are necessary.

Traditional Sprocket Edit, Film Finish

By current standards, many of the procedures of traditional film post production might be considered time-consuming and labour-intensive. There were, however, very few alternative pathways, so the system that evolved was the most efficient for all possible styles of production.

After processing each day's negative, the required 'print' takes are selected and printed. (In 16 mm it is usual to print the entire negative.) At the same time, sound of the corresponding takes is transferred from the original tape to 16 mm or 35 mm magnetic film. After printing, the negative is sent to the negative matching department, where a log of edge numbers for each roll is made. (This previously manual operation is now automated through the use of machine-readable barcode edge numbers.)

Sound and print are synchronized by the assistant editor, and may then be viewed by cast and crew at the daily rushes screening. Editing is done using flatbed editing tables, on which the image is rear-projected onto a small screen using a moving prism, and up to three magnetic soundtracks can be played in sync with the picture. Editing proceeds through sequences of assembly, rough cut and fine cut, with dialogue sound being cut together with the picture. 'Rubber numbers' will have been printed onto image and sound rolls so that they can be kept in sync throughout the editing process. Scenes required for optical effects are identified by slate number and edge number, and the negative is extracted and sent for optical printing. The work print from the resultant optical dupe negative may be cut in with the rest of the work print.

When picture editing is finalized or 'locked off', sound editing may proceed. Using the cut work print (or usually a duplicate) as a guide, effects are synchronized or 'track-laid', building up the complete soundtrack on many separate tracks. This involves the use of large quantities of track spacing to keep the many separate elements of track in sync throughout each reel. In mixing, the multiple tracks are mixed down to a single master or final mix, balancing and equalizing each component. The magnetic final mix (or stereo print master) is transferred to optical sound negative.

Meanwhile, in negative matching the printed-through edge numbers on each scene of the cut work print are read, and computer systems are generally used to locate and assemble the corresponding frames of each shot thus identified in the original negative rolls. Exact matching is confirmed by visual comparison of the negative and corresponding work print.

After negative matching is complete, image and sound are synchronized, the image is graded on a colour analyser and the first answer print is made.

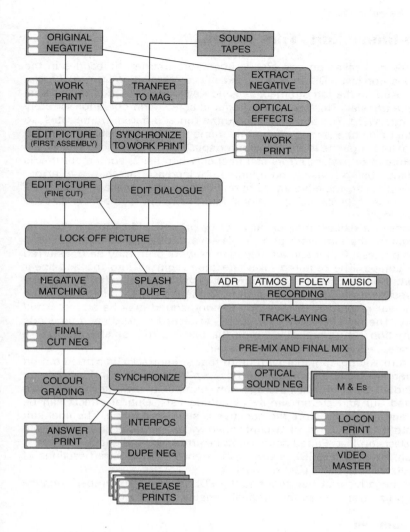

TRADITIONAL FILM POST PRODUCTION
Image and sound are on film throughout the post production process.

Non-linear Edit, Film Finish

This method relies on one crucial operation: tracking timecodes in the Edit Decision List (EDL) back to the exactly corresponding frames of negative, based on the log of timecodes and Keykodes created at the original telecine transfer. This crucial logging and conversion operation is rarely straightforward. The film and video often run at different frame rates, so that there is not a simple one-to-one frame relationship between the two media. Interruptions in the transfer, or splices in the film, complicate the log. Human or system errors can happen when using equipment that is frequently being revised and updated. All increase the chance of error.

Nevertheless, the advantages of non-linear editing make it worth overcoming the technical complications, and this is the method that is used most widely.

Rushes (or dailies) may or may not be printed: although not required for editing, the film work print fulfils several other important functions in the process. Either camera negative or work print may be transferred to videotape. The required takes are then digitized into the non-linear system. Sound, usually on DAT, may be synchronized either to the tape or directly into the non-linear system. While the images are compressed to a lower resolution to save on memory, sound may be stored at full quality. The negative may be logged – to record Keykode and timecode information – automatically during the telecine run, or afterwards in a separate pass, by the negative matcher.

Picture editing, together with up to four soundtracks, is carried out on the non-linear computer system. Because the images can be accessed at random from the disk storage, any number of alternative edits can be tried out and stored simply as cutting lists. Optical effects can be tried and adjusted before the negative is sent for printing. The final edit is output in the form of a conformed video cassette and a separate Edit Decision List. Edited sound is transferred to the digital audio workstation, or an audio EDL is used to re-transfer the required sections of soundtrack for sound post production.

The negative matcher converts the EDL to an edge number negative cutting list, from which the original negative can be cut.

Pos conform

Any errors in the complex chain of logging and computation will lead to a fatal miscut of original negative. Once cut, original negative cannot be rejoined without losing frames. It is preferable to fine cut the work print as a check that everything is correct, and also to provide a film print (known as a pos conform or film conform) for the director's approval of the cut. Only after any adjustments have been made should the negative be cut, matching directly to the work print.

If film rushes were not printed, the takes required for cutting can be extracted and printed, using the EDL as a guide.

See also page 102.

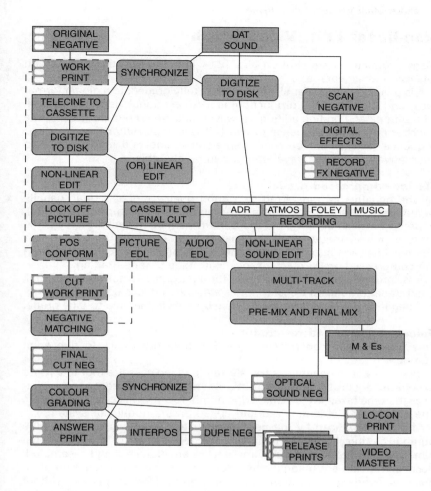

DIGITAL FILM EDITING

Image and/or sound are transferred to digital format for editing. This allows a range of alternative pathways, and introduces some complications where media are not entirely compatible.

. . . and another variation on a theme.

Non-linear Edit, Video Finish

Many productions are shot on film, but will only ever be distributed on television or videotape.

It is possible to transfer all the negative, fully graded, to a digital format tape, and then treat the production as a conventional video production, with off-line and on-line editing. However, this would require grading the entire shoot, in the sequence in which it was shot, rather than in edited sequence. This would be costly, time-consuming and ineffective. Two alternative procedures have emerged to resolve this.

Flat or compressed grade

All the negative is transferred to a good quality digital format, usually Digital Beta. Grading is set at a very low contrast (compressed grade), to preserve the entire range of tones in the camera negative. At the same time, a dub is made of all the material for digitizing and non-linear editing. After editing is complete, the final programme is compiled from the compressed-grade master tapes, with tape-to-tape grading.

It is important to understand that the first grade is not meant to look good. A better looking transfer at this stage would lose some of the original negative data and limit the grading options in the tape-to-tape grade.

Select negative and retransfer

This process relies on referring the EDL timecodes back to film edge numbers.

First, the entire negative is transferred to video cassette (not to a more expensive digital format), with little or no grading correction, to minimize the time taken on telecine. Edge numbers and timecodes are logged. The video material is digitized and edited on the non-linear system.

The EDL produced by the non-linear system is converted to an edge number cutting list by the negative matcher, just as for a conventional film finish. Using this list, full camera takes are extracted and assembled. Because no cuts are made within a take, a shot may be used more than once (or overlapping sections may be used in different places) without the need for duplicating the shot. The resultant *select takes* roll (or rolls) are typically about 20 per cent of the entire production footage.

The rolls are now relogged and then transferred on telecine, this time with a full grading session, and recorded on to a broadcast quality tape format. Timecode sync values from this transfer are added to the new negative log. A new EDL containing these new source reel timecode values is now computed by the negative matching system from the edge number list. This new 'on-line EDL' is used for the final on-line edit of digital quality, graded video.

See also pages 104, 190.

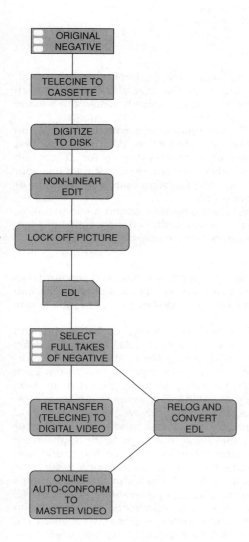

ORIGINAL
NEGATIVE

TELECINE TO
CASSETTE

DIGITIZE
TO DISK

NON-LINEAR
EDIT

LOCK OFF PICTURE

EDL

SELECT
FULL TAKES
OF NEGATIVE

RETRANSFER
(TELECINE) TO
DIGITAL VIDEO

RELOG AND
CONVERT
EDL

ONLINE
AUTO-CONFORM
TO
MASTER VIDEO

DIGITAL EDITING FOR TELEVISION

After non-linear editing, instead of negative cutting, the required full takes of nega-
tive are re-transferred to video with full colour correction. This selected material
is then ready for on-line editing, correction and effects. In the alternative,
compressed grade process, the negative is not used again after the initial transfer.

Get the right information, right from the start.

Supervision

Lab liaison

Labs normally have several experienced liaison people or production co-ordinators, whose job is to look after the special interests of each production as it goes through the lab, and to liaise between the various technical departments and the customer.

It is important to establish a good relationship with the lab liaison person at the earliest possible stage in a production. Very often your first contact with them will be to get a quote or estimate for all the lab services. This is the time to seek advice on any technical matters: your choice of film stocks or gauge, how long negative matching will take, or how to achieve a particular effect on film.

Other facilities – editing suites, telecine houses, sound mixing studios, digital effects companies – all have similar staff, variously called production co-ordinators, facilities managers or producers.

Post production supervisor

In traditional film production, post production followed a well-ordered and familiar course: each specialist received work in a standard way, and passed it on likewise. Post production management was essentially one of booking and scheduling.

The newer technologies of non-linear editing, digital audio and computer graphics, however, all have very precise and specialized technical requirements, particularly regarding the management of information: negative logs, timecode systems, EDL formats and so on. Each technical facility may reasonably be expected to be expert in its own field, but in the context of rapidly emerging new systems, software revisions and so on, even this expectation is not always perfectly fulfilled.

While you are probably concerned with just one production, remember that the lab and other facilities may have many going through at the same time. A post production supervisor working for the production company rather than for any particular facility can give one production full attention. It is their job to ensure that all the technical requirements of each facility are catered for in the preceding operations. For example, telecine transfer logs containing Keykode and timecode data must be in the correct format to be read by the negative matcher, as well as the editing facility and the sound studio. These departments may often have different requirements and priorities: the post production supervisor's job is to ensure that the work done in all areas is compatible. This role requires a working knowledge of all the systems used in the post production process.

BLOCKBUSTER - THE MOVIE POST PRODUCTION SCHEDULE as at 15/3/96

WEEK ENDING (FRI)	FEB			MARCH					APRIL				MAY					JUNE				JULY				AUGUST					SEPTEMBER				
	9	16	23	1	8	15	22	29	5	12	19	26	3	10	17	24	31	7	14	21	28	5	12	19	26	2	9	16	23	30	6	13	20	27	30
Shoot – Sydney		█	█	█	█																														
Shoot – Tokyo							█	█	█																										
Assembly										█	█	█																							
Picture Cut													█	█	█	█	█																		
Sound Edit – FX																			█	█	█	█													
Sound Edit – Dial																			█	█	█	█	█	█											
Music Composition																			█	█	█	█	█	█											
Neg Matching																			█	█	█	█	█	█											
Mix																									█	█									
Tiles/Opticals																					█	█	█												
Trial Print (16 mm)																											█								
Blow-up Interpos																												█							
Interneg																													█						
Trial Print (35 mm)																														█					
Video Master																															█				
Delivery																																█			

PRODUCTION SCHEDULE

Production and editing schedules must be calculated very precisely, as large numbers of crew and expensive facilities are involved. After picture lock off and mixing, the lab stages depend more on lab schedules, but enough time must be allowed to complete the job before any scheduled distribution, broadcast or festival entries.

The lab quote is just an estimate.

Lab Estimates

Film laboratory quotes are normally sought early in pre-production, when many details are unknown, and may vary widely from any estimate. The eventual charges will be on the basis of actual (rather than predicted) footage and time.

A lab quote will include some or all of the following services.

Negative processing, tests, push processing
The final running time of the film, and the proposed shooting ratio, will tell you the total length of film to be processed. Check on turnaround time and any extra charges for weekend or public holiday work.

Extraction of takes, or preparation for telecine
Charged per hour: offset this against the saving of work print footage or telecine time.

Work print (one-light or graded)
This is estimated as a proportion of negative processed. In the case of 16 mm, it is best to avoid cutting the freshly-processed negative, so the ratio would be 100 per cent. In 35 mm, only 'print' or 'circled' takes (typically 60–70 per cent) are printed.

Telecine transfer
An hourly rate: depending on colour correction, syncing etc. to be done during transfer, this is several times longer than the actual running time of the negative.

Negative logging
Labs may charge per hour or per cut. Any estimate is based on the type of production: action TV has more cuts than an interview.

Titles and optical effects
An average allowance is made here unless you have specific requirements.

Duplication
Essential before the answer print in the case of (for example) Super 16 shot for 35 mm blow-up. Charged at a rate per foot.

Answer print
Based on the exact final footage, plus the length of leaders etc. Colour grading is included in the cost of this first print: subsequent prints are charged at a lower rate.

A number of other items are sometimes overlooked, such as an optical sound negative (if not provided by the sound facility), artwork for titles, and leaders, including those used for telecine transfer, couriers, etc.

Always obtain an estimate from the lab rather than working your own out from the rate card. Labs will usually offer a substantial discount on

the basis of a cash deposit at the start of the work, which is always to be maintained in credit. The prices will be maintained for a stated period of time, but may be on the basis that all the quoted-for work is brought to the lab. Laboratories reserve the right to hold a lien over film materials to the extent of any unpaid accounts.

* * * SAMPLE FIGURES FOR ILLUSTRATION ONLY * * *						
CLIENT:	BOADICEA FILMS					
TITLE:	BLAZING CHARIOTS					
DURATION:	100 MINUTES		FILM EDIT/FILM FINISH			
SHOOTING RATIO:	12:1		SUPER 16		STEREO	
LABORATORY ESTIMATE:						
	Unit Cost	/	Amount		Total	
16mm camera tests + w/pt	0.28	ft	800	ft	224.00	
Develop Super 16 negative	0.21	ft	45200	ft	9,492.00	
Remove NG takes	60.00	hr	0	hr	0.00	
16mm 1-lt work prints (10%)	0.40	ft	4500	ft	1,800.00	
Telecine rushes transfer	400.00	hr	45	hr	18,000.00	
Video casettes	90.00	ea	30	ea	2,700.00	
Negative extractions	49.00	hr	12	hr	588.00	
Negative filing and prep	55.00	hr	54	hr	2,970.00	
Negative matching to w/pt	62.00	hr	100	hr	6,200.00	
16mm black spacing	0.24	ft	3600	ft	864.00	
Condense negative	44.00	hr	32	hr	1,408.00	
Super 16 slash dupe print	0.80	ft	3844	ft	3,075.00	
Mute Super 16 answer print	1.45	ft	3844	ft	5,573.80	
Optical effects allow	8.000				8,000.00	
Textless backgrounds	1,200.00				1,200.00	
35mm blow-up interpos	3.37	ft	9270	ft	31,239.90	
35mm dupe negative	2.54	ft	9270	ft	23,545.80	
35mm stereo sound neg	1.20	ft	9270	ft	11,124.00	
Synchronizing	49.00	rl	10	rl	490.00	
35mm answer print	1.35	ft	9270	ft	12,514.50	
35mm release print	0.35	ft	9270	ft	3,244.50	
LABORATORY TOTAL					144,253.50	

LABORATORY ESTIMATES
THESE FIGURES ARE FOR ILLUSTRATION ONLY (no currency is stated!). Lab costs are based on footages, rather than time taken. Some items (e.g. opticals, titles) can only be rough estimates until the work is actually done. Check what the lab has quoted for: some essential services may not be provided by the lab.

'All care but no responsibility.'

Insurance, Liability, Troubleshooting Tests

Laboratory liability
The film laboratory, including the negative matcher, has the unique responsibility of handling the original negative of a production. This film is the only record of the creative effort of shooting the film, and once production is over, it is effectively irreplaceable. The value of the negative is thus out of all proportion to the charges made by the lab.

For this reason, labs always limit their liability to the cost of replacement of any damaged material, although naturally all due care is taken in the complex and hazardous operations they carry out. Production companies should therefore arrange insurance cover. General insurance during the shoot usually includes such risks as 'faulty developing' and 'use of faulty equipment or materials'. Claims will cover the costs of repair if this is possible, or reshooting if this is the only alternative. Additional negative insurance extends cover against loss or damage during post production.

Troubleshooting
Problems affecting the negative that occur during the shoot are frequently difficult to trace. Image quality may be affected by dirt appearing on the negative, scratches, fog or other stains, an unsteady image and so on. The effect may vary from barely noticeable to disastrous. The problem is often due to a complex combination of circumstances. The lab is often the first to discover the problem, and is often best equipped for investigation. This may involve a number of controlled tests, which should be carried out as completely as possible if the fault is to be discovered quickly. The effect on morale in a production crew that loses confidence can often be far more costly and damaging than a simple delay.

Many errors during post production are a result of misunderstood or poor communications. As with technical problems during production, however, finding the source of the problems is rarely easy.

Increasingly, post production services are spread between a number of independent service providers: laboratory, sound studio, optical effects house, negative cutter and so on. While this leads to a greater range of specialized services not always available from a single company, it can also be more difficult if things go wrong. Understandably, most companies would prefer not to accept liability for an error if there is a possibility that it occurred elsewhere. Naturally, it is important to check that each company is fully aware of each other company's requirements, and it is wise to have an experienced post production supervisor on your crew, who can investigate problems without bias to any one facility.

See also pages 90, 94.

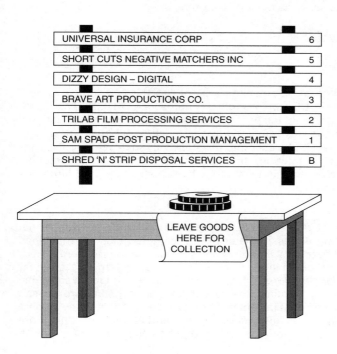

UNIVERSAL INSURANCE CORP	6
SHORT CUTS NEGATIVE MATCHERS INC	5
DIZZY DESIGN – DIGITAL	4
BRAVE ART PRODUCTIONS CO.	3
TRILAB FILM PROCESSING SERVICES	2
SAM SPADE POST PRODUCTION MANAGEMENT	1
SHRED 'N' STRIP DISPOSAL SERVICES	B

LEAVE GOODS
HERE FOR
COLLECTION

WHOSE FAULT?

When something goes wrong, there are often many people or organizations involved. The commonest problem is lack of clear communication.

Film Stock

35 mm Film

The standard gauge of 35 mm film is as old as the film industry itself, having been used in Dickson's original Kinetoscope of 1891. This width of film, with four perforations per frame, was adopted as an international standard in 1909 and has remained largely unchanged ever since.

While videotapes have become progressively narrower, but maintaining the image resolution, the 35 mm film format has remained unchanged. Improvements in technology have instead allowed film resolution and emulsion speed to increase.

Perforations

The perforations, at one time round, were modified so as to have flat leading and training edges. Register pins in camera gates are machined to make a perfect fit to this shape, which is known as the *Bell and Howell* or *negative perforation*. Positive print film has slightly larger rectangular perforations (*Kodak Standard*), which are stronger and run more smoothly in projectors. During printing, the raw stock and negative are passed around the printer sprocket in contact with each other. The negative, being on the inside, follows a slightly shorter path, and so its perforations are manufactured about 0.2 per cent closer together than those of the print.

Aspect ratio

The ratio of screen width to screen height is termed *aspect ratio*. The original 35 mm silent frame had a ratio of 1.33:1, about 1 in × 3/4 in. This ratio was later adopted for the smaller 35 mm Academy frame (leaving space for an optical soundtrack on the left), for standard 16 mm film and for television.

So-called 35 mm widescreen formats use the same width of film, but the top and bottom of the frame are cropped in the projector, giving a screen shape that is more like the normal field of human vision. A shorter lens in the projector then enlarges the image more, leading to a wider image with the same height. The standard widescreen aspect ratio is 1.85:1, although in Britain and Europe some theatres have had masks cut to the slightly higher 1.66:1. This ratio has persisted because it happens to fit perfectly with material blown up from Super 16 negative.

In Panavision or Cinemascope systems, an anamorphic camera lens produces a 'squeezed' image on the negative, reducing horizontal dimensions to half the size of vertical dimensions. The full frame negative area has a ratio of 1.18:1, which, on projection through a similar lens, yields an undistorted image in the ratio of 2.40:1.

Other aspect ratios have been used from time to time, and various 'universal standards' have been proposed. 'Univision', at 1.75:1, is virtually identical to widescreen television, while a 2:1 ratio for all cinema releases is an alternative proposal. A variety of ratios seems likely to continue, forcing cinematographers to frame for several different release formats.

See also pages 120, 122.

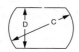

Bell & Howell

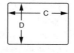

Kodak standard

Perforations		
Dimension	BH	KS
C	0.110"	0.110"
D	0.073"	0.078"
Pitch		
short	0.1866"	
standard		0.1870"

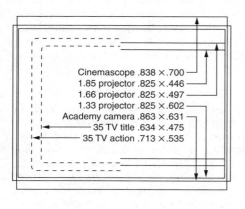

Cinemascope .838 × .700
1.85 projector .825 × .446
1.66 projector .825 × .497
1.33 projector .825 × .602
Academy camera .863 × .631
35 TV title .634 × .475
35 TV action .713 × .535

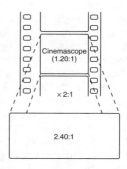

FRAME SIZES

Camera negative has barrel-shaped Bell and Howell perforations, for a precise fit to register pins. Print film has rectangular Kodak Standard perforations, which withstand the strain of repeated projection much better. Productions may be shot using either a full-height or an Academy mask in the camera, but are then cropped to various widescreen sizes by the projector mask. Measurements are shown here in inches, according to SMPTE standards.

Once called substandard, but a viable alternative.

16 mm Film

16 mm

Eastman Kodak introduced the 16 mm gauge in 1923, as a low-cost alternative for amateur film makers. The reversal process was used predominantly in 16 mm, giving finer grain than negative, with no need for the added expense of printing. (Prints, in fact, were more expensive and inferior to those from the negative–positive system and so reversal has never been appropriate for theatrical production.)

Sixteen millimetre prints became a convenient format for distribution of 35 mm theatrical productions in smaller auditoriums, and of documentary and educational films. 16 mm colour reversal became a convenient format for television news reporting, but original negative was less widely used in this gauge until significant improvements in grain structure, as well as in printing techniques (e.g. wet gate printing), in the 1970s.

Well-exposed 16 mm negative resolves at least as well as conventional television, and so has been used in many parts of the world as a convenient and inexpensive shooting format for TV drama and documentaries. (Thirty-five millimetre remains the dominant TV film format in the USA.)

The image on 16 mm film has an aspect ratio of 1.33:1 – the same as for standard television. Perforations, one per frame, are on one side only on prints, leaving space for the optical soundtrack on the other side. Negative may be perforated on one or both sides of the film. Both negative and positive perforations are rectangular, but, like 35 mm, negative has a slightly shorter pitch.

Super 16

When standard 16 mm is blown up to 35 mm, some image must be cropped from top and bottom to fit the theatrical widescreen ratio of 1.66:1 or 1.85:1. The Super 16 frame is wider, using single perf 16 mm negative exposed almost to the edge of the non-perforated side, and so already has an aspect ratio of 1.66:1. Nearly 47 per cent more negative area is available for blow-up, leading to substantially improved definition. However, because the 'soundtrack area' is used for image, composite 16 mm prints are not possible from Super 16 negatives.

Current developments in television (both widescreen and High Definition television) all have widescreen aspect ratios (1.77:1) close to Super 16, and current negative resolution can match High Definition standards. This has led to the promotion of Super 16 as a 'future-proof' format, compatible with all likely improved television standards.

There are dedicated Super 16 cameras: others can be changed between standard and Super 16 mm. The gate is widened and the lens recentred. Some standard lenses may not cover the extra width of the image.

See also pages 112–118.

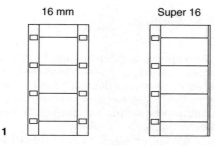

	16 mm	Super 16
Frame width	0.404"	0.493"
Height	0.295"	0.292"
Area (1.66:1)	0.107 sq"	0.148 sq"
Blow-up to 35 mm	× 2.18	× 1.75

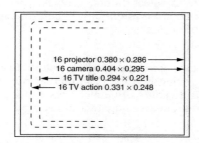

16 projector 0.380 × 0.286
16 camera 0.404 × 0.295
16 TV title 0.294 × 0.221
16 TV action 0.331 × 0.248

16 mm FRAME SIZE
(1) Blowing up to 35 mm 1.66 ratio, Super 16 negative provides 46 per cent more image area. Standard 16 mm requires the top and bottom to be cropped. (2) Image outside the safe action or title area may be seen on some, but not all, TV sets.

Different stocks have different characteristics for different purposes.

Types of Colour Film Stock

Camera negative films

Manufacturers provide a range of camera negative types. Fine-grained emulsions give the best resolution, but they are less sensitive to light: where there is limited available light, or where depth of field is important, a faster emulsion may be needed, but these show more graininess. Slow or medium speed emulsions are best when shooting 16 mm for blow-up, if grain is not to become a noticeable problem.

Emulsions may be balanced for daylight (5400K) or for artificial tungsten (3200K) light. Tungsten films may be used in daylight with an orange Wratten 85 filter and a 2/3 stop increase in exposure: a blue (WR 80B) filter (and 1 2/3 stop increase) would be required for daylight films under artificial studio lighting.

Some camera negative stocks have a slightly lower gamma, increasing their exposure range and latitude: these are particularly suitable for telecine transfer and TV release.

All colour negative stocks require the same chemical process (ECN2) and are theoretically intercuttable. However, the slight differences in image quality, colour rendition and response to special lighting conditions will lead cinematographers to select particular stock types for any given project. Tests under production conditions – before the shoot begins – are recommended.

Colour reversal film

These types of film produce a positive image with rich, saturated colours. They are suitable for telecine transfer, but do not fit readily into systems for printing or duplicating from negative originals. They require the E6 process, less widely available than colour negative processing.

Print film

This stock has a much higher gamma (contrast) than negative. The process uses a different developing agent and a slightly different sequence of fixing. Lab stocks are much slower than camera stocks, requiring bright printer lamps, but giving finer-grained images.

Print film was formerly manufactured on acetate or polyester base, but the latter is now used extensively. Low-contrast print film is sometimes used for making prints for telecine transfer.

Intermediate film stocks

Colour intermediate stock (Eastman type 5244/7244) is used for making interpositives and duplicate negatives. Its gamma is 1.0, so that image contrast is left unaltered through the duplication process, and like colour negative, it has integral masking dyes to improve colour saturation. The two stages – interpositive and duplicate negative – are printed on the same emulsion type. As with all film stocks (except reversal), printing from a negative yields a positive: printing from this in turn yields a negative.

Another stock type, colour internegative (Eastman 5272/7272), has a much lower gamma, and is designed for making negatives from reversal or positive prints.

Range	Type	E.I.	Colour Balance	35mm code	16mm code	Use
EASTMAN						
Camera Original						
EXR	50D	50	5,400K	5245	7245	slow, micro-fine grain
EXR	100T	100	3,200K	5248	7248	medium, very fine grain
EXR	200T	200	3,200K	5293	7293	med/high speed
EXR	500T	500	3,200	5297	7297	v. fast
VISION	200T	200	3,200K	5274	7274	medium, wide latitude
VISION	250D	250	5,500K	5246	7246	med/high speed
VISION	320T	320	3,200K	5277	7277	fast, wide latitude
VISION	500T	500	3,200K	5279	7279	v. fast
VISION	800T	500	3,200K	5289	7289	extra fast
SFX	200T	200	3,200K	SFX	–	blue/green screen
EKTA	100D	100	5,400K	5285	–	rich colours (reversal)
VNF		125	3,200K	–	7240	Video News Film (reversal)
VNF		160	5,400K	–	7239	Video News Film (reversal)
VNF		400	3,200K	–	7250	extra fast (reversal)
Intermediate						
CI			from clear	5272	7272	internegative from print
CI(EXR)			from orange	2/5244	7244	interpos/interdupe neg
Print						
	LC		from orange	5385	7385	low contrast print
			from orange	2/5386	7386	colour print
VNF			from clear	–	7399	reversal print
FUJI						
Camera Original						
	F64D	64	5,400K	8521	8621	slow, extra-fine grain
	F125	125	3,200K	8531	8631	medium speed
	F250	250	3,200K	8551	8651	high speed-grain ratio
	F250D	250	5,400K	8561	8661	high speed-grain ratio
	F500	500	3,200K	8571	8671	very fast
	RT125	125	3,200K		8427	colour reversal
	RT500	500	3,200K		8428	col. rev. (high speed)
Intermediate						
	FCI		from orange	4/8502	8602	interpos/interdupe neg
Print						
	FCP		from orange	3518	8618	colour print
AGFA						
Print						
	CP10		from orange	✓	✓	colour print
Gevachrome			from clear	–	782	reversal print

TYPES OF COLOUR FILM STOCK

All colour negative stocks require the same process (ECN-2), and all can be intercut and printed onto any colour print stock. Camera reversal materials go through a different process. Kodak 35 mm polyester materials have the prefix 2 instead of 5. Some stocks are also available in 65/70 mm: the Fuji code for these has the second digit 7; Kodak uses the same code as for 35 mm.

Not all stocks are sensitive to all colours.

Black and White Film Stocks

Black and white prints
The black and white positive process uses a higher contrast developing agent than the negative process. The process gamma, or contrast of a particular stock type, can be varied by changing the developing time. Typically, black and white prints are processed to a gamma of between 2.1 and 2.5. This is lower than for colour prints, but matches the higher black and white negative gamma of 0.65, to produce a 'print-through' gamma of up to 1.65 – similar to the final result in the colour system.

Black and white duplicating stocks
Like colour, black and white duplication is a two-stage process, but in this case, different stock types are used for each stage. A low-contrast positive is made on so-called 'fine grain' stock (5/7366), which has a gamma of around 1.4, and a dupe negative is made from the fine grain positive onto a grey-based panchromatic stock (5/7234) with gamma around 0.65. These two gammas combine to produce a duplicating gamma of 1.0, so that the end result is unchanged in contrast from the original. Both fine grain and dupe negative stocks are processed in the low-contrast black and white negative process.

Another duplicating material, panchromatic separation (pan sep) stock (5/7235), is designed primarily for making black and white separation positives from colour negative film. Three such separations are made, printing respectively through red, green and blue filters. As the images are of silver, rather than colour dyes, this originally provided the most reliable means of long-term archival storage: however, modern dyes, stored correctly, are much more fade-resistant, and so the system is rarely used. However, pan sep stock is also useful when reducing colour images to black and white.

Other black and white stocks
The high-contrast positive process is also used for optical sound negative stock and for 'hi-con' or titling stock. Both these emulsions are processed to a gamma of more than 3.0. As with colour, the essential quality of a so-called 'positive' process is that it produces a higher contrast than the corresponding 'negative' process. A negative film image always results from a positive scene or original, and a positive image is always produced if printed from a negative.

See also pages 64, 136.

CAMERA ORIGINAL FILM TYPES (BLACK AND WHITE)

35 mm code	16 mm code	Type	Process	E.I.	E.I. as neg	Type
5231	7231	Plus-X	Negative	80	–	Medium speed negative
5222	7222	Double-X	Negative	250	–	High speed negative
–	7276	Plus-X reversal	Reversal	50	25	Low speed reversal film
–	7278	Tri-X reversal	Reversal	200	100	High speed reversal film
71112	–	Fuji FG	Negative	80		Medium speed negative
–	72161	Fuji RP	Negative		80	Medium speed negative

LABORATORY STOCKS (BLACK AND WHITE)

35 mm code	16 mm code	Process	Sensi-tivity	Gamma	Type	Use
5366	7366	Neg	Blue	1.2–1.4	Fine grain pos	Low contrast pos for duplication from b/w
5234	7234	Neg	Pan	.65–.75	Pan dupe	Duplicate negative from b/w fine grain
5302	7302	Pos	Blue	2.1–2.5	Pos print	Prints from b/w neg
5235 (so-296)	7235	Neg	Pan	1.0–1.4	Pan fine grain	Low con positive from colour neg for duplication or seps.
so-369	7369	Pos	Pan	<3.0	Pan hi-con	Title and matte negatives and masters
2/5378	3/7378	Pos	Ortho	<3.0	Sound neg	Optical sound negs (v. area or digital)
–	7361	Reversal	Pan	1.2	Reversal pos	Reversal prints from b/w or col pos.
Agfa	362	Neg	Blue	1.2–1.4	Fine grain pos (polyester)	Low contrast pos for duplication from b/w
Agfa	464	Neg	Pan	.65-.75	Pan dupe (polyester)	Duplicate negative from b/w fine grain or reversal pos
Agfa	561	Pos	Blue	2.1–2.5	Pos Print (ac'te or polyester)	Prints from b/w neg
Agfa	ST.8	Pos	Ortho	>3.0	Sound neg (ac'te or polyester)	Optical sound negatives (v. area)
Agfa	ST.8D	Pos	Ortho	>3.0	Sound neg (ac'te or polyester)	Optical sound negatives (SR.D)

TYPES OF BLACK AND WHITE STOCK
Different negative stocks require different processing times, although all in the same developing solution. Reversal materials give a positive image direct from the camera after processing. Kodak polyester-based films (and some other 'special order' products) are designated by the prefix SO.

Film Processing

Additive and Subtractive Colour

Colour vision: additive colour

The retina of the eye is covered with light-sensitive cells, known as rods and cones. Rods are the more sensitive, but do not distinguish colours: cones fall into three classes, sensitive respectively to red, green and blue light, although the response curves overlap considerably. The brain is able to recognize any combination of signals from the three types of cone as evidence of a specific colour. For example, yellow light of wavelength 580 nm produces equal responses in the red and green cones.

We can produce the effect of any colour by adding together the right proportions of the three additive primary colours red, green and blue, which correspond to the peak sensitivities of the three types of cone. Thus, roughly equal intensities of green (550 nm) and red (640 nm) light will stimulate red and green cones in the same proportion that yellow light does, and therefore produce the same sensation – yellow. Different proportions will produce different colours: all three colours together will produce the effect of white light.

Colour television uses the additive principle of colour synthesis: the video signal is separated into red, green and blue components, each of which illuminates a correspondingly coloured set of phosphor dots on the monitor as each frame is scanned. Viewed at the correct distance, the eye cannot resolve individual phosphor dots, and sees only groups consisting of all three colours.

Subtractive colour mixing: filters and dyes

The secondary colours (yellow, magenta, cyan) are formed by adding two of the three primaries. Each combination could therefore be thought of as white light with one primary component missing. Thus:

- Yellow (red + green) = white − blue
- Magenta (red + blue) = white − green
- Cyan (green + blue) = white − red.

Yellow, magenta and cyan filters or dyes absorb one primary colour each: if pairs of these filters are overlapped in a white light beam, then two primary colours will be removed, leaving one. For example, yellow and magenta filters respectively absorb blue and green light: together they transmit only red light.

All modern types of film, negative and positive, use this system of colour reproduction, with three dye image layers coated one over another on film base.

See also pages 76, 78, 190, 192.

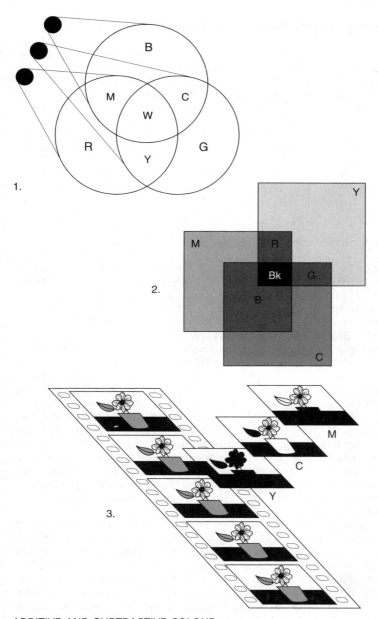

ADDITIVE AND SUBTRACTIVE COLOUR
(1) Adding primary colour lights in different combinations produces the full range of colours. (2) Each subtractive filter filters out one primary colour: combinations of two or three laid over white light produce the full colour range. (3) Dye layers in a colour film combine to form a colour image: here, a yellow flower with a green leaf in a red pot on a black table.

Roses are red, violets are blue.

Colour Specification and Perception

It is possible to distinguish many millions of distinct colours: there are, for example, many different shades of red, varying towards orange, pink, brown or purple. Most coloured objects reflect light of many wavelengths: the exact mix of wavelengths determines their colour. However, any colour can be specified exactly in terms of the quantity of each of the three primary colours (red, green and blue) that produce the same effect. In film this may be measured by the density of the three dye layers in a print: in digital images, by the red, green and blue values of the appropriate pixels.

TV broadcast signals (e.g. PAL and NTSC) encode the RGB components of an image into new values Y, u and v, where Y represents brightness or luminance, and u and v are two chrominance or colour difference values, related to the red and blue proportions of the total signal.

Neither of these systems describes the visual nature of the colour in question. Three descriptive terms are used. *Hue* (or chroma) names the basic colour in question – red, orange, yellow, etc. Many hues correspond to particular wavelengths of light in the visible spectrum. *Saturation* (or purity) describes the richness or colourfulness of a colour. Adding a small amount of the opposite hue desaturates a colour, progressively from a pure, rich colour through more subtle pastel shades to a neutral grey. *Brightness* is defined as the sensation of intensity of light. Increasing the total amount of light, while maintaining the proportions of red, green and blue, increases the intensity of a colour.

The colour qualities of complete images may be described using these terms. Lighting, make-up and art direction are among many factors that can influence the qualities of a scene as photographed: exposure, grading, printing, duplicating and telecine transfer may all have an effect on the reproduction of the scene. A shot may appear overall lighter or darker, or may be more or less contrasty, as the difference in brightness of different parts of the scene is varied. Similarly, a scene may take on an overall cast of any hue, or may appear more or less saturated, as some or all colours increase in purity at the same time. Film grading can affect the overall hue, while saturation can only be varied in telecine or digital colour correction.

Subjective colour vision, however, involves many more factors than these objective measurements of light. The brain can adapt to different light sources, so that, for example, a dress that appears blue in daylight appears the same colour even in the predominantly red and yellow balance of candlelight. In dim light, as non-colour-sensitive rod vision takes over, colours appear less saturated. Colour photography has no equivalent to rod vision, and day-for-night shots, for example, require careful design, lighting and grading to simulate the effect.

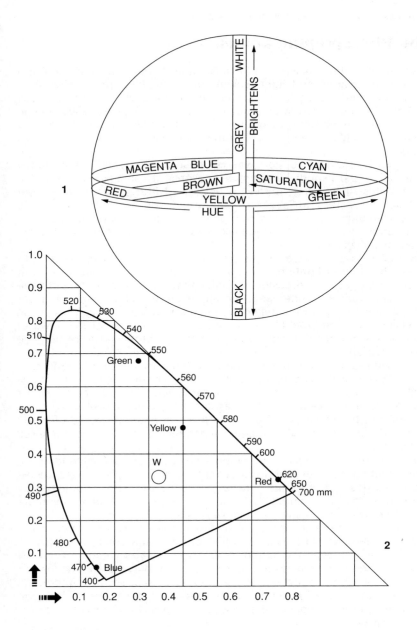

COLOUR MAPPING
(1) The three attributes of hue, saturation and brightness can be used to map all colours into a spherical colour solid. (2) The CIE colour diagram maps colours of equal brightness onto a graph. Saturated tones (pure spectral colours) are on the horseshoe outline: less pure colours are inside it. Primary colours are as close as possible to each corner of the triangle.

Colour specification and perception **45**

Film must be made before you can make a film.

The Photographic Emulsion

Photographic film consists of a flexible support coated with an emulsion containing gelatine and light-sensitive silver halides, principally silver bromide. These chemicals undergo certain chemical changes when struck by light. When treated with a developing agent, exposed silver halide crystals are converted into grains of metallic silver, while unexposed halides are left unchanged. This forms the basis of the photographic image.

Originally, the film support was cellulose nitrate. This is very highly flammable (and cannot be extinguished once it catches fire), and also deteriorates, becoming brittle, with age. Nitrate was phased out completely by 1951 in favour of 'safety film' on a cellulose triacetate base, used universally for camera negative films and many other stocks, although some laboratory film stocks and print films are made of much stronger polyester material.

Some films are coated on the back (i.e. the non-emulsion side) with an anti-halation or light-absorbing backing layer, which is washed off in the early stages of processing. In other film types, a soluble anti-halation layer is placed underneath the emulsion. In either case, this layer acts to prevent light from reflecting off the film base back through the emulsion a second time. Films also include a supercoat, or thin layer of gelatine on top of the emulsion, to protect the emulsion from damage due to friction.

The various layers of emulsion are coated onto the film base in rolls up to 150 cm wide, and up to 10 000 ft long. A number of such rolls is coated from each batch of emulsion. After coating, samples from various parts of each roll are tested for all aspects of quality control: even slight variation in the thickness of any of the dozen or more layers of emulsion could lead to changing image characteristics or colour from one roll to another.

Finally, the rolls are slit into the required gauge and length, and perforated. Slitting and perforating is carried out to very precise standards: the film's position in the camera is guided by the perforations and by the edge of the film, and a variation of one hundredth of a millimetre would be enough to cause noticeable image unsteadiness.

Rolls are packed and numbered to show their emulsion batch and roll number. Manufacturers usually draw from a single batch to supply all film for one production, to minimize any possibility of variation from roll to roll, although tolerances are sufficiently tight that mixed batches can be used with only slight – if any – grading correction. It is important, however, that emulsion numbers are controlled during production, so that if any problems appear, it is easy to trace possible defects to a particular batch or roll number.

In the case of laboratory film stocks, printing tests in the lab will determine any differences between different emulsions.

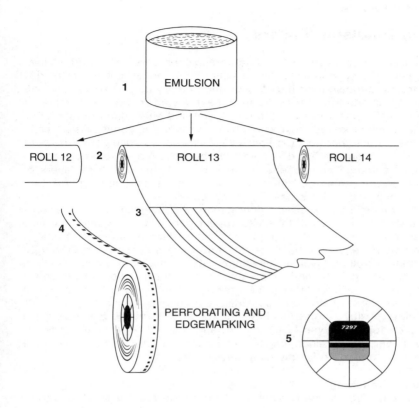

ROLL IDENTIFICATION
One particular mix or batch of emulsion (1) is used to coat a number of parent rolls (2). Each roll is then cut to a number of lengths (3), then slit (4) and perforated. After packaging, the can label (5) carries numbers that identify the precise pedigree of each individual roll.

Coats of many colours.

Film Emulsion Layers

Colour is reproduced in the photographic process by laying yellow, magenta and cyan images over a white light source. Each filter or dye controls the transmitted intensity of one primary colour: red, green and blue, which add together to produce the intended colour. Each dye layer is a photographic record of the red, green and blue colour components of the original image. Just as a black and white negative has silver in exposed areas that absorbs light when viewed, so each colour layer of a colour photograph has dye in its exposed areas that absorbs the appropriately coloured component of the viewing light. The three layers of emulsion are coated on top of each other on a single film support, and all are exposed and processed simultaneously.

The image in a processed colour negative is reversed in colour as well as in density: just as bright areas appear dark in the negative and vice versa, green objects, for example, are represented by a magenta image.

In colour negative emulsions, the top layer is sensitive to blue light (forming a yellow layer on development). Immediately under this is a blue-absorbing filter, and below this are green-sensitive and red-sensitive layers. The filter layer is necessary to remove blue light, as these two lower layers happen to be sensitive to blue as well.

Colour positive emulsions have the magenta-forming, green-sensitive layer on top. The cyan layer is next, and the yellow layer underneath. The slower, finer-grained magenta and cyan emulsion layers are not blue sensitive, and so no yellow filter layer is needed.

Integral masking

The colour dyes formed in the emulsion layers are not ideal for reproducing an accurately coloured image. In practice, the magenta dye is a little too yellow, absorbing a small amount of blue light in addition to green. The cyan dye is slightly desaturated, absorbing some green and blue as well as the intended red (as if a small amount of red dye had been added to the cyan). If uncorrected, many colours would be reproduced inaccurately.

This problem is largely overcome by the method of *integral masking*. The magenta dye is developed from a colour coupler, which remains unchanged in unexposed areas of the film. In a negative or intermediate stock, this colour coupler has a pale yellow colour, instead of being clear. Both exposed and unexposed areas in the magenta layer thus have a similar yellowish bias, absorbing a uniform amount of blue light. The cyan dye is similarly formed from a pale red coupler. The overall result is that all areas of processed colour negative have an overall orange bias, due either to the original colour of the coupler or to the unwanted absorption of the developed colour dye. As it is an overall bias, it is easily corrected in printing. Note that this is an integral part of the image layers: it is neither a separate filter layer nor a dye in the film base.

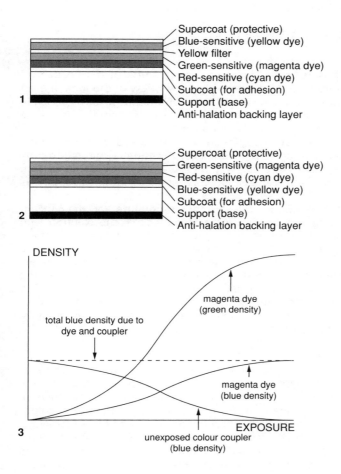

Layer labels for figure 1:
- Supercoat (protective)
- Blue-sensitive (yellow dye)
- Yellow filter
- Green-sensitive (magenta dye)
- Red-sensitive (cyan dye)
- Subcoat (for adhesion)
- Support (base)
- Anti-halation backing layer

Layer labels for figure 2:
- Supercoat (protective)
- Green-sensitive (magenta dye)
- Red-sensitive (cyan dye)
- Blue-sensitive (yellow dye)
- Subcoat (for adhesion)
- Support (base)
- Anti-halation backing layer

Figure 3 graph labels:
- DENSITY (y-axis)
- EXPOSURE (x-axis)
- total blue density due to dye and coupler
- magenta dye (green density)
- magenta dye (blue density)
- unexposed colour coupler (blue density)

COLOUR FILM EMULSION LAYERS
(1) Colour negative stock. In practice, each colour is represented by two or three layers of varying granularity and sensitivity. (2) Colour positive stock. The latest emulsions omit the backing layer. (3) Colour couplers are a yellow or orange colour, to cancel out the unwanted green and blue absorbtion of the developed dyes.

Light changes the chemical properties of the emulsion.

Developing the Image

Black and white development
When film is exposed to light, photons strike some of the crystals of silver bromide in the emulsion, converting just a few of the ions in each affected crystal to atoms of silver. This is not enough to form a visible image (although if raw negative stock is exposed for some minutes, a slight darkening of the emulsion can be seen).

However, if the exposed film emulsion is immersed in a developing agent, the remainder of each exposed silver bromide crystal is progressively converted to silver. After a few minutes, exposed areas of emulsion are well developed into silver grains, while unexposed areas remain as silver bromide.

The speed of this reaction is affected by temperature and the concentration of developing agent and of other chemicals in the solution, and so precise control is required, to prevent the image from over-developing and forming silver even in the unexposed areas.

At this stage, the darker silver areas form a clearly visible image. However, any attempt to view the image would expose the remaining silver bromide crystals to more light, and darken the entire film. The image can be made permanent by passing the film through a fixing solution, which dissolves away the unexposed silver bromide crystals, leaving the developed silver grains to form an image.

Colour development
In addition to silver bromide, each layer of a colour emulsion contains a colour coupler – a chemical that will form a coloured dye during the development process. Each colour is complementary to the sensitivity of the layer: the blue-sensitive layer forms a yellow dye, etc. In the colour developing solution, exposed silver bromide is converted to silver. Now, in the colour process, the oxidized developing agent formed by this reaction in the exposed areas has an important function: it reacts with the colour couplers in each emulsion layer, converting them to appropriately coloured dyes.

The film now carries a dye image in each emulsion layer, but the original silver image remains. In the bleach solution, this silver is converted back into ionized silver bromide, which is then dissolved out, along with the originally unexposed silver bromide, in the fixer solution. The coloured dyes are unaffected by these later solutions, and the final image thus consists of three superimposed images, of complementary colour to the original.

See also pages 68, 70, 72

B/W		Colour

 After exposure:
latent image of silver
halide crystals: couplers
throughout colour
emulsion only

 After development:
silver image in exposed areas
in colour emulsion, colour dye
clumps around each
developed grain.
Couplers unchanged elsewhere

After bleaching:
(colour emulsion only)
developed silver is reconverted
to silver bromide

 After fixing:
silver bromide is washed out of
emulsion, leaving silver grains
in exposed areas
(black and white) or dye clumps
in exposed areas and unconverted
coupler elsewhere
(colour emulsion)

THE STAGES OF COLOUR DEVELOPMENT
Silver development is necessary for the formation of any image, but all silver is
subsequently washed out of a colour emulsion.

The Processing Sequence

Backing removal
Many colour negative stocks have an anti-halation layer of fine carbon (jet) coated on the back of the film. This is no longer used on print film, however. It absorbs light during exposure, preventing flare from internal reflections. In processing, this layer is first softened in the prebath (borax) and then removed by scrubbing jets of water. Care must be taken that no carbon spots reach the emulsion side of the film, where they would be rapidly and irreversibly absorbed by the gelatine.

Some types of stock have an alternative anti-halation layer coated underneath the image-forming emulsion layers, which is completely dissolved during the bleach and fixing stages of processing.

Colour positive sound redeveloper
Although the basic process is the same for positive as it is for negative, the need for a silver soundtrack leads to a couple of extra processing stages.

Immediately after colour development (and a stop bath), the film is passed into the first fixer solution. This removes silver bromide from the unexposed areas (as in black and white processing), leaving a silver-plus-dye image in both picture and soundtrack. Bleaching now converts the exposed and developed silver back to silver bromide. After a short rinse and superficial drying, the film passes to the sound applicator station, where a narrow stripe of redeveloper solution is applied, just to the soundtrack area at the edge of the film. This is a thick, treacly and fast-acting black and white developer. The silver bromide is developed once again to form a silver image. After development to completion, the film is washed by water sprays, and passes into the second fixer, where silver bromide in the exposed image areas is dissolved out.

Where a cyan analogue soundtrack is required, there is no need for this redevelopment stage.

Drying
Fully soaked gelatine swells, softens and carries a lot of water. Wet film emulsion is therefore very soft, liable to absorb any dirt particles and difficult to dry. Processor drying cabinets circulate large volumes of heated and filtered air past the film surface, and drying normally takes between 5 and 10 min. If the temperature is too high, the surface of the emulsion hardens prematurely, leaving moisture trapped underneath. This leaves the emulsion very 'green' or soft for a day or more, until its humidity stabilizes. During this time, the film is highly susceptible to scratching, rubbing or to absorbing dirt particles. Note that this is precisely when print rushes or video dailies are made from the negative. Extremely careful handling is essential. The same applies to prints, which are most susceptible to projector damage at this stage.

See also pages 146, 160.

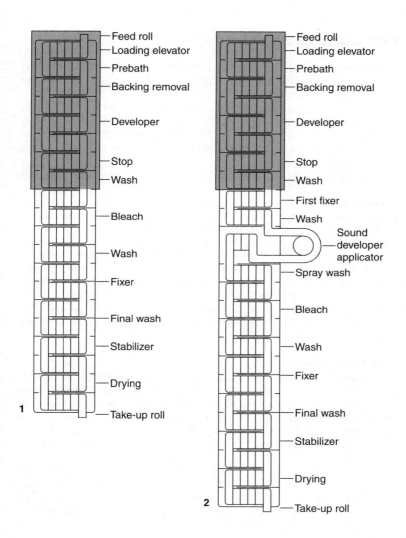

1
- Feed roll
- Loading elevator
- Prebath
- Backing removal
- Developer
- Stop
- Wash
- Bleach
- Wash
- Fixer
- Final wash
- Stabilizer
- Drying
- Take-up roll

2
- Feed roll
- Loading elevator
- Prebath
- Backing removal
- Developer
- Stop
- Wash
- First fixer
- Wash
- Sound developer applicator
- Spray wash
- Bleach
- Wash
- Fixer
- Final wash
- Stabilizer
- Drying
- Take-up roll

CHEMICAL MANAGEMENT

Most laboratories maintain a range of chemical recovery, recycling or regeneration systems, for reasons of economy as well as environmental considerations. Metallic silver is electro-plated out of the fixer, developer and bleach can be reconstituted, and wash water can sometimes be captured, purified and recycled: this also reduces heating energy costs.

Consistent processing leads to predictable results.

Process Control Standards

Laboratories aim to provide a standard and consistent process, so that negative shot under the same conditions on different days will come back with exactly the same results.

Some chemicals in the processing solutions are used up as film is developed: other chemicals are released into the solution by the action of the developer. Chemical equilibrium is maintained by adding a *replenisher* – with high concentration of the active chemicals – to displace the exhausted solution at a constant rate, all the time that film is being processed. Thus, there is no variation between the start of the run and the end.

The chemical solutions are monitored by regular chemical analysis, and the actual processing results are checked by running sensitometric strips, or scientifically made exposure wedges, through the process on a regular basis. Any slight deviation from aim densities is corrected by small changes to processing time or by chemical adjustments.

The laboratory is sent camera negative of many different types and batches, exposed under a wide range of conditions, not always ideal. While occasions may arise when processing is varied (e.g. push processing), the laboratory process must normally be maintained at a constant standard, so that the full range of work may be processed together for optimum and consistent results.

Tests and comparisons

Although laboratories normally work to the same recommended aims for their processes, results from different labs may vary slightly. This may arise where different designs of processing machine are used, or in the case of black and white, where different chemical formulae are favoured. If more than one lab is being used for a production, it is vital to have camera tests processed at both, for comparison before production starts.

The results of work prints, whether graded or 'standard one-light', are less straightforward. There is no universal set of aims: the colour and density of a print are very much subject to the grader's preferences, and can easily be changed for another print. For this reason, it is important to discount a simple colour difference when viewing laboratory or stock comparisons.

Where the production will be blown up from 16 mm to 35 mm, or where any other special technique is being used (e.g. bleach bypass or colour drain), it is important to see tests followed right through: not simply as far as a print from the original, but also to test the results of duplication.

TREND CHART

Aims for a process are established by processing test strips in a correctly mixed and analysed bath at the specified time and temperature. Once standards are established, the process is monitored by reguarly processing test strips (sensitometric strips), and by comparing selected steps with the aim point. Trends may be spotted and corrected before the process goes beyond tolerance limits.

Density values may be added together.

Units of Density

The sensitivity of a film emulsion is measured in terms of exposure (brightness of the scene multiplied by the time of exposure), and of density, or the darkness of areas of the developed image. The science of measuring and controlling film exposures is called sensitometry.

Logarithmic scales
While some quantities behave in a linear relationship with others (for example, the running time of a film is proportional to its length), others behave in a logarithmic relationship. In particular, the sensation of brightness is such that, over quite a broad scale, the smallest increase to be 'just noticeable' to the eye is proportional to the actual level of brightness. Thus, if adding one candle to 10 makes the light just noticeably brighter, then 10 candles would have to be added to 100 to produce the same perception of 'just noticeably brighter'.

Logarithmic numbers represent these proportional increases in a linear fashion, by counting the number of multiplication steps each term is removed from the original. A series with factor 10 would run:

Number:	1	10	100	1000	10 000	100 000	etc.
Logarithm:	0	1	2	3	4	5	etc.

It is mathematically possible to fill in the gaps between the whole numbers, so that every number has a corresponding log value. The most important property of log scales is that every time a number is doubled, its corresponding log is increased by adding 0.30.

Log E
The term log E is a relative unit of exposure. Every time the exposure is *multiplied* by 2 (in camera terms, a change of one stop), 0.30 is *added* to the log E value.

Density
Density is a logarithmic unit that measures the darkness, or light-stopping power, of a filter or an area of processed film. Density is defined as log of the opacity (or 1/transmittance) of the film or filter. A density of 0 means 100 per cent transmittance. Clear film base typically has a density of around 0.03 (94 per cent transmittance). A filter of density 0.30 transmits 50 per cent of light, while film of density 3.00 transmits only 0.1 per cent of light, and is effectively black.

One advantage of using log scales is that a just-perceptible increase in density or brightness is represented by the same change in value anywhere on the scale between dark and light. The visual difference between image areas of density 0.30 and 0.40 (for example) appears to be the same as between image areas of density 1.30 and 1.40.

For the same reason, some digital imaging systems (e.g. Cineon) store brightnesses (pixel values) as logarithmic values.

See also pages 198, 204.

NUMBER	LOG
1	0.0
2	0.3
4	0.6
8	0.9
10	1.0
16	1.2
32	1.5
64	1.8
100	2.0

1

2 — 0 10 20 30 40 50 60 70 80 90 100 %

3 — 0 4 6 9 12 18 25 35 50 70 100 %

VISUAL PERCEPTION OF BRIGHTNESS
(1) Numbers increasing in a proportional scale may be represented by logs progressing in a uniform or linear scale. (2) A linear progression shows large steps of brightness at the shadow end, but small increments at the brighter end. (3) A logarithmic progression produces more uniform steps of perceived brightness.

The slope of the curve measures the contrast.

Gamma

Gamma in film systems

The graph showing the density of processed film for a complete range of grey-scale exposures is known as the characteristic curve of the film. Both exposure (plotted as log E) and density are logarithmic scales. Typically, the main stretch of this graph is a straight line, showing that any change in density is proportional to the corresponding change in exposure. The gradient of this straight line is known as the gamma of the film stock.

The straight line indicates that a uniform grey scale in a scene will be reproduced as a uniform grey scale in the film. A steeper line (higher gamma) results in greater density differences, and a more contrasty image overall.

The extreme ends of the characteristic curve – the toe and shoulder – gradually flatten off. Given the best exposure for any scene, the highlight to shadow range should fit entirely on the straight-line portion of the curve.

When film is duplicated through a series of film stocks, the final contrast of the image is derived by multiplying the gammas for each stage together. Colour negative has a gamma of about 0.55 (density differences are just over half the corresponding log E exposure differences). Colour print film, however, has a gamma around 3.0. The combined result (print from negative) has an image gamma of about 1.60. It turns out that, allowing for typical projection conditions and some psychological factors, this result gives the most preferred image on screen.

Gamma in video images

In video and digital images, the term gamma has a related but slightly different meaning. Brightnesses are not normally expressed in log terms, and so the straight-line relationship between input and output is not evident. It happens that the brightness of a video display monitor is not linear, but is proportional to the voltage of the signal raised to the power of about 2.2. In practical terms, a scale from black to white is flat and too dark at the dark end, and excessively contrasty in the mid-scale to white end.

Telecine chains therefore introduce gamma correction immediately after the scanning stage, applying exactly the inverse of the picture tube effect. This gamma correction is normally set at about 0.45 (the inverse of the output value), but can be adjusted as a grading correction. Reducing gamma in telecine reduces highlight contrast, brightens midtones and increases shadow contrast.

Gamma in digital images

For similar reasons, digital effects systems and CGI systems must take display gamma into account so that the images displayed on a work station monitor match the eventual output on film. Similarly, gamma correction is necessary when using video projection to preview film outputs, or when making paper printouts of scenes or effects for future reference. Different computer platforms handle this issue in slightly different ways.

See also pages 190, 204.

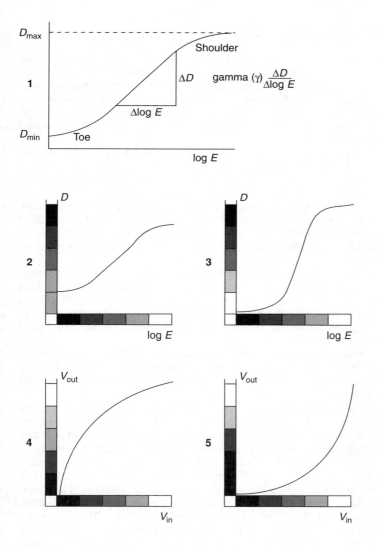

GAMMA

(1) In film, gamma is the gradient of the straight D–log E characteristic curve: density change divided by exposure change. A lower gamma (2) results in less density differences between grey tones, while a higher gamma (3) results in much greater density differences and more contrast. In video, brightnesses are represented by voltage, a linear (not log) function. Decreasing gamma (4) brightens the image but increases shadow contrast. A higher gamma (5) compresses blacks so that there is more contrast in the lighter tones.

Film can handle a wider tonal range than television.

Contrast and Latitude

The contrast of a scene is the range between the brightest highlight areas and the deepest shadows, and is a combination of two factors: the range of tones in the subject, and the lighting ratio, or difference between key-lit areas and shadow or fill areas. The human eye can respond to a ratio of about a million to one by adjusting the iris or aperture in the eye, and by chemical changes in the retina. At any instant it can see tonal detail over a range of about 100:1.

Negative film can record tones over a range of nearly 1000:1. In the mid-tones the response is uniform – changes in negative film density are exactly proportional to changes in log E, brightness or exposure. Extreme shadows and highlights are tonally compressed, leading to a gentle reduction in local contrast in these ranges. This effectively extends the range of tones that the film records, and contributes to the so-called 'film look' by comparison with the more abrupt cut-off delivered by video systems. Graphically, this response is shown as the S-shaped 'characteristic curve'.

Contrasty scenes often extend over the full range of the film's sensitivity, and accurate exposure is important. Underexposure means that more of the shadow tones are reproduced on the flatter toe of the film's characteristic curve, leading to grey, lifeless shadows in the image: overexposure has the converse effect, with flattened burnt-out highlights lacking any tonal detail.

It is also important to control the lighting ratio. Bright sunlight leads to deep shadows so that – for example – faces under broad-brimmed hats can be hard to distinguish. Large diffuse reflectors are often used to fill these shadows.

Projected film prints can give a screen brightness range of roughly 100:1, depending on ambient light in the theatre. This is much less than is recorded in the negative, and so prints must be graded to favour either the darker shadows or the highlights, particularly in contrasty scenes.

Normal TV screens offer little better than 20:1 (the greyish tone of a switched-off TV screen is effectively the darkest black possible). The brightest white is taken as a reference point, and so shadow detail that would be clearly visible on the cinema screen is too dark to be visible on TV. Film shot specifically for TV must therefore be lit with a relatively flat lighting ratio. When cinema film is to be transferred on telecine, it is often best to use a print made on low-contrast print stock, or an inter-positive.

Some camera film stocks claim a slightly lower contrast than normal. More accurately, they have a lower gamma, allowing them to record a slightly greater scene brightness range within the same density range on the film, particularly useful for TV productions.

See also page 188.

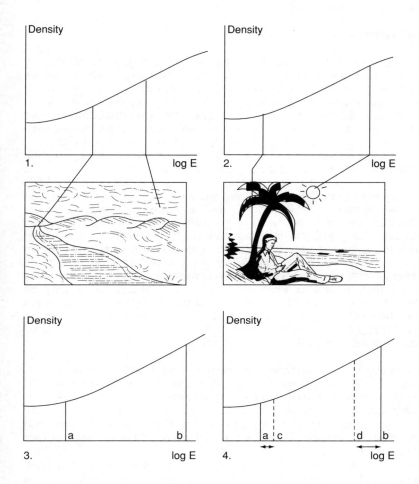

EXPOSURE RANGE
(1) Exposures from scenes with soft or flat lighting fall on a relatively short section of the characteristic curve. (2) Strong lighting uses the full length of the curve. (3) The useful exposure range for an emulsion extends between a point on the toe of the curve (a) and the top of the straight line (b). (4) The brightness range in most scenes (c to d) fits well within this range, allowing a certain latitude of acceptable exposures.

Faster films have larger grain.

Graininess

A photographic image is made up of silver grains or dye clouds centred on the sites of developed silver grains. These form where silver bromide crystals in the emulsion have received sufficient exposure. The crystals vary in size, shape and sensitivity, and are randomly distributed within the emulsion. Because the grains are located in a random pattern, they tend to form into clumps, which give the impression of graininess even when the magnification is too small to show individual dye clouds or grains. Faster films have a greater proportion of large crystals, which in turn form larger clumps, and so appear grainier.

In areas of image that receive less exposure, it is the largest crystals that respond to the light, and so the shadow areas of negative contain the grainiest part of the image. In a well-exposed negative, these areas are printed very dark: the eye is less sensitive to tonal variation in dark tones and the graininess is less apparent. If the negative is underexposed, the grainy shadows are printed onto the contrasty mid-scale of the print, and the eye becomes much more sensitive to the grainy pattern. Cinematographers therefore often overexpose colour negative by about half a stop to minimize grain where it is an important factor – e.g. in 16 mm for blow-up to 35 mm. Black and white negative, on the other hand, shows minimal graininess at the recommended exposure rating.

The term *granularity* is an objective measurement of the size of grain clusters, and the microdensitometric variation across an area of uniform tone.

Subjectively, the nature of the scene has considerable effect on the perceived graininess of the image. Large areas of steady, uniform tone reveal the grain pattern most clearly: where they eye is distracted by fine detail, bright highlights or busy movement, it pays less attention to the grain. Similarly, where the image itself is sharp, grain is often less apparent than when the image is poorly focussed (due to depth of field limitations or simply poor camera work).

When projected images are viewed at great magnification, the grain appears to 'crawl'. This is due to the changing grain pattern from frame to frame.

Duplicating and print stocks have much finer grain than camera negative. However, where exposures are not well controlled, successive stages of duplication may distort the tonal scale, thus exaggerating the effect of original image grain. (The grain clumps are no bigger, but the density variation is greater.) Grainy images therefore may be made worse by duplication, while apparently grain-free originals will remain so.

It is common to 'de-grain' images during transfer to telecine. This simply reduces the acutance or apparent sharpness of the image very slightly, making the micro variations in density less noticeable. It is usually accompanied by a slight loss in resolution. Film grain should not be confused with electronic noise, caused (particularly in older telecines) when the system is working at high gain to deal with a dark, overexposed negative. Noise is more often apparent in highlight areas.

GRAININESS

(1) Because film grain occurs in a random pattern, it tends to form in clumps and appears as an overall coarser pattern than a regular video or dot matrix pattern would. (2) Increased contrast can alter the perception of grain considerably: less graininess is apparent in blacks than in greys, but a contrasty print can sometimes exaggerate the visibility of grain in mid-tones.

A simple process, but capable of some variation.

Black and White Negative

Black and white negative is manufactured in a range of speeds: as with colour, faster emulsions produce larger grain. All black and white negative requires the same chemical process, but developing times (the running speed of the machine) vary for different stock types. The lab may require a short length of the stock for testing prior to processing your work. In practice, the lab's processing turnaround times may be slower, because one processing machine may be used for a variety of film types.

Black and white processing

The contrast given by black and white film can vary a lot. Labs will normally develop to a standard gamma of 0.65, although this may vary from lab to lab. Different labs may also use different chemical formulae, and this can lead to noticeably different results. It is wise to have all your processing through one laboratory. Depending on camera test results, you may ask for a slightly lesser or greater contrast (e.g. gamma 0.60 or 0.70), which the lab will achieve by varying the amount of development. Of course, if you are working with a low lighting ratio, you may use this to advantage. Note that increased developing may also increase the graininess slightly.

The contrast of the image varies with the overall exposure slightly more than it does in colour emulsions. Overexposure by more than (about) one stop will lead to increased contrast, noticeable in a graded print, with very dense shadows as well as burnt-out highlights. Black and white negative will tolerate slight underexposure, although substantial underexposure will result in extremely flat images, with thin shadows and no clear highlights.

Processing instructions

Obviously, it is vital for camera assistants to label all camera rolls clearly, and if different stocks are being used in one shoot, they must be kept separate at all times. If black and white negative is put through a colour process by mistake, the bleach solution will remove the developed silver image, leaving nothing but clear emulsion. Worse still, the higher temperatures used in colour processing may well soften the black and white emulsion so much that it is removed from the film base, contaminating the rollers, jets and solutions in the processing machine. Colour negative is also rendered useless if it is processed in a black and white machine: remjet backing will only be partially removed and will contaminate the solutions in the processor. Laboratory staff should always remove a few centimetres of film from the end of the roll (in the darkroom) and inspect the sample in the light before processing, to ascertain the type of stock.

See also page 40.

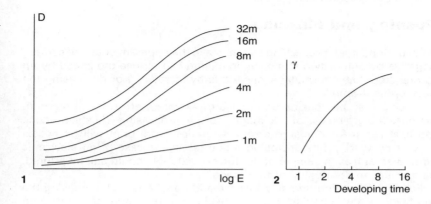

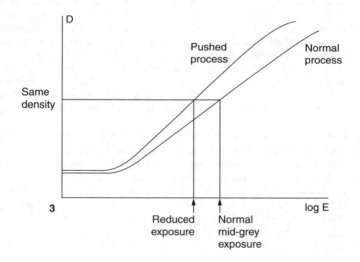

PROCESSING VARIATIONS

(1) Gamma is determined by processing time. (2) A series of curves can be summarized in a time–gamma curve. (3) Pushed (or forced) processing compensates for underexposure by returning negatives to their ideal density.

Ways of seeing further into the shadows.

Pushing and Flashing

Forced (or pushed) processing can increase the apparent speed of camera negative by one or two stops, while pulling can reduce the speed by up to one stop. Labs normally achieve this by increasing or decreasing the development time.

Forcing may be considered in case of exposure error, but it tends to increase the graininess of the image. Normal processing will still produce the best result for one-stop errors. A graded work print will be necessary. If no work prints are being made (as in the case of an electronic edit), then at least a sample of the forced material should still be printed, as a check on the quality of the image.

Forcing more than one stop has the additional effect of increasing the fog level of the negative, and this results in murky grey shadows with little detail, and no true black tones.

Strictly, push processing only increases film speed by a fraction of a stop. What it does do is increase the density of the mid-tones by an amount equivalent to an exposure change of one stop. Thus, underexposure combined with push processing yields a negative that still prints at the same light as a correctly exposed, normally processed one.

Pull processing, or reducing the development of the negative, combined with correspondingly increased exposure, yields a negative with slightly increased colour saturation and slightly finer grain. Pull processing is normally achieved in the lab by speeding up the processing machine.

Varying the processing time for black and white negative affects contrast as well as compensating for over- or underexposure.

Some cinematographers make use of the slightly different results to achieve a special 'look'. Well-exposed but push-processed film, for example, may give a hard or gritty 'documentary' look, while overexposed and pulled images on a fine-grained emulsion can produce a very clean, luminous look. Tests should be carried out before production.

There is normally an additional charge, and some delay, for push or pull processing because the rolls have to be processed separately.

Flashing

The term *flashing* refers to exposing the negative to a uniform low level of white light either before or after exposing the image. This adds a fixed amount of light to all areas of the image, and moves every tone a little way up the characteristic curve of the emulsion. There is little difference between pre- and post-flashing. The flashing exposure on its own should not be enough to produce a significant density in the negative, and so areas of black should remain unchanged, but relatively deep shadows should receive a significant boost. Mid-tones and highlights are much brighter than the flash level, and so are relatively unaffected, so the technique tends to lower the contrast of the image, particularly in the shadows, and arguably increases the film's sensitivity to dark shadows.

Film may be flashed by running it through a printer or by shooting an out-of-focus, evenly lit white card, either before or after the scene is shot.

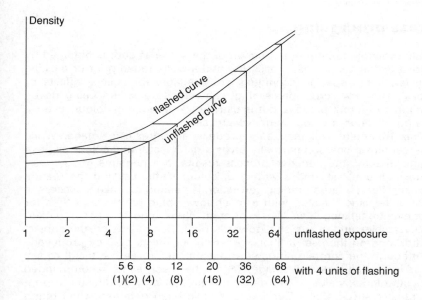

Density

flashed curve
unflashed curve

| 1 | 2 | 4 | 8 | 16 | 32 | 64 | unflashed exposure |

5 6 8 12 20 36 68 with 4 units of flashing
(1)(2) (4) (8) (16) (32) (64)

FLASHING
An overall fogging exposure has the greatest effect on the shadows of the image exposure, reducing the effect of different shadow tones. The same amount of fogging light has proportionately less effect on highlights.

Cross-processing

While the most faithful reproduction of the scene as shot is obtained by correct exposure, normal processing and a well-graded print or telecine transfer, some special techniques are available for special effects or 'looks'. The term 'cross-processing' can refer to any film being developed in a different process, but is usually taken to mean colour reversal film put through a colour negative process.

This treatment will inevitably produce an unrealistic image. While reversal film processed normally gives a richly saturated colour positive image directly, the negative process results in a negative image, with quite high contrast, and a variety of colour shifts. Lacking the orange masking dyes, a large grading correction is needed to make a successful print or telecine transfer, with a much lower blue printer light than for a conventional negative. When printed, blues tend to appear darker, yellows paler and cyans shift towards blue. Depending on the subject matter, and on the use of filters, other colour twists may be produced.

Although the contrast and colour mismatches make it difficult to say what is a 'well-exposed' image, rating the stock at its recommended exposure index yields a very dense image, that may be difficult to print or transfer successfully. Good results have been obtained when rating the stock a stop faster.

As with any non-standard technique, it is important to discuss your plans with the lab beforehand. In this particular instance it is vital. During processing, reversal stock consumes different amounts of developing agent and releases chemical by-products into the solution at a different rate, compared with normal negative stock. If a significant proportion of reversal is run through a negative process, the bath will be quite out of balance for the next conventional negative run. The ideal solution to this problem would be to have a dedicated run, and to dump the chemicals after the run is complete. Labs understandably are reluctant to do this, as the costs in time, chemicals and the disposal issues are generally too great to be passed on. Small footages (maybe just a few rolls per day) can be managed without any noticeable variation in the chemistry, but this may result in some delay in turnaround.

The recommended E-6 process for reversal stock includes a dye-stabilizing chemical in the pre-bleach: this solution is not present in the negative process. As a result, the long-term stability of cross-processed reversal film cannot be guaranteed.

See also page 50.

Negative process	Reversal process
Latent image in exposed emulsion	Latent image in exposed emulsion
Colour neg developer produces a silver and dye image	First developer produces silver image only
Bleach converts silver to silver bromide	Colour developer fogs and produces silver and dye in unexposed areas
	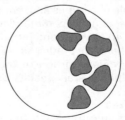
Fixer removes silver bromide leaving dye in exposed area	Bleach and fixer remove silver bromide leaving dye in unexposed area

COLOUR REVERSAL PROCESSING
In colour reversal processing, the positive dye image is formed in those areas
unaffected by the first exposure and development.

Silver in the image makes richer shadows.

Bleach Bypass (Negative)

The so-called *bleach bypass* process uses a modified processing sequence to retain silver in the colour image, adding to contrast.

Colour negative
In conventional colour processing, the bleach solution reconverts developed silver in the exposed areas of the image, back to silver bromide. This is then dissolved away in the fixer solution, leaving dye alone in the exposed areas, forming a pure colour image.

By eliminating the bleach part of the process, metallic silver grains are retained in the image as well as the three coloured dyes, just as in a simple black and white process. The negative image becomes darker and contrastier as a result. Silver retained in any one colour layer absorbs all colours of light, desaturating that colour.

Printing such a negative, with suitable grading correction, results in a much contrastier image, with colours relatively duller than normal, blown-out highlights, and deeper shadows. A darker print can give very blocked-up shadows. As the silver adds to the density of the negative, underexposure by up to a stop is usually best. Thorough tests are essential, as with any original negative technique.

The increased contrast gives a very hard-edged look, and some cinematographers have used diffusion filters to modify the effect. Similarly, additional fill lighting can be used to soften the blocked-in shadow areas, thereby giving the colour desaturation without excessive contrast.

Bleach bypass tends to emphasize grain. This is not significant with slower stocks, but becomes noticeable, particularly in yellow areas, when high speed stock is used.

Theoretically, it is possible to re-process a bleach-bypassed negative normally, removing the silver and obtaining a 'normal' negative. However, where lighting or exposure have been modified to take the bleach bypass effect into consideration, you will be left with an abnormally thin and flat negative, probably the opposite of what was required.

'Partial' bleach bypassing, whereby the negative is bleached for a reduced time, is not recommended. The normal time in the bleach allows the process to go to completion – different stocks may take different times. It is hard to predict consistently how far the process will have gone in any given portion of the full time, and this can lead to unexpected and inconsistent results day to day.

Intermediates
It is also possible to bleach bypass interpos or interdupe. This has the advantage that, once applied in the dupe negative, the desired effect is obtained for all release prints, with no additional work at the printing stage. Intermediates to be bleach bypassed must be underexposed in the printer by between one and two stops, or they will be too dense to print through to the next stage. As always, careful testing is essential.

See also page 50.

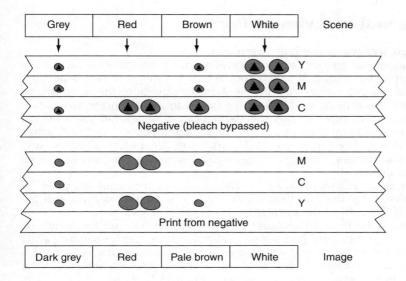

Grey	Red	Brown	White	Scene

Negative (bleach bypassed)

Print from negative

Dark grey	Red	Pale brown	White	Image

BLEACH BYPASS (NEGATIVE)

Silver is retained in the highlights of an unbleached negative, absorbing extra light during printing. A normal print would have very bright highlights: a graded print restores the correct density, but with increased contrast and blocked-up shadows.

Several ways to vary the end result.

Alternative Styles of Print

Bleach bypass and silver retention
The additional contrast and desaturation given by retained silver have frequently been used to give a special look to release prints. Depending on the subject matter and the lighting and grading, the look can be sombre and moody, or it can be the hard-edged grey, gritty look suited to action adventure films. A silver-enhanced print is a full colour image with an additional black and white layer superimposed: most noticeably, this adds to the image contrast, particularly deepening shadows and subduing colours. The effect is generally less pronounced than negative bleach bypass.

The simplest process uses the bleach bypass technique, as used for negative. After the first fixer wash, the film is passed straight into the second fixer. All of the developed image silver is retained.

In a variation on this process, the film passes through the bleach as normal, but then goes into a black and white developer for a short period of time before fixing and washing as usual. The developer reverses the action of the bleach, converting silver halide back to metallic silver (working in the same way as the soundtrack redeveloper). Once again, the end result is retained image silver. An advantage of this method is that the time of redevelopment can be adjusted by altering the racks in the redeveloper tank, thereby controlling the amount of retained silver and adjusting the contrast and saturation as desired. The method is called variously ENR (after three film technicians at Technicolor Rome who are credited with inventing the process), CCE (colour contrast enhancement) or NEC (noir en coleur). This process should not alter the properties of the prints with regards to archiving, although it has been suggested that the extra heat absorbed by the silver during projection may cause focus difficulties or increase the risk of print wear.

High-contrast print stocks
High-contrast print film stocks (e.g. Kodak's Vision Premier) have a slightly higher gamma than the normal stock, but also work by extending the straight-line portion of the characteristic curve, pushing the shoulder up higher. Shadow contrast is increased, giving deeper blacks and richer colours. This also tends to counteract the effect of the toe shape of negative stocks. Slightly underexposed negatives, showing washed-out shadows on normal print stock, may look much better on high-contrast print stock.

Dye transfer prints
Also known as Technicolor, or imbibition printing, this was the principle method of colour release printing between the 1930s and 1970s, when it was discontinued. However, it is once again in (limited) use by Technicolor. Instead of a duplicate negative, colour separation 'matrices' are made. These carry a clear, absorbent gelatin emulsion, which varies in thickness with the image tone. During printing, the matrices absorb yellow, magenta and cyan printing inks, and transfer them by contact

72

onto film stock, forming a full-coloured image. A black and white image is exposed onto the print stock before dye transfer to enrich the blacks.

Because printing dyes are used instead of photographic dyes, the resultant image has characteristically rich, vibrant colours which also have excellent archival keeping qualities.

See also page 48.

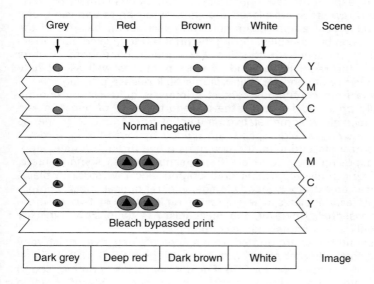

SILVER-ENHANCED PRINT
A silver-enhanced print retains silver, absorbing all colours, yielding a darker and more contrasty print, with deep and dark coloured areas.

Transferring the image from negative to positive.

Film Printing

The Film Printing Machine

Contact printers

During printing, the image on a negative is copied by passing light through it to expose the raw print stock. In continuous contact printers, negative and raw stock are placed together, emulsion-to-emulsion, and moved steadily past a light beam slit. The exact colour balance of the printing light can be controlled during the print run to give colour corrections for different scenes in the film. Fast-running continuous printers are used for the rapid turnaround of work prints, as well as for fully graded answer prints and for high volume bulk release printing.

The image from continuous contact printers is quite steady enough for normally projected films, but the transport system of negative and raw stock does allow some relative movement from frame to frame, as both films, moving at high speed, are guided by loose-fitting sprocket teeth. In contact step printers, the two films move through a gate, stopping and exposing each complete frame separately. In some printers, precisely fitting registration pins hold original and raw stock in place. This produces an extremely steady image, vital for optical effects components or projection plates where precise registration of two or more images is essential. However, the mechanism is quite slow, typically exposing only a few frames per second.

Optical sound tracks are printed from a separate negative, which may carry up to four different sound formats: analogue, SR-D, SDDS digital tracks and the control code for DTS. For normal release printing, sound and image are printed simultaneously on the two heads of a single continuous contact printer. The sound head has a different light source for each soundtrack format. Where the image of a release print is, for any reason, step printed, the soundtrack, if required, must be added in a separate pass on a continuous printer.

Optical printers

In optical step printers, the original negative is stepped through a projector gate, and light from the image is focussed, frame by frame, by a lens onto the raw stock stepping through a synchronized camera gate. Since negative and raw stock run independently, optical printers can be used for reduction or blow-up from one gauge to another, or for printing short sections of an exact number of frames from longer, uncut originals. More sophisticated machines may be used for a wide variety of special optical effects.

The continuous optical printer is less common. As its name implies, this uses a lens system to project the image from the negative onto the raw stock, but both film strands move continuously, instead of intermittently. Image resolution and steadiness are adequate for – for example – reduction of 35 mm work prints from 65 mm camera negative, but do not compare with that of a step printer.

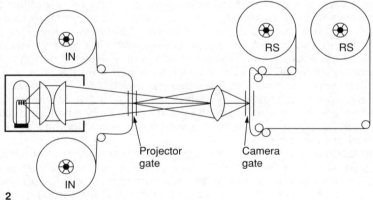

TYPES OF PRINTER
(1) A continuous contact or 'panel' printer used for high-speed release printing.
(2) An optical step printer, used for duplication, format changes and optical effects.
(IN = image negative; RS = raw stock; SN = sound negative.)

Red, green and blue are controlled independently.

Colour Correction in Printers

The light in the gate of a printing machine must be controlled to allow not only for the density and colour balance of the negative, but also for the wide range of raw stock sensitivities. Most printers have an additive light head, in which a system of dichroics separates the white printing light into separate red, green and blue components, each of which is passed through an adjustable light valve to control the intensity before being recombined at the printing gate.

Each light valve can be opened to any of 75 settings, in increments of 0.025 log E points, giving a total range for each colour of just over 1.80 log E, or a ratio of 64:1. Each step increases the printing exposure by around 6 per cent: with every 12 steps the exposure is doubled. A filter pack is used to bring the exposure into the range required for the type of printing stock being used. The trim setting, ranging between 1 and 24, is used for day-to-day control of printer balance, compensating for overall changes in stock and process, while the grading lights, between 1 and 51, are chosen by the grader or timer, using a colour analyser, to suit the particular negative scene. The actual opening of any valve is determined by adding trim and grading light together.

The light vanes change automatically for each scene as the negative passes through the printer, triggered by a list of Frame Count Cues (FCCs) marking each scene change. Mechanical light vanes take a few milliseconds to move from one setting to the next. A big light change may cause a coloured flash at the top of the first frame of the new scene. This is more critical in anamorphic images, where the frame line is very narrow, but is often not noticed in cinema prints and is only detected during critical frame-by-frame QC checks of a telecine transfer from the print or IP. Faster light vane mechanisms have become available which, together with slower printing, reduce this 'light vane drag', but it can never be reduced to less than the height of the printer gate. Fully balanced duplicate negatives require little or no scene-to-scene correction and so can be printed at much higher speeds.

Many laboratories still use the simple and robust system of punched paper tape to load RGB and FCC data between colour analyser and printer. Others use a local area network, often combining grading data transfer with production control systems to monitor the throughput of work.

Printer control
The colour analyser is calibrated so that the controls exactly match the effect of the printer light vanes. However, overall control of the printer line-up is still critical, and the lab must carry out regular tests to maintain consistent overall results from day to day. Many labs cut a few frames of their reference LAD or chinagirl into all negatives. So long as the printed densities of this test remain within tolerance, the colour of the prints should accurately reflect the grader's choices.

See also page 42

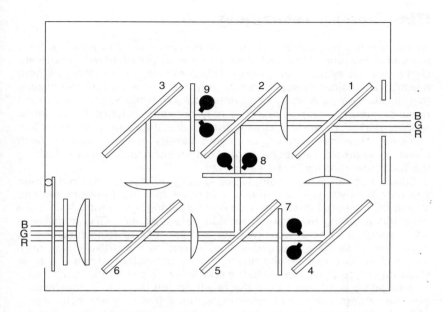

Dichroic	Reflects	Transmits
1	Red	Green and Blue
2	Green	Blue, some Red
3	Blue	Some Red and Green
4	Red	Some Green and Blue
5	Green	Red, some Blue
6	Blue	Red and Green
Light valve	Controls	
7	Red	
8	Green	
9	Blue	

COLOUR CONTROL IN PRINTERS

The additive light head uses a system of dichroics (1–6) so that separated red, green and blue light beams can be controlled individually by light vanes (7–9).

Film Grading Techniques

Negative must be graded – or colour corrected – prior to printing, for a number of reasons. Variations in exposure and lighting between different shots must be evened out, to provide a continuity of colour throughout a scene. The colour of some objects may need to be reproduced exactly (e.g. product or pack shots in commercials). And the appropriate mood must be created – for example, a rosy or warm balance for romantic scenes, darker for stormy effects and so on. Unlike grading for video, however, only the overall balance and density can be changed; flesh tones, for example, cannot be singled out for correction without affecting the background tones in the same way.

Colour correction is accomplished during printing as the red, green and blue light vanes in the printer's additive light head are opened and closed by fractional amounts. These vane settings, or printer lights, are determined during the grading session before printing. The negative is run through a video colour analyser, similar to a telecine machine, in which the negative is scanned and converted to a positive image on a TV monitor. Controls on the analyser vary the colour of the image in steps that correspond exactly to the light vanes in the printer. Each scene in a negative is adjusted until the result on the monitor is satisfactory, and the settings are stored, together with the frame (frame count cue – FCC) at which the scene starts. These data are used in the printer at the time of printing, and may be fed in as a computer file, or more often in a standard punched paper tape format.

If a negative is overexposed by one stop in the camera, the negative will require a grading correction of approximately +7 lights to produce a corrected print. Negatives that are over- or underexposed by up to two stops will thus print at lights in the approximate range 10R, 10G, 10B to 40R, 40G, 40B. Of course, grading cannot entirely compensate for underexposed negative, and some shadow detail will be lost, however much the print is lightened.

A change of one point of colour will result in an only just perceptible shift in colour in the print, sometimes more noticeable in scenes with greys and muted colours. Normal laboratory printer and process control limits variations to one point either way. It should also be noted that projectors can vary by the equivalent of two or three points of print density within the published standards for screen brightness – and often by considerably more in practice! If you plan to check your answer print in a commercial theatre it is important to check that the screen brightness is correct before you pass judgement on the grading.

See also pages 42, 192.

PUNCH PAPER TAPE

(1) Colour grading data for each scene are entered as a series of three coded numbers for red, green and blue light vane settings. (2) Frame count cue (FCC) data are entered as a six-digit binary coded decimal number, representing a frame count between 000001 and 999999 frames. In the foot-and-frame system, four digits represent feet, the last two frames (e.g 123412 represents 1234 ft, 12 frames).

. . . to interpret the director's ideas.

Film Grading for Answer Print

Unlike telecine or video grading where the final result is a video image which can be seen directly on a video monitor, the final result of film grading – a film print – can only be simulated on the monitor of the colour analyser. There are inevitable differences between film and video images (since monitors show much less contrast, and TV phosphors only roughly match film dye characteristics), and so many laboratories discourage the 'group grading' sessions that often occur in video post production, preferring to leave a film grader, experienced with the particular equipment, to work alone.

On simple productions, the graders will often simply use their own judgement as to the colour for each sequence. Often, however, the director, or director of photography, will supply instructions, or grading notes. If there is a cut work print this may be screened, with the grader noting the directors' comments. Where the work print was graded, these grading values must then be recovered and used as a starting point for corrections: some negative matching computer software can track these grading data through the editing stages. Where there is only a video edit available, there is no real reference point, and the grader's judgement and understanding of the film becomes more critical.

Grading corrections

At the first answer print screening, there may be some shots which need further grading. Because grading corrections actually work in reverse (adding green points actually makes the next print less green), instructions must be clear and unambiguous, and should describe the desired result in basic colour terms. Avoid 'take two greens out', which could be interpreted as more green or less green. 'Make this sequence bluer' is preferable to 'make this sequence cooler', which could mean more cyan or blue. 'That shot must be much darker' is better than 'that shot is too hot', which could mean it is too red, yellow or too light.

Where an interpos is to be made before an answer print (e.g. for a Super 16 to 35 mm blow-up), it is still important to see a print and to approve the grading before making the interpos. It is sensible to check for any miscuts or damaged film before incurring the expense of an interpos. Furthermore, it is important that the grading used to make the interpos is as accurate as possible: any errors will result in light changes being needed in the duplicate negative stage, and may also compromise the quality of the dupe.

This also applies to individual scenes, which must be graded accurately before making an interpos for optical effects or title backgrounds.

See also page 154.

```
-------------------------------------------------------------------------
  Version          :  1
  Film Format      :  35mm 4 perf
  Roll Length      :  355:07 Feet/Frames
  Current Grade    :  01 Jun 1996
  First Regrade    :
  Second Regrade   :
  Notes            :  VARIAN'S RAINBOW
-------------------------------------------------------------------------
```

Event	Cue_Ft	Len Ft	Red	Grn	Blu	Description
0001	0:00	51:01	28	34	34	startup leader
0002	51:01	7:08	26	32	32	chinagirl
0003	58:09	7:11	27	35	34	w/s hills
0004	66:04	9:05	26	33	33	car
0005	75:09	61:05	36	38	27	man on road/titles
0006	136:14	43:12	25	29	30	clouds
0007	180:10	27:00	27	32	32	rainbow
0008	207:10	68:01	25	32	31	w/s hills
0009	275:11	57:03	37	41	29	rainbow/titles
0010	332:14	22:09	30	30	25	int. bar

FILM GRADING

Colour grading records show red, green and blue printing lights for each scene
in the negative, together with the frame count where the scene starts. Descriptive
notes may be used to help identify shots for correction.

First, get the grey card right, then the rest of the scene will follow.

LAD Exposure and Grading Line-up

Film exposure is controlled through every stage of the process – from camera, through duplication to the final print, using density readings from an 18 per cent grey card or patch on the film. Densities for each stock type are adjusted to match aim values published by Eastman Kodak in their LAD or Laboratory Aim Density system.

LAD values for original negative are 0.80R, 1.20G and 1.60B. A correctly exposed 18 per cent grey card will have a negative density similar to these figures (typically within ±0.10 for each colour), although the values will vary for every different type of negative stock. (Most modern stocks are higher in the green density.) An exposure increase of one stop would produce densities about 0.17 higher in each colour. By shooting a range of exposures and having the 18 per cent grey card densities read, it is possible to find the best exposure rating for any given film stock.

Labs that base their printer line-ups on LAD values would print a negative with density 0.80R, 1.20G, 1.60B at printer lights close to 25, 25, 25, and produce a print with the grey card having a density around 1.09R, 1.06G, 1.03B, the standard LAD print densities. (These readings correspond to a neutral mid-grey tone.) Because the various types of negative have different density readings for an 18 per cent grey card, the same scene shot on different types of negative stock will require a different printing light to produce the same result.

Day-to-day variations in the printer lamp and print emulsion, as well as between printers, are then regularly adjusted with printer trim settings, so that the same grading lights will always produce the same printed result, regardless of printer, print emulsion or time.

In practice, different laboratories may have chosen slightly different negatives as their standard, and so negative grading data from one laboratory will not apply without correction in another laboratory. Ideal negative densities have changed with emulsion improvements over a number of years, but grading standards are not easily altered, as the lab's entire back collection of negatives would require grading correction if the reference point were to be changed. As a result, any given negative is likely to require different grading lights at different labs.

Nevertheless, a well-exposed negative should print in the middle of the 1–50 light range, typically between 25R, 25G, 25B and 30R, 30G, 30B, in any lab.

Non-standard techniques such as over- or underexposing, push or pull processing, bleach bypass or cross-processing, or simply the use of filtration, can all be controlled in an objective way by reference to an 18 per cent grey card. Provided the grey card is graded and printed to produce the standard LAD in the print, the effect of the special technique can be most accurately judged or compared with other tests.

See also page 92.

CHINAGIRL OR LAD
A lab standard test frame or chinagirl usually includes an LAD (18 per cent grey) square as well as a full grey scale and flesh tones.

Film Cleaning

Possibly the commonest technical problem with both film prints and with telecine transfers is 'sparkle'. White spots on the image may be caused by dirt on the negative, or by 'cinches' or abrasion marks. Dirt may be loose or stuck on to the negative, and may have arrived during camera exposure, processing, printing or telecine transfer itself, or any of the intervening winding and handling operations. Dirt may originate as: airborne particles carried through drying, ventilating or air conditioning systems (or even through compressed air lines intended to clean the film!); fibres from clothing or skin; from wear and tear on moving parts in any of the machines involved; or even as fragments of the negative itself due to excessive friction on an edge or surface.

Negative is normally ultrasonically cleaned immediately prior to printing or transfer: however, this does not remove dirt that is firmly stuck into the emulsion, nor does it remove scratches or cinch marks.

Particle transfer rollers

Particle transfer rollers (PTRs) have a soft polyurethane coating which picks up loose particles from the film's surface. The rollers are cleaned regularly with a damp sponge, or by dabbing with adhesive tape. PTRs may be fitted to the feed paths of printers, projectors and telecine machines. Simple and effective as they are, however, they are not effective in removing fingermarks or other greasy marks.

Ultrasonic cleaners

Negatives must be cleaned immediately before printing or telecine. In addition, if a negative is stored uncleaned, then over time the dirt will become pressed in to the relatively soft emulsion. It must therefore be cleaned after any handling operation (e.g. negative cutting, grading).

In ultrasonic cleaners, the film is passed through a heated solvent in a tank fitted with a high-frequency transducer or vibrator. This removes loose dirt and greasy materials. The film is subsequently dried by hot air jets, which blow most of the solvent off and evaporate the rest. It is important for the drying system to be maintained carefully: if excessive evaporation chills the film, water condensation from the atmosphere can permanently damage the emulsion surface of the negative with a streaky mark. Some ultrasonic cleaners are fitted with rotating buffer rollers, which remove more stubborn particles, and wiper blades that help to remove surface fluid prior to drying.

For many years the standard solvent for cleaning film was 1,1, 1-trichloroethane. However, having been identified as a significant ozone depletant, this chemical is no longer manufactured. The closest equivalent, perchlorethylene, has toxic fumes, and appropriate vapour-containment systems have been fitted to overcome any danger. (This, incidentally, reduces the wastage of fluid by evaporation.) Nevertheless, perchlorethylene is now also very tightly controlled in some countries. Other solvents are being sought, but most are considerably more costly.

Both negatives and prints may be cleaned ultrasonically. However, as prints are usually considerably dirtier after projection and handling, the cleaning solution should be changed before attempting to clean negatives.

Some manufacturers have developed aqueous cleaners as an alternative to organic solvents. The emulsion is wet for just fractions of a second, so that water has little time to soak into the emulsion. The film is dried by microwave or RF heating.

ULTRASONIC CLEANING
All negative should be cleaned prior to printing. In the ultrasonic cleaner, a high-frequency vibrator loosens dirt, grease, etc. from the film. Trichloroethane is no longer used as it damages the ozone layer.

Try cleaning the film before attempting electronic cures.

Clean-up Processes

Rewashing
Light emulsion scratches, as well as some stuck-in dirt, can be removed by running the negative through the processing machine a second time (or through a dedicated 'rewash' solution). This causes the emulsion to swell up and heal the abrasion. There are limitations: deep scratches that have fogged or removed a dye layer cannot be removed, and of course if the processing machine was the source of the original damage or dirt then there is a possibility that a second pass may repeat the damage.

Hand cleaning
In some instances where dirt particles have become embedded into the film surface too firmly for ultrasonic cleaners to be effective, skilled lab technicians may resort to winding the negative through a clean velvet cloth soaked in an appropriate solvent. Do not try this at home! This is a skilled operation, and errors such as winding too quickly, or using the wrong chemical, can result in severe and permanent damage to the negative.

Spotting
Individual spots of dirt may be located by viewing a print, and removed one at a time from the negative using cotton buds with a suitable solvent (mainly as a lubricant to prevent scratching). Film cleaning fluid (e.g. perchlorethylene) is the most reliable liquid, but the fumes must be avoided. Isopropyl alcohol is a safer alternative. Acetone may remove cement smudges from the emulsion, but dissolves acetate film base, so must never be used on that side. Methanol may be used with care on the emulsion, although it tends to absorb water during evaporation, causing the emulsion to swell and scar. Water may be effective on the base (but never on the emulsion). Any solvent should be used with due care and attention to health and safety. Owing to the fragile nature of the negative, attempts to clean more than a few spots by hand often damage the negative more than it was before. It is important to remember that while most negative remains impeccably clean throughout the various processes, dirt and other problems will occasionally occur in even the best production facilities.

Electronic solutions
If these methods fail to remove the sparkle problem, it can often be minimized by electronic means. Aperture correction or edge enhancement modifies the image slightly to give the appearance of finer detail and sharper edges, but has the effect of enhancing unwanted fine detail such as white spots. It can sometimes be reduced enough to suppress very small white dots with only minimal effect on the image itself. Many digital colour correctors have a 'grain remover' which softens the image very slightly overall, but suppresses apparently random fine patterns such as grain and dirt. A more powerful digital dirt remover (or 'dustbuster') compares images frame by frame and identifies small single-frame spots

as unwanted dirt, eliminating them by replacing them with the corresponding pixels from an adjacent frame. This technique can, however, occasionally eliminate intentional images such as firework displays or showers of sparks. Larger spots of dirt can be painted out one at a time in a digital editing or graphics suite. These methods, of increasing time and cost, may be convenient for a video finish, but are entirely unsuitable for a film-finish production, as the dirt remains on the original negative.

Film-finish productions that are going through the digital intermediate process may, however, be spotted digitally as part of this process and of course, individual shots that are damaged by dirt may be scanned for digital repair and then recorded back out to film.

PARTICLE TRANSFER ROLLERS
PTRs may be fitted to most film winding mechanisms: a portable bracket with a pair of rollers for each surface of the film may simply be placed between bench rewinders.

Make scratched film look as good as new.

Wet Gate Printing

Inevitably, film negative will pick up a number of fine 'cinches' or abrasion marks during handling, winding, negative cutting, etc. Occasionally, there is greater damage, and larger scratches may occur. These surface marks deflect light as it passes through the film, resulting in white marks on the print. Wet gate or liquid gate printers work by immersing the negative in a fluid – perchlorethylene – with the same refractive index as film base, thereby eliminating the light scatter and making the marks invisible.

In contact wet gate printing, the entire printing gate area is immersed in fluid, which also aids in smooth contact between the film layers. This can often give a slightly sharper image as well as a cleaner one. Optical projection wet gates enclose the negative in a glass 'sandwich' similar to a glass slide mount, filled with fluid. If any dust, splashes or streaks landed on the outer glass surfaces, they would appear as fixed marks on the film print. The glass panes are several millimetres thick to throw any such blemishes out of focus.

While wet gate printing is the standard way of printing final cut negatives for the cleanest result, it is not used universally. Not only are wet gate printers slower than normal contact printers, the need for cleaning and re-drying the negative after wet printing further adds to the number of hazardous processes the film goes through. Minute amounts of plasticizer are dissolved from the film base by wet gate fluid, and the fluid itself must therefore be replaced from time to time. Perhaps more importantly, indiscriminate wet gate printing of original camera negative may hide defects (such as camera or processor scratches), which need to be noticed and rectified. Typically, final cut negatives (particularly 16 mm) are wet gate printed, both for answer print and duplication, but work prints and release prints from duplicate negatives (which, uncut, have received less handling) are normally printed dry.

Limitations of wet gate printing
Wet gate printing will hide quite alarming cell-side scratches and even fine emulsion scratches very successfully. However, it cannot hide emulsion scratches which have either led to pressure-fogging (before development) or have removed emulsion or dye layer (before or after processing). These coloured marks can only be dealt with by optical printing or digital effects.

Fine showers of particulate dirt on the surface of the negative can sometimes resemble cinch marks when the negative is printed. However, wet gate printing cannot redirect light through opaque particles, and only thorough cleaning of the negative will remedy this defect.

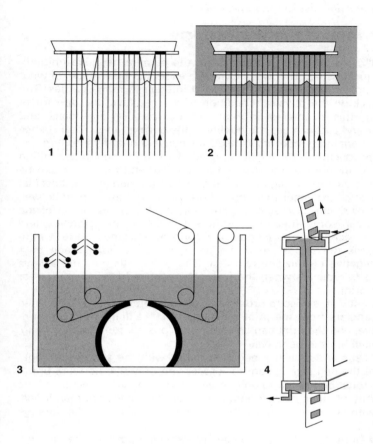

WET GATE PRINTING
(1) Scratches cause light to refract, leading to unexposed shadows on the raw stock. (2) Light passing from wet gate fluid to film base is unaffected by refraction, making scratches invisible. (3) In contact printers, the entire printing area is submerged in fluid. (4) Optical printers sandwich the film in a thin layer of fluid between glass plates.

The work print is the first and best check of what was shot.

Work Prints: Negative Reports

Traditionally, a work print is made from the camera negative immediately after processing. This work print serves as the first check on what is actually on the negative, and is of vital interest to many parties. The lab can check on the physical condition of the negative, the director of photography has an interest in exposure, composition and focus, and the director and cast can see the quality of the performance. After rushes or dailies screenings, the print is used for conventional film editing.

When a production is to be edited on videotape or on non-linear editing systems, a work print is not required for editing, and the image can be transferred to the tape or digital format directly from negative by telecine. However, not all the other functions of the work print are served as well by a video or digitized image. In particular, the lower resolution of the tape image can sometimes hide indifferent focus or fine scratches, and the different techniques of colour correction on telecines make it difficult to assess the exposure of the negative. Corrections made to a 'difficult' negative on telecine to match it to other rolls may not always be possible to replicate when the final cut negative is being graded for an answer print.

Consequently, it is wise to order work prints even for a non-linear edit. Telecine transfers from the print reduce the risk of damage to the original negative, and the print can be used for a 'pos conform' after editing, prior to matching the negative.

The lab usually supplies a negative report with the processed negative. Where the negative is sent for processing only (i.e. no work print), this report must be limited to an overall cursory bench inspection of the negative. Any obvious edge fogging or severe scratches are mentioned, together with a simple log of the number of rolls and the footage processed.

If a work print is made, the lab usually screens the print (often at high speed) and is able to report on many other details. These may include:

- printing lights used (if the print was graded, this gives an idea of any exposure variations);
- any focus problems, dirt in the gate, unsteadiness or flicker;
- scratches (not always visible in the negative);
- negative dirt, print dirt and whether it can be cured;
- any other processing or printing problems.

Lab reports should describe the scale of any problem (e.g. whether a flicker is a minor irritation or a certain reshoot). Minor problems should be noted to avoid repercussions later on. However, the report 'all OK', particularly on a 'process only' production, may simply mean that the lab could not see any physical problems. It is important for the post production team to check all processed work as soon as possible.

See also pages 32, 94.

876 Production Avenue (PO Box 932) Movietown NSW 2901 Australia Telephone: (02) 9473 2654 Fax: (02) 9473 2902

any lab
AUSTRALIA

NEGATIVE REPORT SHEET

PRODUCTION COMPANY

ORDER NUMBER

DATE

PRODUCTION

ANYLAB ID

ORIGINAL NEGATIVE REPORT

ROLL NUMBERS

EMULSION

COMMENTS

SIGNATURE

EDGE NUMBER INFORMATION

RUSHES REPORT

PROCESSED	NORMAL	FORCED
PRINTED	BASIC PACK	ONE LT. GRADE
LIGHTS		
COLOUR		
EXPOSURE		
FOCUS		TICKED IF OK OTHERWISE SEE REPORT
EDGE No's		

SCENE	TAKE	COMMENTS

NEGATIVE REPORTS

The lab supplies reports immedately after negative is processed. Negative reports simply detail what film has been processed: where a work print is ordered, comments on exposure, focus, etc. can be included.

Print only what you want, the way you want it.

Work Prints: Selecting and Screening

Selected takes
In any camera roll, many takes will never be used, and it is common for the lab to remove these takes before the work print is made. 'OK' or 'Print' takes should be indicated on the camera sheet by the camera assistant. Typically, about one-third of work printing costs can be saved this way, although there is a charge for removing 'NG' takes or out-takes. Sixteen millimetre negative is usually printed uncut: any handling marks are proportionally larger, and the savings in print costs are often outweighed by the extra charges.

'One-light' or graded work prints
Laboratories usually have a standard printing light, which will give a good, neutral print from correctly exposed negative. This printing light may vary slightly for different types of negative stock. 'One-light' work prints make no attempt to compensate for exposure or colour variations. This has the advantage that the cinematographer can very easily pick up any errors, and also that any deliberate filter or lighting effects are retained in the work print and not cancelled out by an over-zealous grader. On longer productions it is common to shoot tests and arrive at a specific printing light that suits the director of photography's exposure style.

Alternatively, the lab may print each roll of negative at a single grade based on the first couple of shots. Where lighting conditions vary (or where the negative process varies slightly from day to day), this may produce more consistent results. The lab report will show the grading lights used, which should give an indication of any exposure variations encountered. A difference of seven to eight printer lights (in all colours) is equivalent to one camera stop. However, while major variations in the negative may be graded out day to day, it may prove difficult to match shots from different rolls later when the answer print is graded.

Fully graded work prints show the best possible results. However, both one-light graded and fully graded work prints take longer in the lab, and generally cost substantially more than one-light standard prints.

Grey-scale cards
Cinematographers often shoot a grey card (18 per cent) at the start of each lighting set-up, to give the rushes grader an objective scale for reference. If this is graded to a neutral mid-grey, the subsequent scene should follow correctly. Note, however, that if filtered lights or any other special lighting technique is being used for a special effect, the grey card should still be shot with normal lighting: otherwise, the effect will be cancelled out in the print when the grey card is graded back to normal.

See also page 82.

EDITOR'S COPY

ACCOUNTS COPY

PRODUCTION OFFICE COPY

CAMERA DEPT COPY

LABORATORY COPY

876 Production Avenue (PO Box 932) Movietown NSW 2901 Australia Telephone: (02) 9473 2654 Fax: (02) 9473 2902

any lab
AUSTRALIA

CAMERA SHEET

ANYLAB SHEET No

SHEET SEQUENCE
FROM SHEETNo | TYPE SHEETNo | DEPT SHEETNo

PRODUCTION COMPANY	DATE
PRODUCTION	CAMERA
STUDIOS/LOCATION	STOCK NUMBER
	EMULSION
CAMERAPERSON	ROLL NUMBER
CAMERA OPERATOR	

MAG. NUMBER	ROLL NUMBER	SLATE NUMBER	TAKE NUMBER	COUNTER READING	TAKE LENGTH	P FOR PRINT	ESSENTIAL INFORMATION/GENERAL NOTES

TOTAL EXPOSED	TOTAL EXPOSED	TOTAL FTGE PREV DRAWN	
SHORT ENDS	TOTAL DEVELOPED	FOOTAGE DRN TODAY	
WASTE	TOTAL PRINTED	PREVIOUSLY EXPOSED	
FOOTAGE LOADED	HELD OR NOT SENT	EXPOSED TODAY	

FOR AND ON BEHALF OF COMPANY
SEE REVERSE REGARDING LIMITATION OF LIABILITY

CAMERA SHEETS

Camera sheets, completed by the camera assistant, show each take on the roll of negative, and include 'print' or 'no print' instructions for rushes.

Check that all's well . . . so far.

Technical Problems at Rushes

Whether a work print has been made or the negative goes straight to telecine transfer, the first viewing of the images is a vital opportunity for close inspection of the material that has been shot.

Marks seen at the telecine transfer, or when screening prints, may be on the negative (or the print), or may occasionally be due to problems on the telecine or projector itself. Viewing the image on telecine or projector should be followed by a careful examination of the negative itself on a rewind bench. Remember that marks on the negative appear the opposite colour in a print or on telecine – e.g. a blue mark seen on telecine will correspond to a yellow or brown mark on the negative.

Sparkle

This refers to small but frequent white spots seen on telecine or print, due either to dirt or to cinch marks (minute scratches or rubs) on the negative.

Sparkle is often concentrated around splices or roll ends, and this may indicate careless handling, possibly when loading the camera or the processing machine, or later when the rushes rolls are being assembled. Inspection of the neg will show if it is caused by cinches or dirt stuck to the negative. Rewashing may remove most of it.

Intermittent sparkle on a print may be due to loose dust on the negative or on the print stock. Ultrasonic cleaning and reprinting or retransfer should clean this up.

Dirt embedded in the negative may have arrived during processing. However, repeated patterns of occurrence may point to certain batches of raw stock, to individual cameras or magazines (which may be scraping the edge of the negative), or to any other common factor.

Negative scratches

A perfectly straight, continuous scratch could be from the camera magazine, processing machine, ultrasonic cleaner, telecine or printer.

A pre-development emulsion scratch on the negative is usually yellow–brown, appearing blue on telecine. There may be no sign of a scratch on the surface of the film (as it has healed over). If the scratch occurs after processing and drying, there should be some trace of rough edges to the scratch, which may be blue (yellow on telecine or print) due to removal of the top yellow dye layer, or may have no colour. Cell scratches appear white when printed or on telecine.

Rewashing the negative may cure light emulsion scratches if they have not reached the dye layers, but will not improve a cell scratch.

Comparing other negative rolls or extracted out-takes may indicate common factors or a repeating pattern. For example, a scratch common to rolls from different productions is most likely to be a lab or telecine problem. A scratch running between two camera stops is unlikely to be caused by the lab. If the scratch runs over a splice into the leader, it cannot be a camera scratch. Look for where the scratch starts or ends: it may correspond to lace-up over a particular roller or gate on telecine, or a synchronizer, printer or other device.

A regular frame scratch (same place in every frame) is almost certainly caused in the camera gate or elsewhere within the camera.

'Green' negative
Film emulsion is still relatively soft and slightly swollen (green) for the first few hours after processing, and must be handled with extra care. Slight rough edges on rollers or guides may be safe for seasoned film, but still damage green negative. Despite the term 'green', there is no colour shift as film hardens.

Positive scratches
Scratches in a print usually appear black (cell side) or green (emulsion). Continuous lines may be from printing or processing, or the projector, before the gate loop. A frame-repeat scratch is likely to come from the projector gate. A scratch in a work print is most unlikely to imply any damage to the negative.

A continuous minus-density line (known as a D-line) is caused by dirt in the printer gate.

Fogging
Light fogging in the negative shows as a white, yellow or orange, or sometimes blue, area on the print, and the opposite colour on the negative. Edge fogging is usually due to the roll of negative being exposed to white light while in roll form.

A regular pattern may be caused by a small patch of fog on one section of the roll: the distance between repeats indicates the circumference of the roll, and may show whether fogging occurred before or after exposure in the camera.

A light leak in the camera or magazine can sometimes cause a short burst of fog a few frames after each camera stop, when the neg is at rest for long enough to fog. With some cameras, an intermittent grey 'veil' over the image may be caused by light spilling through the reflex viewfinder onto the image, varying as the operator's eye moves away from the viewfinder.

An overall grey veil, sometimes pulsing with each turn of the negative roll, could be X-ray fog. A single airport X-ray scan is usually safe, but the effect is cumulative, and high-speed negative is much more sensitive to X-rays as well as to visible light.

There is no cure for any form of fogging: it becomes a part of the image.

Old negative stock
High-speed stock has a shorter shelf-life than normal. All stocks deteriorate if stored warm, or if subjected to heat or frequent changes of temperature. The effect is high base fog, leading to washy shadows and increase in graininess.

See also page 32.

A unique number for every frame of film.

Negative Matching

Keykodes

Printed into the edge of negative film is a series of running numbers: in 35 mm they appear every foot (16 frames), in 16 mm they are every six inches (20 frames). As the numbers increase by one each time, they can be used to uniquely identify any frame within the production. The numbers also include an alpha prefix, which identifies the type of emulsion, and a roll number. Alongside every edge number is a corresponding machine-readable barcode. These edge numbers (or Keykode) are exposed into the negative raw stock during manufacture: they do not become visible until the negative is processed.

A Keykode reader can read the barcode as the film is passed through a bench rewinder. The values are passed to specialized computer programs to build a database of all the negative used in a production. The edge numbers are printed through onto the work print, so that when editing is complete, the negative matcher can identify each shot in the cutting copy and locate the corresponding frames of negative.

Some care must be taken in the lab that the edge number printing exposure is correct: over- or underexposure makes the barcode unreadable. Some barcode readers can be adjusted to some extent for sensitivity, but unreadable edge numbers render a work print useless.

Where editing has been on a non-linear or tape-to-tape system, the video frames are identified by timecode, laid down on the videotape during telecine transfer. A Keykode reader may be fitted to the telecine, but many negative matchers prefer to complete the logging themselves, so as to confirm the accuracy of the data. The computer system correlates the video timecodes in the Edit Decision List (EDL) back to Keykodes for the corresponding film frames.

Offset frames

A small dot is printed between the edge number and the barcode. The frame adjacent to this dot is taken as the 'zero frame' and is designated by the exact edge number. Any other frame has a positive or negative offset (e.g. KA27 1234 5678 + 04). In some cases, the first frame of a shot is counted back (negative offset) from the first edge number within the shot, while the end of the shot is a positive offset from the last edge number in the shot: 5678 + 04 is exactly the same as 5679 − 12 in 35 mm (16 frames per number). Some systems use only positive offsets.

Edge numbers normally increase in the direction towards the tail end of a roll. However, if camera negative has been rewound before use (e.g. to break it down into smaller rolls), the edge numbers appear on the opposite edge of the film, and decrease towards the tail. This can cause confusion, as not all computer logging systems are well equipped for this (either for the reader position or for the reversed counting). Any rewound stock should therefore be double wound before use.

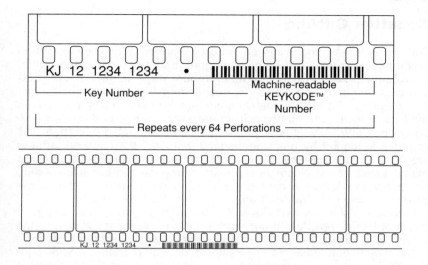

EASTMAN KEYKODE™ Numbers Imformation

| 0 2 | 9 6 | 2 3 | 1 2 | 3 4 | 5 6 | 7 7 | 0 0 |

Start Character | Mfg. I.D. Code | Film Type | Prefix | Count | Offset in Perfs | Check Sum | Stop Character

Encoded in USS-128 Barcode

MACHINE-READABLE EDGE NUMBERS

Keykode includes human-readable numbers as well as machine-readable barcode numbers. The exact number, with zero frame offset, refers to the frame alongside the dot between the two codes.

Copying the editor's final decisions.

Negative Cutting

Traditional film editing is carried out on a work print: as soon as cutting is complete and final, the edited work print is sent to the negative cutter, who identifies each shot by its printed-through edge number, then selects and cuts together the precisely corresponding frames of original negative. Logging of original negative edge numbers and searching through the lists to locate the numbers from each shot in the work print, previously done manually, is now generally a computer-aided operation. The negative is logged by machine-readable barcode; the cut work print is logged in the same way, by winding the print through a reader and marking each splice. Negative and work print edge number lists are then compared to produce a cutting list, guiding the negative cutter to the correct camera roll, and the frames required from each camera take.

Precise matching is aided by assembling the negative in a dual-gang synchronizer alongside the cut work print, and visually comparing the action, edge codes and other marks on the negative and work print.

Off-line or non-linear editing systems do not produce a work print directly. The edit is represented by an Edit Decision List (EDL), denoting the beginning and end of each edit by timecodes rather than edge numbers. Provided that the negative matcher has logged the original camera negative complete with the timecodes laid down at the telecine transfer session, computer software can convert the EDL timecodes to corresponding Keykodes, and once again locate the required frames within the logged original negative. Many non-linear systems can also be used to produce an edge number cutting list directly, provided the original negative Keykodes have been logged into the system.

This method, although seemingly very efficient, is approached with great caution by many negative cutters. Unfortunately, negative, once cut, cannot be rejoined invisibly: at least one frame is lost in the process. Cutting errors therefore are difficult to fix.

A more reliable alternative is available when work prints have been made from the original negative. In this case, the work print (with printed-through edge numbers from the negative) is cut to match the EDL. Only when this assembled work print has been screened and checked for accuracy will the negative be cut, this time in the traditional method by matching it to the cut work print.

See also pages 180, 182.

Standard editor's marks

1 Fade out Fade in

Head

2 Dissolve (effectively, a fade-in superimposed on a fade-out)

3 Superimposition

4 Wipe

5 Unintentional splice

6 Build-up within a shot Black leader

7 Extended scene with Build-up at the cut Black leader

Cut

8 Intentional jump cut

or J | C or both J ——►|◄—— C

9 Synchronization (sync) marks

(i) Picture ——⋈—— (ii) Sound ——|| ——

10 Cue marks

(i) Dubbing ⋈ (ii) Rushes ⋈——

MARKING UP WORK PRINTS

Standardized marks simplify the editor's work and ensure that the negative matcher understands the exact requirements.

Plan your cut so you have the right information.

Preparing for Negative Cutting

Before starting the production, it is important to discuss the negative cut with the negative matcher. Various alternatives are available, usually following the principle that the safer and more accurate methods are more expensive.

Traditional sprocket edit
Following the traditional method of editing a work print is the simplest of all, as the neg matcher simply cuts the negative to match the work print, guided by edge numbers. Negative matching costs are less expensive, but this is outweighed by the cost of the work print, and the actual edit is slower and less flexible than a non-linear edit.

Negative cut from EDL
Images are transferred from negative directly to tape, without a work print. So far as possible, image quality is checked at telecine. Following the non-linear edit, the negative matcher cuts the negative directly from the EDL. Although this saves the cost of work print and appears straightforward, the risk of cutting negative to calculated numbers, with no check, is considerable. This is a cheap, but risky, method.

Pos conform
While many of the early problems with non-linear systems, edge number logging and list conversions have been resolved, the consequences of a mis-cut or sync failure in original negative remain just as great. Several techniques have been devised to revert to the benefits of a cut work print, using the technique known as 'pos conforming'. Generally, select negative shots are extracted and a mute print made. By then logging the Keykodes on the mute print, the exact location of each shot in the EDL is traced, and a 'pos conform' can be made. This is effectively a final cut work print, using the EDL to copy the editor's decisions on a print. It can be used as a check that the shots have been cut in exact sync, and for test screenings (with a temporary or 'rough' sound mix). Following approval, the cut work print is used as a template for traditional negative matching.

The pos conform method can be applied in various ways.

Print rushes, EDL and pos conform
This method retains the advantages of both previous alternatives. Rushes are printed in the traditional way and transferred to tape, for non-linear editing. The rushes work print is then rubber numbered. (These numbers can also be entered into the neg matching logs along with telecine timecode.) Following editing, the negative cutter (or an editing assistant) cuts the print to the EDL (pos conform). The cut print is available for test screening, etc. When approved, the neg cutter matches the negative to the pos conform print in the traditional way.

This method minimizes negative handling (no negative telecine) and provides a safety check for the negative cutter. It is perhaps the most expensive.

100

Select takes pos conform

As in the second method, images are transferred from negative directly to tape, without a work print. However, the EDL is used to select full takes of negative for each shot required. These are printed and conformed to the EDL (either by the neg matcher or assistant editor). Following approval, the negative may be cut to match the pos conform print. Typically, 30–40 per cent of negative will be extracted for printing: this saves half the cost of rushes work prints but misses the advantage of seeing film-printed rushes at production time.

Greater economy is achieved by cutting and printing negative with 10-frame or longer 'bumpers' or 'handles' at each end, instead of full takes. This allows a margin for error in case the edit has to be adjusted by a few frames. However, there is a chance of cutting into action that may be required elsewhere in the film, or in a re-edited version.

Never ever forget that negative cutting and, to a great extent, negative splicing are irreversible processes. Once a cut or splice is made in a negative, it cannot be uncut, and at least one frame must be lost.

A mixed method

When cutting negative from an EDL, some negative matchers make up a template from film spacing, with the start and finish edge numbers of each shot written in, as a guide when splicing shots together and to check that the calculated shot lengths fit. If the cost of work printing for a pos conform is prohibitive for a low-budget production, a few shots only can be printed and these will be cut in to the dummy template, which may then be run in sync with the soundtrack. If shots near the start and end of each roll appear in sync, there is a good chance that the rest of the reel will work as well.

See also pages 116, 176.

Cutting to an EDL

An Edit Decision List, or EDL, shows, for each shot, the source reel time-codes, indicating where the scene is to come from, and also the record reel timecodes, indicating where the shot is to be placed in the edited master tape. Each event on the EDL also shows the source reel number, whether the edit is image, sound or both, and the style and duration of any transitional effects such as wipes or fades.

Provided a log has been created at telecine transfer to relate video timecode to film Keykode edge numbers, computer systems can convert the EDL back to film Keykodes. The converted list corresponds exactly in function to a logged cut work print.

EDLs often include traces of complex stages of editing from assembled sub masters. These must all be cleaned from the EDL before attempting to convert it to an edge number cutting list. In particular, events in the EDL need to be strictly in record sequence, and with no gaps or overlaps. Audio events should be removed, and even simple shot extensions should be converted to a single event to avoid the risk of false cutting of the film. Because negative cutting is simply assembling shots in the right sequence, the only transitions that can be handled are straight cuts, or fades and dissolves. Any other effects, as well as speed-shifted events, need to be identified and dealt with separately as film opticals or digitals well before attempting a final negative match. Descriptive notes should always be entered into the EDL following any events other than straight cuts.

Video editors can easily use the same shot, or overlapping sections of a shot, twice. For negative cutting, these repeats must be identified so that the entire take can be extracted from the original negative and dupli-cated: the dupe negative can then be used for the repeated shot.

The same timecode values may be used on more than one source reel, and the video roll number is needed to identify the correct section of negative from several with the same timecode. Many video editing systems require the video source roll number to be entered manually: if this is overlooked, the negative may not be identifiable, or the wrong negative may be cut.

Differences in terminology

In video terminology, events occur at the start of the specified frame, and the first frame is frame 0 (not 1). This differs from the normal film approach, and care must be taken. A 10-frame shot might be specified as 00:00:00:00 to 00:00:00:10. Frame :00 is the first frame included. Frame :10 is the frame *after* the last frame included. In film edge numbers, the same shot might be listed as KJ11 1234 0000 + 00 to +09. In this instance, 09 is the last frame included in the shot.

Fades and dissolves are indicated in EDLs at the frame where the effect starts: in a marked-up work print, scenes are joined at the middle of a dissolve, not at the start.

While most computer negative matching systems address most of these problems, they do not all report in exactly the same way. Great care must be taken.

See also pages 24, 174, 176.

```
TITLE:   neg1B     FORMAT:  CMX 340  2—CHANNEL
FCM:  DROP FROME
001   055   V   C   15:03:22:12   15:03:28:15   01:01:30:00   01:01:36:03
002   055   V   C   15:07:12:03   15:07:20:22   01:01:36:03   01:01;44:22
003   056   V   C   16:11:09:09   16:11:16:15   01:01:44:22   01:01:52:03
004   055   V   C   15:03:33:01   15:03:37:22   01:01:52:03   01:01:56:24
005   055   V   C   15:03:41:04   15:03:48:15   01:01:56:24   01:02:04:10
006   056   V   C   16:11:23:23   16:11:31:24   01:02:04:10   01:02:12:11
007   056   V   C   16:12:02:03   16:12:09:21   01:02:12:11   01:02:20:04
 |     |    |   |       |             |             |             |
evt   reel vid cut  source in     source out    record in     record out

1
```

```
12:42:46        Excalibur II  Filmlab Systems Ltd  1995   27/06/1996
C:/EXCALII/USER0004/P0000137/P0000137
- - - - - - - - - - - - - - - - - - - - -CUTTING LIST- - - - - - - - - - - - - - - - - - - - -
Production          TO CATCH A CHICKEN        Job Number 137
Notes
Date Started             12/01/1996        Page 001
- - - - - - - - - - - - - - - - - - - - - - - - - - - - - - - - - - - - - - - - - - - -
                              Can Order
                      Cutting Margin   0    Fine Cut
```

Neg	4								
KDL	Scene	Man	Pref	Start	End	FCC		Scene/Take	Camera
11 A	1	KX07	1311	5195—03	5206+03	0192:07	0011:07	23A 3	308
	4	KX07	1311	5215—04	5223+08	0212:06	0008:13	23A 3	308
	5	KX07	1311	5230—01	5243+11	0227:09	0013:13	26A 1	308
	2	KX07	1311	5566—04	5581+14	0538:15	0016:03	29A 1	308

Neg	5								
KDL	Scene	Man	Pref	Start	End	FCC		Scene/Take	Camera
	3	KX27	8020	3157—08	3169+15	0128:08	0013:08	23B 1	309
	6	KX27	8020	3184—06	3198+10	0155:10	0015:01	23B 1	309
	7	KX27	8020	3242—11	3255+08	0207:14	0014:04	23D 1	309

2

TIMECODES AND EDGE NUMBERS

(1) An EDL shows the source reel start and end timecodes to locate each edited scene and the record reel timecodes for where each scene is to be placed. (2) Negative matching software compares the timecodes with the negative log to convert timecodes to Keykode numbers, and can sort the shots into source reel order for convenience in locating the negative.

Select full takes of negative before attempting a frame-exact cut.

Extracting Select Negative

In one variation of post production methods for a video finish, camera negative is transferred, uncut and with minimal colour correction, to video cassette for digitizing and non-linear editing. The negative is logged by timecode and Keykode and, after editing, the resultant EDL is converted to an edge number list. However, instead of frame-exact negative cutting, negative of only the takes that were used in the final edit are extracted and assembled to a new roll.

This new roll is re-transferred, this time with full grading, to digital tape, and the programme is finally compiled in an on-line edit suite.

The timecodes in the off-line EDL refer to the original videotapes. When the 'select takes' negative has been assembled and re-transferred, there are new timecodes for the same material. It is necessary for the negative matcher to log the new select takes roll, and then use a computer system to convert the cutting list (Keykode values) back to a new EDL based on this new timecode log. This new EDL now relates to the second telecine transfer, of the selected takes roll, which will be the source for the on-line compile.

Pos conform
Takes are extracted in the same way to make work prints (where none exist) of required footage only, prior to a pos conform. The pos conform may be carried out by the negative matcher or an assistant editor.

Scanning lists
The same procedure can be used when extracting takes for digital scanning or optical effects. Instead of producing a new EDL, it is possible to generate a scanning list or an optical make-up list based on a frame count list that is traced back to the original EDL.

Lock-off and change lists
In the traditional method of editing, once a work print was locked off and in the hands of the negative matcher, it could not be changed: the editor no longer had possession of the film. This is no longer the case with non-linear systems, and there is a possibility for editors to continue to make changes after an EDL has gone to the negative cutter. Indeed, some non-linear systems produce 'change lists' which include only new or altered cuts compared with a previous list. These are most useful when re-edits are being made (using the non-linear system) after screening a cut work print or pos conform. Once the negative has been fine-cut, the only changes possible are to shorten or remove shots. Even this should be avoided, to minimize handling marks on the original negative.

See also pages 26, 190.

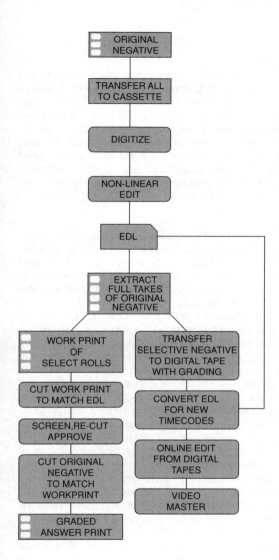

EXTRACTING SELECT NEGATIVE

Using an EDL to extract full takes of negative (flash to flash) may be used either for a positive film conform prior to final negative cutting, or for re-transferring negative prior to an on-line video finish.

Clean and careful handling of the negative is vital.

Splices

Tape splices for work prints
Work print is normally edited using a tape splicer: two pieces of film are each cut precisely in the middle of the frame line (between frames), aligned flush with each other in the splicer block and joined with adhesive tape. This produces a smooth splice which will run through sprocket machines. Importantly for editing, the splice can be taken apart, and cut film can be rejoined in its original (or any other) sequence, with no loss of film. A similar technique is used in theatres to assemble release print reels together. However, tape is quite unsuitable for negative splicing. Joins can stretch, adhesive can mark adjacent layers of film in the roll, and the edges of the tape make a white mark when printed.

Cement splices for negative
Camera negative is therefore joined with an overlapping cement splice. Each section of negative is guillotined in the splicer to provide an overlap of about 1.5 mm. The emulsion is scraped off one section, and the two sections are joined with cement. Film cement works by dissolving a layer of film base so that the two sections are welded together. Splicers are heated to promote faster setting of the join.

While this is an extremely strong and stable join, it cannot be undone without damage, so mistakes cannot easily be rectified. Furthermore, because the film sections overlap, a short fragment of film is actually lost in the process. In practice, the negative cutter makes a scissor cut in the middle of the frame beyond each end of the desired frames, so that half a frame is discarded from each end in the final splice. Thus, if one scene runs up to frame 100, frame 101 is destroyed in the process of cutting, and a later scene in the film cannot start before frame 102.

This is an important point for both film and non-linear editors to note. Cutaways or reaction shots, as well as action scenes, may often use multiple short sections from a single take. There must be an interval of one frame or more between selected cuts.

The negative is held in place in the splicer on accurately fitting register pins. On some machines the sections to be joined are located using the same pins, before trimming the ends. This ensures that both sections are joined in perfect alignment, provided there is no wear or free play in the splicer block. Other machines use different pins for each film section, and the relative position of these pins is crucial. If the two sections of negative are spliced out of alignment, the negative is likely to jump slightly as it passes through the printer, causing a disturbing jump in the image. Splicers should be inspected regularly, and a few test splices should be printed and screened to check for steadiness.

Many of these problems are avoided by use of the Hammann cutter. This makes a chamfered cut through the negative, on the frameline at an angle. A single thickness cement join can then be made without overlap and without losing any frames.

Polyester weld splices

Dupe negatives are often printed on polyester-based stock. This cannot be spliced in the same way as acetate. Instead, the splice is made using an ultrasonic welder, which melts the film base then joins the two pieces. These splices are less accurate than cement splicers, so are not suitable for picture-to-picture cuts. Polyester can only be satisfactorily joined to acetate using adhesive tape, and so optical dupes and similar material are printed onto acetate-based dupe stock.

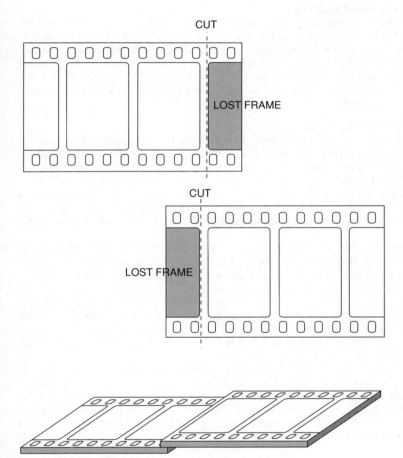

OVERLAPPING SPLICE

OVERLAPPING SPLICES
A small portion of the frame next to the cut is used for the overlapping negative splice. This frame is thereby destroyed and cannot be used elsewhere.

Alternating shots allows smoother transitions.

A- and B-Rolls

In 35 mm negative, the frameline between successive frames is wide enough to allow a cement splice without intruding into the picture area. (Anamorphic productions leave a very small frame line area, and a splicer making a narrower join must be used.) However, in 16 mm, there is no room for an overlapping splice between frames, and so a different technique is used.

Checkerboard cutting
In checkerboard cutting, alternating shots are made up into two rolls (A and B) interspaced with black spacing. The cement splice is made off-centre, so that the entire splice overlaps into the black spacing rather than into the last frame of the picture. Each roll is printed in succession onto a single roll of print stock. The black spacing in each roll blocks the printer light to allow the scenes from the other roll to be printed in the correct sequence.

Fades and dissolves
This system allows fades and dissolves to be incorporated in normal continuous printing. The tail of an outgoing scene in the A-roll is cut so as to overlap the head of the incoming scene in the B-roll by the required number of frames. During printing, the fader shutter on the printer is gradually closed as this part of the A-roll is printed. In the B-roll run the shutter, previously closed, is opened at the corresponding section, so that the image changes progressively from the A-roll scene to the B-roll scene.

Fades to black are simply a dissolve from a shot on one roll to clear negative on the other. A simple fade out on one roll with no corresponding scene faded in on the other roll appears as a fade to white.

In 35 mm, generational loss of quality is less noticeable, and so dissolves are usually printed as optical effects and the optical dupe negative cut into the original negative complete. However, negative may alternatively be spliced picture-to-picture in a single roll until a dissolve is required, at which time a B-roll is introduced. Scenes then remain on the B-roll until the next dissolve.

After the printer fader shutter has closed for a fade out or dissolve, it must be opened in time for the next scene change, or reset before starting to fade in again. After one dissolve is complete, at least four frames must pass before the next dissolve starts, or at least 20 frames before a straight cut. Faster cutting can be achieved by creating a C- and sometimes a D-roll.

Handles
Sixteen millimetre negative for blow-up may be cut in a single roll with each shot several frames overlength at head and tail. Printing on a step optical printer, these 'handles' or 'bumpers' are skipped over. This avoids printing the jumps that sometimes occur when a splice passes through the gate during printing.

See also page 116.

1

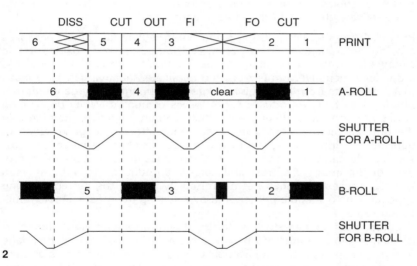

2

A- AND B-ROLL NEGATIVE CUTTING
(1) The overlapping splice extends into black spacing but not into image nega-
tive. (2) Fades and dissolves must be spaced out to allow the printer fader time
to reset. Preparatory fades take place in black spacing so that the fader is correctly
open or closed for the next scene or effect.

The original image must be duplicated for many reasons.

Laboratory Processes

Duplication

Reasons for duplication

- A final cut negative represents the entire production investment of a film. Preparation of an interpositive provides a printing quality back-up copy of the film in case of damage to the original, while printing from a duplicate negative protects the original from wear and tear.
- Prints are often required in different formats, so that a blow-up or reduction negative must be made.
- Bulk release printing requires that scene-to-scene grading corrections be incorporated into a splice-free duplicate negative, which can then be printed at high speed at 'one light'. Often, more than one such negative will be required to service different territories: these may be slightly different versions, or with different titles and credits, etc.
- Optical effects and titles require an original image to be printed onto a duplicate stock, with the effect incorporated.

Printing from a negative, using colour intermediate film stock, produces a colour interpositive – a low-contrast, orange-masked positive image suitable for further duplicating stages. Printing from this in turn leads to a duplicate negative. Prints from the duplicate negative can be a close match to prints from the original negative, although every generation of printing inevitably introduces slight losses of quality. While duplicating stocks are very much finer-grained than camera negative, graininess in the original often becomes more apparent after some generations of duplication. Printer losses due to slippage between negative and raw stock, or flare in optical systems, tend to reduce the definition and sharpness of the image. Contrast and colour reproduction may be affected slightly. These losses can be minimized by setting the correct printing exposures on a suitable printer, and by selecting the most suitable duplicating route.

Colour intermediate stock is designed with a long, straight characteristic curve and a gamma of 1.0, which maintains the contrast of the image unchanged through the duplication process. While print emulsions are manufactured for their visual appearance, duplicating emulsions are optimized for further stages of duplication (i.e. their appearance to another film emulsion rather than to the human eye).

A negative may be made directly from a print (or reversal positive), using a different stock, termed colour internegative stock. This has a much lower gamma than intermediate duplicating stock, and is balanced for unmasked prints rather than orange-masked negative or interpos. Results, however, would be noticeably more contrasty and poorly coloured than those obtained via interpos.

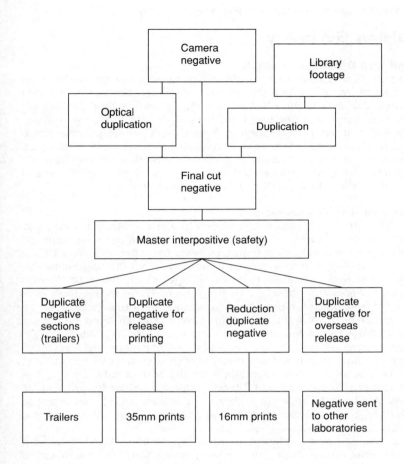

REASONS FOR DUPLICATION
Both individual shots and complete rolls of cut negative may be duplicated in the laboratory.

Take care that the image is the right way round.

Emulsion Geometry

A-wind and B-wind raw stock

Single-perf 16 mm raw stock can be supplied with the perforations on either side of the roll, to suit the position of the sprockets in the camera or printer. Cameras require B-wind negative stock: perforations appear on the right-hand side (viewed from behind) as the film runs through the camera. Contact printers require A-wind print or interpositive stock. B-wind raw stock, when rewound, becomes A-wind, and vice versa. Double-perf stock by definition is neither A- nor B-wind, but Keykode edge numbers are pre-exposed into the perf area on one side only, and so raw stock should only be used in its original winding.

A-type and B-type geometry

Camera original film is exposed emulsion towards the lens. If viewed so that the image appears correctly (i.e. so that any writing runs from left to right, etc.), the emulsion is therefore away from the observer. This is referred to as B-type film. A contact print made from the original (emulsion to emulsion) produces a mirror image which must be viewed emulsion towards the observer. This is A-type. These terms apply irrespective of whether the film is single or double perforated: however, on 16 mm single-perf stock, the perforations are on the left-hand side of the image, and this is the side on which edge numbers are printed.

B-type negatives are printed head first. A-type materials (e.g. interpositives, or internegatives from reversal originals) must be run tail first on the printer to align the perforations on the correct side. Clearly, it is impossible to splice A-type and B-type negative together for printing (as the emulsions are on opposite surfaces of the film), so it is important to specify B-type when ordering duplicate negatives of sections to be cut in with original negative.

On optical printers, different rules apply. Printing head first from B-type original will produce a B-type print or duplicate. For the image to appear the right way round, the negative emulsion is towards the light source. A-type materials must be run with the emulsion towards the lens, again producing a B-type print. To produce A-type prints, the original material must be reversed and printed tail first.

Similar rules apply in 35 mm, but because the stock is perforated on both sides, more options are available on contact printers, where the image gate can be adjusted to mask off a soundtrack area on either edge of the film. Edge number position should be considered, however, if original numbers are to be printed through, or if duplicate negative edge numbers are to be logged for later negative matching operations.

See also page 36.

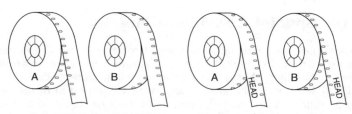

1. Raw stock (emulsion in) 2. Processed film (emulsion out)

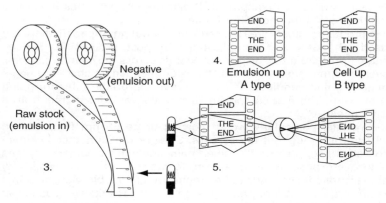

Negative
(emulsion out)

Raw stock
(emulsion in)

3.

4.
Emulsion up
A type

Cell up
B type

5.

Contact printing		
To make from	A-type	B-type
A-type		Tail first cell to lamp
B-type	Head first cell to lamp	

Optical printing		
To make from	A-type	B-type
A-type	Tail first emul. to lamp	Head first cell to lamp
B-type	Tail first cell to lamp	Head first emul. to lamp

EMULSION GEOMETRY
(1) Raw stock can be either A-wind or B-wind. (2) Processed camera negative is B-type: a contact print from it is A-type (3). (4) Geometry can be verified by examining writing, etc. in the image. (5) Optical printing inverts the image: negative is normally run upwards through the projector gate.

More from less – possible if it's done the right way.

Super 16: Special Considerations

Many cameras are now normally configured for Super 16. Compared with standard 16 mm, the lens mount is re-centred, the gate enlarged and viewfinder modified. Lenses need a slightly wider angle of coverage: many standard 16 wide angle lenses may cause vignetting in the Super 16 frame. All laboratory and editing equipment must be modified so that rollers do not touch the film's surface in the 'Super 16' area (the edge opposite the single perforations), which is used for support and transport in standard 16 mm equipment. Projectors and telecines must also be modified to display the entire frame.

While production costs are reduced when shooting Super 16, there are increased lab costs and complications in post production. Sixteen millimetre prints are mute, as picture extends across the soundtrack area. However, a 16 mm answer print is still recommended, to check the negative matching and condition and to approve the grading, before going to the blow-up. The first composite 35 mm answer print is thus from a duplicate negative.

Good results, particularly when blowing up to 35 mm film, rely on careful control throughout the process. Slow or medium speed camera negative stocks are preferred for finer grain, and many cinematographers prefer to overexpose by up to a stop, to maintain shadow detail. Any soft or inaccurate focus tends to be emphasized in the blow-up, so prime lenses are preferred. Work printing is advisable, as critical focus errors cannot be detected on a video or digitized image. In many cases, the greater simplicity of a 16 mm shoot is as important as the budget savings of the smaller gauge.

Budget management is especially crucial on low-budget productions. Lab post production costs are large, but unavoidable. Until the blow-up is made, there is no composite print available for screening.

Optical or digital blow-up?

While blow-ups are traditionally an optical printing process, and this is easily capable of preserving all the tonal quality and resolution of the original negative, the digital intermediate process offers a range of realistic alternative pathways. In perhaps the simplest method, the negative can be telecined and edited on-line to make a video master which is then kine-recorded to 35 mm negative. The cost for this would be competitive with the optical duplication pathway, but quality would be limited to standard TV resolution and to the limitations of kine recording. An HD (or even data) transfer followed by grading and a higher quality film recorder output would be costlier but would clearly provide a better 35 mm negative than the first method. If HD editing equipment is too costly or unavailable, it would be possible to cut the negative to the EDL, and make a fully graded Super 16 print for transfer. However, this would have less resolution than a transfer directly from the negative.

See also pages 16, 30, 200.

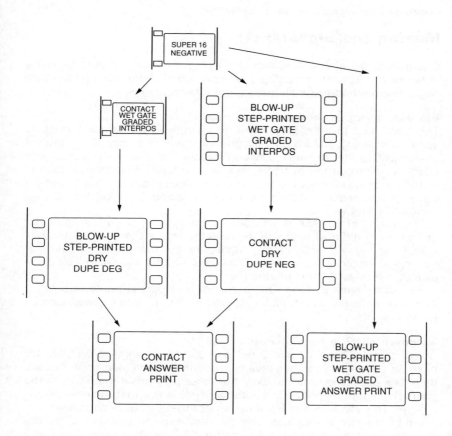

PATHWAYS FOR BLOW-UP
Thirty-five millimetre blow-up may take place at the interpos stage, or later at the duplicate negative stage if a contact interpos has been made. A direct blow-up print is also possible.

Decide on your duplication path at budget time.

Making the Blow-up (1)

Going from 16 mm to a 35 mm dupe neg, the blow-up may be done either at the first interpos stage, or when going from interpos to dupe neg. Each method has advantages and disadvantages.

Blow-up interpos, contact dupe neg

The traditional recommendation is to change to the larger format as soon as possible. During contact printing there is a very slight loss of sharpness due to slippage between negative and raw stock, and this effect, as a proportion of frame size, is minimized if contact printing is in the larger 35 mm gauge. So, for the sharpest results from 16 mm, a blow-up interpositive should be made, followed by a contact 35 mm duplicate negative.

The quality of the lens in the optical printer is also important. Any hint of flare from diffused light will degrade the image: flare in the interpos would yield very slightly muddy highlights, but flare in the dupe negative stage would give poorer blacks and slightly degraded colours – usually a less acceptable alternative.

As a disadvantage, long runs on a wet gate optical printer are rarely free from difficulty with bubbles, specks of dust or other flaws, necessitating reprints.

Negative cutting for blow-up

Conventional 16 mm A- and B-roll neg cutting presents a problem for blow-up printing. When negative splices run through step printer gates, there is a possibility that the extra thickness may offset the frame in the gate very slightly, resulting in a noticeable jerk in the image at every scene change. This can also happen if the splicer used is out of alignment.

When the film is destined only for blow-up, the problem of splices may be overcome by alternative methods of negative matching. Every negative shot is cut over length by a few frames, but assembled to the correct length in A- and B-roll format with the 'bumpers' overlapping, as if every cut were to be a dissolve. Splices are thus always on unneeded frames of image. On the step printer, the printer light vanes are opened only for the required frames. This method takes no longer to print but provides a jump-free 35 mm interpositive.

Where scenes cannot be cut over length in this way without cutting into other required frames, all the required full takes may be assembled into a single roll (as for selected takes video transfers). A frame-accurate section printing list is created (similar to an EDL), and a fully controllable optical effects printer can then be used to print the selected frames onto 35 mm interpositive stock. This is clearly a more complex operation and will usually be charged at a higher rate.

A variation of this technique is to print a 35 mm interpos from the entire assembled 16 mm negative roll (full takes or shots with handles). This can be done on a simple blow-up printer much more quickly than the frame accurate optical assembly printing described above. The overlength interpos may then be cut to the correct length by a negative matcher, at the same time as cutting in titles and opticals (see page 118).

Sixteen millimetre negative rolls are normally cut to lengths of up to 1000 ft (about 27 min running time). For blow-up, however, shorter reels are required: 800 ft of 16 mm will produce a 2000 ft roll in 35 mm. Some labs prefer to work in single (1000 ft) 35 mm rolls. In this instance, a maximum 16 mm roll size of 400 ft is required.

See also page 100.

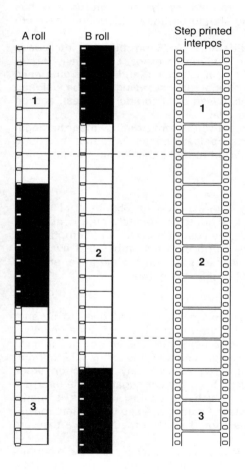

A roll B roll Step printed interpos

ZERO-CLOSE CUTTING
By cutting each scene a few frames over length, splices are always on unwanted sections of image. The printer shutter is used to block out the excess frames during printing.

Making the Blow-up (2)

16 mm contact interpos, blow-up dupe neg

Generally, contact wet gate printers are less sensitive to the types of problem with splices mentioned above, and so conventional A- and B-rolls can be prepared if a 16 mm contact interpositive is to be the first stage. (For the same reason, misaligned splices may not be detected in the contact check print.) The blow-up difficulties do not arise at the dupe negative stage: wet gate is not required, as the new interpositive has received little or no handling and should be undamaged, and there are no splices to contend with.

Furthermore, there is a cost difference. A 35 mm blow-up interpos is two and a half times longer than a 16 mm interpos, and usually dearer per foot. This is an expensive item in lab costs, and so the difference may be substantial. However, any apparent cost saving must be weighed up against the quality differences, based on a comparative test, and on the practicalities as advised by the lab.

If the film has previously been cut for 16 mm printing, then the negative will have to be recut to shorter reels, as above. Note that the sound mix will also need to be retransferred to make the 35 mm optical sound negative.

Direct blow-up print

It is of course possible to make a direct blow-up 35 mm print from a 16 mm negative. (The soundtrack is printed separately on a continuous contact printer.) While this avoids the cost of duplication – tempting if a single print is required for sales purposes – remember that every run through a printer places some wear and tear on the negative, and this is particularly noticeable in smaller gauge negatives.

Titles and opticals

It is normal for opticals (photographic or digital) and titles to be shot onto 35 mm, and so these must be cut into the blow-up dupe negative, which must therefore be treated in some respects as an *original* final cut negative. As it contains splices and light changes it is unsuitable for high-speed bulk release printing, although as with any production small numbers of prints may be produced from the cut negative. The interpos, whether 16 mm or 35 mm, from which the 35 mm negative is made, becomes a safety master in the case of damage. A separate safety master interpos of the titles and opticals should also be made before they are cut in.

For a large release print order it would be necessary to make a contact interpos from the final cut negative, and then a further duplicate negative. These repeated generations of duplication can be reduced if a 35 mm interpos was made in the first stage. Opticals and titles should be generated as interpositives, and cut into the interpos of the body of the film by a negative matcher. This then becomes the master, and one or more dupe negatives may be made from it, for release printing.

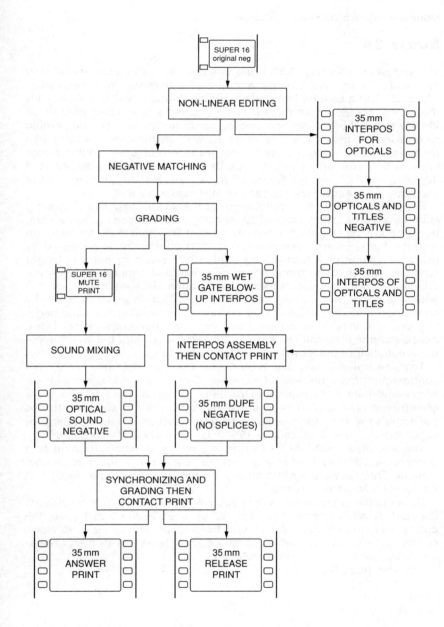

BLOW-UP NEGATIVE FROM SUPER 16
Titles and optical effects are shot directly onto 35 mm negative. Ideally, an interpos of the titles is made, which may be cut into the 35 mm blow-up interpos of the body of the film.

Super 35

The widescreen formats 1.85:1 and anamorphic 2.35:1 were introduced in the 1950s to give cinema a point of difference from television. Although, half a century later, television has found a way to follow, with the 16 × 9 screen, there remain some problems associated with these film formats. Apart from the photographic limitations of anamorphic camera lenses, the difficulty in fitting the wide image onto the TV screen for broadcast or video release is one of these problems. Compromises have to be made either in letterbox or pan and scan approaches (see 'Masking for TV'), but the Super 35 format lessens the problem and at the same time addresses the camera lens issues as well.

Super 35 mm uses the entire width of the 35 mm negative (including sound track area). Conventional spherical lenses are used on the camera, but they are repositioned sideways so that the optical centre lines up with the frame centre. Cinemascope (2.35:1) prints may be produced by using an anamorphic lens during duplication, selecting half the height (and the full width) of the exposed negative, and squeezing it into the full height but narrower Cinemascope frame, leaving space for the analogue soundtrack as normal. Normally, a 'flat' interpos is made by contact printing, and the squeeze is applied by printing the dupe negative on an optical step printer fitted with an anamorphic lens. Titles, opticals and digitals may be cut into the interpos or into the anamorphic dupe negative in the same way as for Super 16.

Telecine transfer to video is normally from the interpos (or a low-contrast print from the original negative). Since this includes extra image above and below the cinema extraction, it is possible to fill the 4 × 3 screen with no cropping from the sides, although it is common to use the same topline as for cinema, with relatively minor side cropping, or slight letterboxing. Transfers to 16 × 9 TV similarly fit much better.

The so-called Super 35 TV format is a minor variation, framing to a conventional 35 mm Academy size on the negative in a Super 35 centred camera. This allows a margin all around the image for repositioning at the telecine stage if required.

By using the entire width of the negative, the Super 35 format achieves the best possible image resolution. When used in the 2.35:1 ratio, the optical squeezing is carried out on a fixed focus lens in the laboratory, so the camera can use conventional spherical lenses, with their greater flexibility, depth of field and resolution.

See also page 34.

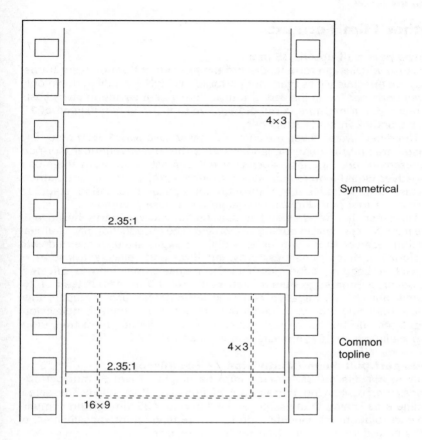

Symmetrical

Common topline

4×3

2.35:1

4×3

2.35:1

16×9

SUPER 35

The entire width of the negative is exposed, and a half-height slice is used for the anamorphic cinema image. Symmetrical framing places the 2.35:1 cinema frame at the centre, but results in a different topline for TV. Framing the cinema version nearer the top allows a common topline for cinema, 4 × 3 and 16 × 9 television.

One size fits all.

Other Film Formats

Three-perf pull-down, 35 mm

Because widescreen formats discard the top and bottom of every frame, they are effectively less than four perforations high. By pulling down only three perfs per frame instead of four, a 25 per cent saving in stock costs is realized. Furthermore, a roll of negative runs for 14 min instead of 11, an advantage in some situations.

Three-perf systems use the conventional widescreen (1.85:1) ratio. The image area on the negative is identical to that of conventional four-perf widescreen, but 25% less stock is used. Contact prints from three-perf negatives would require non-standard cinema projectors, so for theatrical release, the negative goes through an optical duplication stage to produce a four-perf duplicate negative for release printing.

Three-perf film production has had limited success, partly because of the need for specialized editing equipment. The introduction of non-linear editing resolves these difficulties – digital images are unconcerned with perforations and framelines, provided three-perf telecine transport is available. Logging edge numbers for negative matching is affected, however, as one edge number represents 21 1/3 frames instead of 16. Some, but not all, negative matching systems can accommodate this. These matching problems do not arise in film productions for television, and three-perf has been used extensively in TV drama production, more especially where 16 × 9 masters have been required.

Two-perf pull-down (Multivision or Techniscope)

This format fits a 2.35:1 image into the height of two 35 mm perforations, thereby halving the amount of negative stock used. The actual image area is almost the same as used in Super 35 mm, giving comparable resolution for cinema prints, but removing the possibilities of reframing during telecine transfer for TV release.

Vistavision

Vistavision is an eight-perf horizontal format. The film runs sideways in the camera with perforations at the top and bottom of the image. Designed originally to provide a larger negative area for feature productions, it has been used more recently for shooting special effects backgrounds, where grain size is to be minimized.

65 mm and 70 mm

Negative 65 mm wide has perforations similar to 35 mm, five per frame. Prints are made on 70 mm positive stock: the extra width allows space for a magnetic stripe on both sides of the image. The aspect ratio (2.2:1) is similar to Cinemascope.

Imax also uses 65/70 mm film. The film runs horizontally through camera and projector, and the frame is 15 perforations wide.

See also page 34.

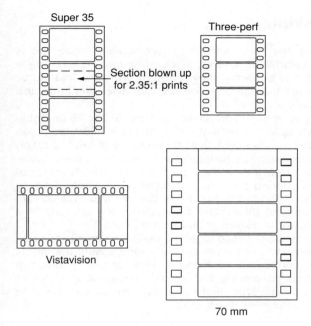

Super 35

Three-perf

Section blown up
for 2.35:1 prints

Vistavision

70 mm

NON-STANDARD NEGATIVE FORMATS
Of these, only 70 mm is a print projection format (printed from 65 mm negative or blown up from 35 mm negative): other negative formats are optically printed onto conventional 35 mm four-perf film with an optical soundtrack for projection.

See what you want to see, and nothing more.

Frameline Masking

In an original negative, the frame outside the projectable image area is normally unexposed (clear), and so prints black. Although this is normally masked when the print is projected, any errors in projector framing or racking result in no more than an unnoticeable thin black line at the top or bottom of the screen.

When a 35 mm negative has been blown up from Super 16 interpositive, the projector gate defines the frame area, giving a 1.66:1 image on the 35 mm negative surrounded by a clear frame that will print to black. However, if the blow-up is done at the interpositive stage, the same frame area leads to a white or clear frameline on the final print. If the print were racked incorrectly during projection, this frameline would produce a distracting *white* line at the top or bottom of the image on the screen. This is avoided by 'burning in' a black frameline in the interpos in a second printing run (using a 35 mm continuous printer).

This technique is occasionally used to define the image area in conventional 35 mm productions where the director wishes to ensure that prints are racked absolutely correctly in all theatres. High or low racking can appear satisfactory in some scenes, but leads to decapitated actors or concealed subtitles in others. Note that framelines can only be burnt in to a positive image (interpos, or direct print).

Reframing

Few commercial theatres today can project 35 mm Academy frame images. Standard 16 mm film blown up to 35 mm (e.g. for festivals) would therefore be projected with the top and bottom substantially cropped. If this is unacceptable, one alternative is to blow up the image only to the 1.85:1 height, and print a black mask on each side of the image. The blow-up ratio is similar to the Super 16 blow-up.

Conversely, some film-makers shoot Standard 16 with a 1.85:1 mask in the camera or burnt in to the print in order to force a widescreen aspect ratio. If this is subsequently blown up to 35 mm, the standard 16 mm to 35 mm enlargement will produce an image suitable for projection with normal 35 mm 1.85:1 lens and masking.

Repositioning

Material shot in Academy ratio (either Super 35 or Standard 16) may not be ideally positioned when the top or bottom is cropped or masked by blow-up, for projection in a widescreen ratio. The lab can raise or lower the image in the gate during blow-up printing to avoid cut-off heads or other essential action. Depending on the printer, this can sometimes be done on selected scenes only, or can be an overall set-up if the film has been shot with a particular framing in mind.

Unless the widescreen area is defined by burnt-in framelines, the edge of a severely repositioned frame may become visible if projected with incorrect racking.

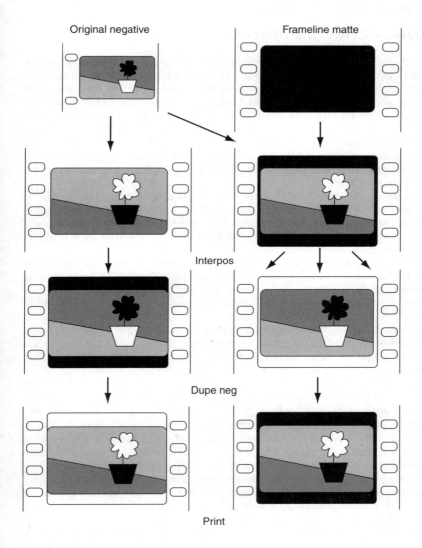

Original negative

Frameline matte

Interpos

Dupe neg

Print

FRAMELINE MASKING
When blowing up from negative to interpos, the edge of the projector gate produces a white frameline on the final print. This can be avoided by exposing an extra frameline onto the interpos, which will produce a black outline.

Optical Effects Printers

In the special effects optical printer, an image of the original film is formed by a copying lens on the emulsion of the raw stock in the camera. Some printers have an additional aerial image head. In this, the light source and film gate are moved back further from the camera, and an additional lens system is used to form the image onto a second film gate, superimposing it on the film in that gate. The combined images are then focussed together by the camera lens onto the raw stock in the camera. A similar principle may be applied to a rostrum camera, in which case the aerial image is focussed from behind onto artwork placed on the copying table.

A system of condensers in front of the light source focusses light from the filament into the copying lens, so that as much light as possible passes through the imaging system. In the aerial image system, an additional condenser or field lens redirects light from the first lens into the camera lens.

The optical printer camera head may be laced up with two layers of film (in 'bipack') so that it may be used for contact printing as well. This is used either where image geometry must be reproduced exactly, or where a projected image is to be superimposed over a contact printed one.

Most optical printers are fitted with an additive light head similar to that used on continuous printers, so that grading corrections may be applied scene to scene. Some simpler printers may simply use subtractive colour filter packs to achieve the same effect.

Optical effects printers may be used for straightforward reproduction, blow-up or reduction duplication, but are better applied to effects where some transformation is required. These are achieved by changing the magnification ratio, freezing or speeding up film transport, lateral movement or rotation of the projected image, varying exposure from frame to frame, superimposing images via aerial image optics or bipack printing, or by multiple pass exposures. Often, these effects call for a complex sequence of actions and settings: while some machines require manual adjustment on each frame, others have various degrees of computer control, ranging from simple advances to preset frame counts, to suitably modified full motion control systems.

Optical printing techniques are highly sophisticated, but systems are unlikely to develop further, as digital effects rapidly become more available. Many of the more advanced techniques (e.g. matting) are now used so rarely that they can no longer be achieved successfully. Conversely, however, some effects have been successfully carried out using a combination of digital and optical printing techniques onto the same piece of film.

OPTICAL PRINTERS

(1) For 1:1 copying, the lens is placed midway between camera gate and projector gate. (2) For different copying ratios, the lens distances are changed. An adjustable condenser lens (a) is needed to focus light onto the repositioned copying lens. (3) In the aerial image printer, lens (b) forms an image at (d), but light must be redirected by the field lens (c) towards the copying lens (e), so that an evenly illuminated image is formed in the camera.

Optical Effects

Optical effects are usually printed from a contact-printed interpositive onto dupe negative stock, although some effects may be accomplished in two optical printing stages. For example, a series of action shots may be slowed down in the interpos by stretch printing, and then combined in a sequence of dissolves at the dupe negative stage. As with simple duplication or printing, the negative should be graded before the interpositive is made. If two or more scenes are to be combined they should be printed to interpositive at the same time to ensure an exact colour match.

Freeze frames are achieved simply by stopping the projector while the camera continues to run. Alternating the camera between two or three adjacent frames gives an improved result, as the grain pattern no longer appears stationary. Action may be speeded up by skip printing, in which only every second or third frame of the original image is printed. This is similar to undercranking the camera (say at eight or 12 frames per second) during the original shoot, but in the case of optical printing the reduced motion blur leads to a slightly artificial result. Stretch printing, on the other hand, slows down action by repeating every second or third frame twice (e.g. 1, 2, 2, 3, 4, 4, ...). Other effects on a single image include zooming, image flips and repositioning.

Most composite image effects require one part of the frame to be exposed with one image, while the rest of the frame is masked off or reserved with a high-contrast silhouette or matte in the projector gate while the image to be shot is in the aerial image gate. A second exposure, with a complementary matte, protects the first area and allows the second image to be exposed onto the rest of the frame. For a wipe, the matte simply has a progressively increasing area of black in each frame.

Where a moving image is to be superimposed over a background, the matte must be a silhouette of the moving foreground image. In the blue screen technique, the foreground subject is photographed against a pure blue background. Printed onto blue-sensitive high-contrast stock, the foreground appears as a silhouette. Where the foreground subject is a model, motion control techniques allow complex camera and model movements to be repeated exactly, so that after shooting a foreground onto colour negative, it can be repeated exactly onto high-contrast film. In either case, colour and black and white matte images of the same subject are produced.

Edge effects, such as fringing due to poorly fitting mattes where the foreground meets the background, often give away matte shots. Other problems occur where the foreground has soft edges due to fast movement, soft focus, wind-blown hair, or features such as glass or smoke. Techniques to minimize these effects require highly accurate sensitometric and optical control at every stage.

Title negative

Title master

Male matte

Female matte

Wipe matte (master)

Wipe matte (return)

Background negative

Background master

OPTICAL COMPONENTS
The various elements used in optical printing.

Combine front-lit art with film images.

Rostrum Camera

The rostrum camera is built with the same precision movement controls as on optical printer, but is capable of photographing a piece of artwork up to about 40 cm across. For opaque art, lighting is from the front. To avoid reflections or hotspots, two or four lights with polarizing filters are arranged at 45 degrees from the optical axis. A cross-polarizing filter on the lens cancels out any direct (specular) reflections from the subject. This technique is particularly important when highly reflective animation cels are being photographed.

The most familiar use of the rostrum camera is to shoot title cards.

Some rostrum cameras are equipped so that a film image can be projected from behind the tabletop. In effect, this is the same as a conventional optical printer, with a greatly enlarged aerial image brought to focus in the plane of the rostrum or copying table. A large field lens is used to redirect the light from this focussed image into the camera lens. For this reason, if the camera position is moved to alter the size of the reproduced image, uneven illumination or even vignetting will result. Different copying ratios can be produced, however, by selecting a different focal length camera lens. The colour balance of the projected image is controlled by filters or by an additive light head in the projector.

Animation

Conventional hand-drawn animation cels are transferred to film using the rostrum camera. Images for each frame are painted onto transparent cels. Normally, one cel is used for the static component of each scene, and the various moving elements are painted on additional cels, with a new cel or cels for each frame. Cels are registered accurately with locating pins on the tabletop of the camera stand.

Other animation techniques on the rostrum camera include the use of cutouts which can be moved or rearranged each frame, and even photographing flat real objects – e.g. books, cigarette packs.

Rotoscoping

Originally a product name, the term rotoscoping is now applied to the general technique where film of an image is projected from the camera onto the tabletop of a rostrum camera, and the desired object is traced off in pen and ink onto paper, frame by frame, to create a series of hand-drawn silhouettes that follow the movement of the object. These frames are about 30 cm across, so considerable accuracy is possible, although skill, care and time are all required. The silhouettes are subsequently rephotographed onto high-contrast stock to produce a matte, which can then be used to combine the foreground with a separate background, or to give a different treatment (such as colour manipulation) to a specific object in the image.

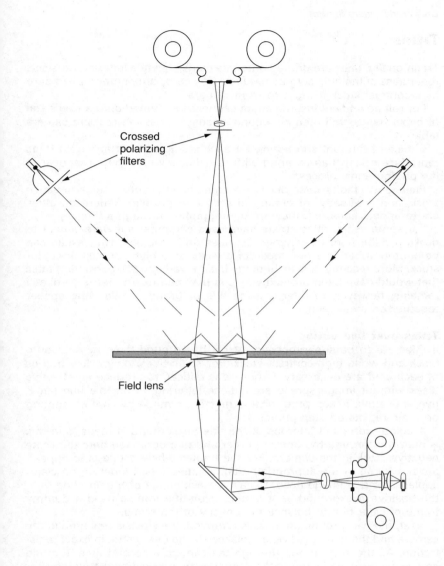

Crossed
polarizing
filters

Field lens

ROSTRUM CAMERA (ANIMATION STAND)
Front-lit and rear-lit images may be combined, or large-scale artwork may be
photographed.

Give credit where it's due.

Titles

Traditionally, titles are printed onto title cards, in white lettering on black, regardless of the final colours required. The cards are photographed onto high-contrast stock using a rostrum camera.

For roll-up end credits, the entire sequence is printed onto a single roll of paper, which will then be wound steadily across the rostrum camera table.

Choice of the font and timing for each credit is important. Bold fonts reproduce better than lettering with fine detail, which may disappear in the photographic process.

Plain end credits over black are shot directly onto colour negative stock, and are ready for cutting directly into the film. Where the titles are to appear coloured, they are photographed through a filter.

For some years, titles artists have used computer software similar to desktop publishers to generate 2D titles and graphics. The results can be photographed in a film recorder directly onto high-contrast or colour stock. More recently, this technology has moved into 3D, permitting titles that would have been prohibitively complex before. The term 'card' still remains, however, to refer to each title or group of titles that appear together on the screen.

Titles over live action

If titles are to be superimposed over a background they are shot onto black and white high-contrast stock. For static titles, only a few frames of each card are necessary. Exposure is critical, to produce an effective black without image spread around the lettering. From this title negative, a positive hi-con print, or title master, is made by contact printing on a pin-registered step printer.

A colour corrected interpos of the title background is made, and this is then run through the optical printer and photographed onto duplicate negative stock in the camera. For the frames where a title is to appear, a clean frame of the appropriate title negative (black lettering on clear) is placed in one image head, to cast a black image of the lettering onto the positive background as it is shot. Non-title frames need a dummy frame of clear film to balance the density of the scene.

Next, the background interpos is removed, the stock is rewound in the camera and the title negative is replaced by the title matte, in exact registration. As the stock is run through the camera a second time, the title area is exposed, while the background image, masked by the title master matte, remains unaffected. If a coloured title is required, it is achieved by filtering or trimming the printing light at this stage. The exact result of lighter colours in particular is hard to predict, and may be affected by a contrasting background: testing is advised.

If the title master is moved slightly out of registration with the title negative, a black fringe will be revealed on one side of the lettering. Careful placing of this produces the relief or 'drop shadow' effect.

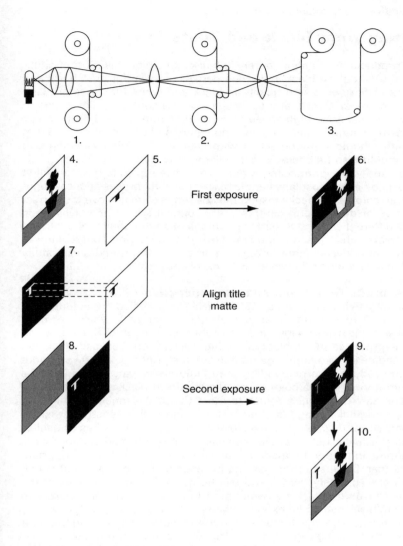

First exposure →

Align title matte

Second exposure →

PRINTING A COLOURED TITLE

(1) Aerial image projector. (2) Projector. (3) Camera. In the first exposure, the background interpositive is placed in the aerial image projector (4). The title negative in the second projector (5) reserves a blank area in the frame when the dupe negative raw stock is exposed in the camera gate (6). The background interpositive is then removed and replaced by the title master (7), which can thus be perfectly aligned to the title negative. The title negative is then removed and the required colour filtration (8) for the title is inserted. The raw stock is rewound and a second exposure is made (9), printing colour into the previously reserved title space. A contact print from the optical negative reveals the final effect (10).

Titles **133**

Black and white and colour don't mix easily . . .

Printing from Black and White

Many productions are shot entirely in black and white. It is most straight-forward to shoot on black and white negative, and print onto black and white print film. Emulsion quality in black and white films has not kept pace with colour stocks, and so images will be slightly grainier than in colour, noticeably on high-speed stock or in 16 mm. Optical printing can emphasize this graininess in black and white, and so blowing up 16 mm to 35 mm should be approached with caution. Availability of negative stock should also be checked, particularly in 16 mm.

Black and white prints can produce magnificent results from a well-lit original; however, most labs handle black and white processing less regu-larly than colour, so special testing may be required to achieve the correct standards of density and contrast. Also, optical sound negatives often need a different set of standards, and the final sound quality of analogue soundtracks rarely reaches the standard of colour prints, particularly in 16 mm. Thirty-five millimetre digital tracks can be printed successfully onto black and white, however, with excellent results.

Colour prints from black and white negative

Colour negative has gamma 0.50, which is multiplied by colour print gamma of 3.20 to produce an overall gamma of 1.60, which normally produces a pleasing image when projected in a theatre. The same end result is produced in the black and white system, but because black and white negative has a higher gamma (0.65), the print stock is lower (about 2.50) to produce a corresponding print (1.60). However, this produces a problem if you order a colour print directly from black and white nega-tive. The gamma product comes to more than 2.0 – much too high.

When original footage is shot on black and white negative, it is not uncommon for labs to provide a slower turnaround for rushes or dailies, as this is usually not a regular service. While faster and cheaper work prints may, in theory, be made directly onto colour stock, it is important to note that, because of the gamma mismatch, such prints will show an unnaturally contrasty image, and will be not at all representative of the intended result on black and white print film. Since contrast is harder to control in black and white exposure and processing, and is a significantly greater element in the lighting and composition of the image, colour work prints must be regarded as misleading and inappropriate.

Where black and white negative is to be incorporated with colour nega-tive (so that prints must be on colour stock), the black and white image must be duplicated onto a colour intermediate stock.

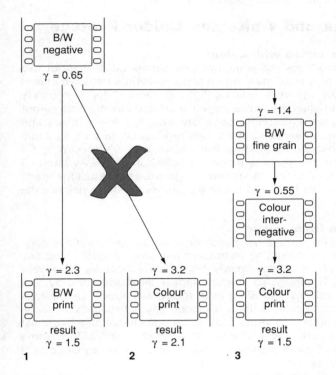

B/W negative $\gamma = 0.65$		
	B/W fine grain $\gamma = 1.4$	
	Colour inter-negative $\gamma = 0.55$	
B/W print $\gamma = 2.3$	Colour print $\gamma = 3.2$	Colour print $\gamma = 3.2$
result $\gamma = 1.5$	result $\gamma = 2.1$	result $\gamma = 1.5$
1	2	3

PRINTING FROM BLACK AND WHITE
(1) Black and white (B/W) print stock has a lower gamma than colour print, fitting well with contrasty (gamma 0.65) black and white negative. (2) Colour print film is too contrasty for direct printing from black and white negative. (3) Duplicating onto colour dupe stock adjusts the contrast and provides an orange mask suitable for colour printing.

... but special effects are possible using the right stock.

Mixing Black and White and Colour Footage

Black and white mixed with colour
Colour negative and black and white negative cannot be intercut for two reasons. The lack of orange masking on black and white negative means that a dramatically different grading light is needed for a neutrally balanced print, and black and white negative printed directly onto colour print stock produces excessively contrasty images. Where black and white material is to be included in a colour production, it must be duplicated onto a colour stock. Starting from black and white original (or duplicate) negative, the dupe is made via colour interpos. As intermediate stock is balanced for orange-masked negative, an orange filter made of unexposed negative film is added to the printer set-up to balance the light.

Black and white from colour
Black and white print stock is not panchromatic, but blue-sensitive only. This is immaterial when printing from black and white negative, but any black and white prints made directly from colour negative give very unnatural results. Naturally, all colours appear as shades of grey, but reds, greens and yellows, including flesh tones, will appear unnaturally dark, and blues unexpectedly light. If colour original material is to be incorporated in a black and white production, the colour negative must be duplicated via a panchromatic fine grain positive (type 5/7235; gamma 1.0) and a black and white duplicate negative in order to render colours with appropriate grey tones.

The pan fine grain can also be duplicated onto colour dupe negative, using an orange masking filter in the printer. This produces a colour dupe negative, with a monochrome image, which may now be intercut with original colour negative for printing onto colour print stock. Slight adjustments to the final grading can yield a neutral grey print, or a yellow–red sepia tone, etc.

Colour drain
This technique is also suitable for desaturated colour. From original colour negative, make both a colour interpos and a black and white panchromatic fine grain positive, processed to a gamma of 1.0. Printing a dissolve from one positive to the other (in successive passes) onto duplicate negative stock will result in the colour appearing to drain from the image. Each frame of the dissolve consists of a progressively increasing exposure of the black and white image, and correspondingly less of the colour exposure. A consistently desaturated image may be made by double printing the entire scene with suitable exposures for each pass. Naturally, every stage of this operation must be on a registering step printer so that the images are perfectly aligned.

See also page 40.

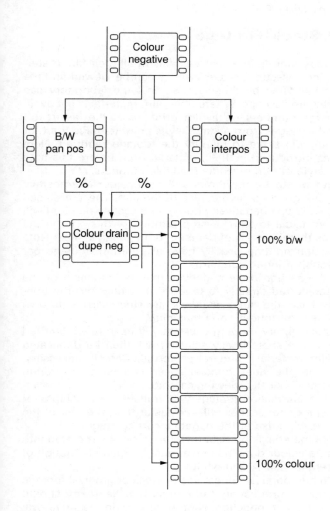

COLOUR DRAINING

Printing a fade from a colour image to the identical black and white image results in progressively desaturated colours. The position of the frame with the desired colour effect indicates the proportion of each exposure needed to obtain that result.

Using other people's pictures.

Archival and Stock Footage

Most commercial stock shot libraries carry copies of all their film material on timecoded video cassette. These cassettes can be viewed and the required footage is identified by timecode, so that the laboratory can then duplicate the required scenes. Where older film material is not available on cassette, edge numbers on a film print, or at the last resort accurately measured footages from a stated sync point (e.g. Pic Start, or first frame of image), will serve to identify the footage required. Note that as Keykode was introduced in 1990, material from before this time will have the older style of non-machine-readable numbers.

Ideally, the archive or stock shot library will hold colour interpositive or black and white fine grain positive copies of the film. These are used for section printing and dupe negatives of the entire scenes required will be supplied. (It is not usual to start or stop printing of this type in the middle of a scene, as there is a risk of damage to the archival reel.) Note that charges for section printing usually have a minimum footage per section and/or a section printing surcharge.

A work print of the section dupe negatives may be supplied, or the negative may be transferred directly to tape for insertion into the non-linear edit. In either case, the dupe negative raw stock carries its own Keykode edge numbers for logging and matching.

Frequently, the stock library viewing cassette will have been digitized and used for editing. The shots finally selected will then be duplicated from the master film materials, and retransferred. Care is necessary, particularly in PAL, that the video transfer speed is consistent through this sequence of events. Typically, viewing cassettes will have been transferred at 25 fps: if the production footage was transferred at 24 fps, for example, then the stock shot scenes will run faster than the rest of the film, and mismatches will arise at the negative cutting stage.

Where the archival material is black and white, to be incorporated into a colour production, a colour dupe negative must be made (although of course the image remains black and white).

When ordering 16 mm duplicate negatives of stock or archival footage for insertion into another production, the correct film geometry should be specified. Normally, a production shot originally in negative will require B-type negatives: reversal footage may differ from this though.

Tri-separations
Early colour material was duplicated through tri-separations, three separate black and white positive copies carrying the red, green and blue records, respectively. Being silver images (not dyes), they resist fading much better and, if preserved, are often the best source for restoration copies.

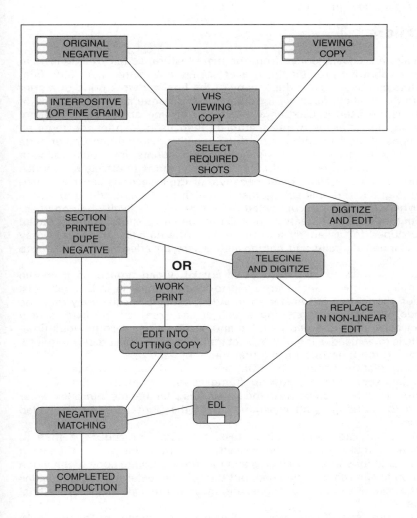

INCLUDING STOCK FOOTAGE

The required scenes may be selected from a film print or VHS viewing copy supplied by the stock library. Sections are duped from the library's master interpos. Film editors can cut the work print from these sections into the cutting copy which will be supplied to the negative matcher. Non-linear editors may have digitized scenes from the viewing tape for rough editing purposes: these must be replaced with telecined and digitized shots from the dupe negative, so that relevant timecodes can be included in the EDL for the negative matcher.

Trailers

Trailers are usually edited from the main feature, as fair trading laws in many countries prohibit the use of scenes not in the main film. Film editors can use a 'slash dupe' copy of the final cut work print, or a print from the final cut negative for editing. More frequently, a video copy of the feature itself is used as a master for off-line or non-linear editing. The master interpos of the feature is then used to print the required sections of the film onto optical dupe negative, using timecodes or edge numbers to calculate the required frame counts for optical section printing. This can be done frame accurately and with effects to produce a single, uncut optical trailer negative, or dupe sections can be printed and then cut and spliced together to match the EDL or edited print.

Where the trailer is completed before the picture itself, the non-linear editing system can create a 'pull list' of negative shots to be extracted and duped for assembly into the trailer. Alternatively, the scenes may be scanned digitally and composited where an effects-rich trailer is to be made.

Correct tracking of timecodes is crucial. Video timecodes from the complete feature transfer are used to locate frames in individual reels. When the feature is transferred to video, either a special copy must be made, with timecode starting afresh at each reel change (with a new hour code, and rezeroed minutes and seconds), or, if continuous time-code is to be used, a log of the exact frame length of each reel is required, showing the timecode for the first frame of each reel.

After picture editing, the EDL can be used to generate an optical printing specification, showing frame counts (from the start of each feature reel) for each scene in the trailer. It is vital that the interpos master used for printing is an exact match for the print used for the video transfer.

As in any non-linear editing task, the safest procedure is then to produce a mute print. A video cassette made from this print is then used as a guide for sound tracklaying and mixing. A cassette copy of the video or non-linear edit may be used, but this will not cater for any difficulties in the negative matching stages, and may lead to sync errors in the final print.

Dialogue and effects will usually be cut to match the feature edit: however, the music track will need a fresh start. Once again, reel-by-reel timecodes from the feature video transfer will be needed to locate and synchronize dialogue and effects tracks, and the sound track timecodes must correspond to the same frame rate as the video transfer. It is often possible to work from the separate dialogue, music and effects components of the final mix, so that the sound edit is relatively straightforward.

See also page 164.

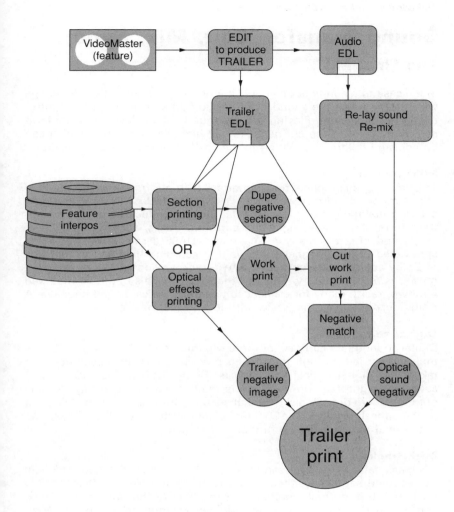

TRAILER EDITING – ONE METHOD
A tape or non-linear edit from the feature video master produces an EDL. This is used to identify sections to be duped from a compatibly timecoded interpos. Editors may order overlength sections with work print, and then fine-cut the trailer on film, or may have a frame-accurate optical negative duped, with effects, from the EDL. It is wise to mix the soundtrack to the final film result, in case of any frame cutting errors.

The correct level for every track.

Sound Transfer, Edit, Mix, Sync

The Final Mix

In the case of a non-linear edit, it is important to establish that the image will exactly match the sound, and that no frame errors have been introduced in the system. Playing the dialogue track against a pos conform or a mute print of the cut negative will highlight any errors which can be adjusted before committing to the costly process of sound mixing.

Print master

After mixing is complete, the soundtrack is in a form known as the final mix. A mono soundtrack was known as a three-track, with separate tracks carrying dialogue, music and effects. Stereo productions are in a four-track form: left, centre, right and surround tracks, each with dialogue, music and effects already mixed down. DA88 cassettes are replacing sprocketed 35 mm magnetic film as the recording medium. In the case of Dolby analogue stereo tracks, a two-track version known as the print master is also necessary. This has the four channels of stereo matrixed into two tracks, ready for transfer to two-track optical sound negative. A Dolby decoder splits them back into four in the theatre.

Digital soundtracks

Digital soundtracks carry six or more separate tracks. Naturally, all tracks must be carried through the mixing process, which increases the time taken. For digital optical soundtracks (Dolby SR-D and SDDS), a six-, seven- or eight-track print master is made from the final mix, usually onto magneto-optical disk, for subsequent transfer to a multi-format digital optical negative. The DTS digital disk system uses the same tracks in the final mix, but has no further film stages.

M&E tracks

Overseas sales will often lead to a need for dubbed dialogue. This will be recorded separately, then mixed with the music and effects (M&E) track, which is normally prepared at the time of the original final mix, and includes everything but the original dialogue. In mono, the M&E consists of two of the three usual tracks. The M&E stereo track, like the final mix, is a four- or six-track (left, centre, right, surround) magnetic recording.

As well as the final mix or print master, the sound mixing facility should output each major element or stem of the mix onto multi-track tape or a digital cassette (DA88) format as the final output of the mixing process. This form of the final mix can be used then or later as a master to produce the various delivery items: M&E, dialogue tracks, print masters and so on.

See also page 152

STEREO TRACKS
(1) Conventional Dolby stereo has four tracks: left, centre, right and a single surround track. (2) Digital stereo has six tracks: surround is split into left and right, and there is an additional sub-woofer track for deep bass notes and rumbles. The Dolby EX system adds an additional centre rear channel.

The Optical Sound Negative and Print

The final mix of a film is recorded on magnetic stock, and it is possible to play this in sync with the image in a double-head screening. However, for the answer print and for distribution, an optical sound negative is made, which is then printed alongside the image on all prints.

The conventional analogue negative is shot in an optical sound camera from the final mix (mono) or print master (stereo): the varying electrical sound signal moves a small mirror attached to an elecromagnetic coil. As the mirror vibrates, it reflects different parts of a focussed light beam through a narrow slit and onto sound negative raw stock passing through the camera at uniform speed. This leaves a continuous trace of the signal: the width of the exposed trace varies in proportion to the sound signal voltage.

The projector

Unlike the intermittent movement of image projection, analogue sound-track reproduction requires an absolutely uniform motion: even a 1 per cent speed variation would cause enough variation in pitch to be objectionable (although this is not the case for digital optical tracks). This constant speed is provided by separating the projector sound head from the image head, with a slack loop of film between the two. The film is driven in the sound head round a heavy, damped flywheel, which eliminates any trace of vibration in the film.

Light passing through a narrow slit in the sound head is focussed onto the soundtrack, where a varying proportion is transmitted, depending upon the width of the track. The transmitted light is collected by a photocell, producing a small electrical signal, which is amplified to produce sound. The slit image has to be very narrow to respond to high-frequency signals, and is normally reduced to 0.033 mm. This theoretically allows response up to about 14 kHz in 35 mm films. In earlier times, film was unable to resolve this well, and soundtracks were mixed with severe attenuation or roll-off (the Academy curve), completely eliminating frequencies above 8 kHz and producing a thin, dead sound.

Modern tracks produce much higher frequencies – digital tracks even more so – and there are various techniques in Dolby soundtracks to reduce recording noise and to improve high-frequency response.

The digital optical sound camera uses a small LED array to expose a checkerboard-like image along the edge of the film, or in the case of Dolby SRD, between the perforations. All tracks are shot at the same time in a single pass through the sound camera (fitted with however many heads are required).

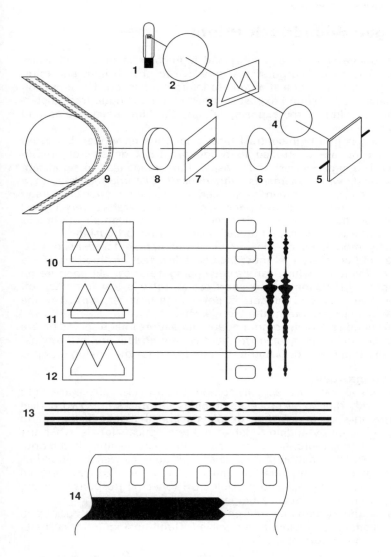

VARIABLE AREA ANALOGUE SOUNDTRACK
The optical sound camera. (1) Light from the lamp is collected by a condenser (2) and passes through a W-shaped slit (3). Lenses (4) and (6) image the mask onto slit aperture (7), but the mirror galvanometer (5) oscillates with the sound signal, moving the W image up and down. The varying-width slit image is refocussed by lens (8) onto moving sound-recording stock (9). Varying positions of the image on the slit result in mid-range (10), wide (11) or narrow (12) areas of the optical soundtrack. (13) The grain in a silent track would lead to noise. With ground-noise reduction, a bias is applied to quiet (unmodulated) signals: the narrower track has less noise-producing grain. (14) Each roll of sound negative includes a section of 'flood track' where the density of the exposed negative can be measured.

The optical sound negative and print **145**

An image of the sound wave.

Analogue Soundtrack Prints

Sound negative stock is a fine-grained high-contrast black and white emulsion. The base incorporates a grey dye to absorb light and minimize image spread and halation due to internal reflection. The emulsion is very sensitive, as sound exposure times in the analogue track (determined by the width of the exposing slit and the film speed) are around 1/80 000 s.

Processing is in a high-contrast black and white developer. Exposure and processing are controlled to produce a track density of around 2.50–3.00. The high contrast and density of the image lead to significant image spread, which increases with density. Distortion is kept to a minimum if this image spread is balanced with equal but opposite spread in the positive print. Negative density control is therefore very important. Many sound cameras include direct control of the lamp's brightness by means of a servo-linked photocell inside the lamp housing.

Normally modulated or silent track is too narrow for densitometer readings, and so every reel must include a few feet of 'flood track' – a full-width bias line – which can be read using a narrow slit aperture on a conventional densitometer. A short section of this test is broken off and processed first, and the correct developing time for the rest of the reel may be calculated from the test density.

Digital soundtracks can accommodate a little more image spread before the code becomes unreadable, so there is enough latitude in the negative density to allow processing to be controlled for the analogue track.

Stereo soundtracks

Dolby stereo optical tracks actually comprise four tracks: left, centre, right and surround. The Dolby process combines the tracks into two optical waveforms in such a way that, on playback in the cinema, the centre track is recovered by adding together the two optical signals, while the surround sound is reproduced from their difference, resulting in the original four channels – although sounds are not quite as well separated as in the original four-track discrete magnetic mix. In 1987, the original Dolby A system was replaced by Dolby SR (Spectral Response), giving wider dynamic and frequency range.

Digital sound systems all rely on the analogue track as a back-up in case the digital signal cannot be resolved. Good analogue tracks therefore remain an important element of a print.

Silver tracks

Conventional projector photocells are sensitive to infrared. This was not a problem for black and white prints, but as colour dyes are transparent to infrared, it has always been necessary to redevelop the optical soundtrack print, adding silver to the track image so as to give it sufficient density. This is achieved by applying a stripe of viscous black and white developer immediately after the bleach solution.

This has always been a difficult process to maintain: splashes of applicator (redeveloper) may stain the image area, while bubbles or a weaving edge to the applicator cause pops and rumble in the soundtrack.

Conventionally, the printing light is filtered yellow so as to expose only the top two layers of the colour print emulsion: this gives a sharper track image, with correspondingly better high-frequency response. It appears a characteristic dark blue–black in colour.

High magenta and cyan tracks

The recent swing away from tungsten sound lamps to red LED lamps has presented the opportunity to change the printing technique. Cyan-coloured soundtracks (using a red filter on the printer) present sufficient density to a red reader without the need to redevelop the print for silver.

Unfortunately, the changeover is not so straightforward. Theatres using the older tungsten soundheads simply cannot play cyan tracks. Until all theatres have changed, therefore, distributors must be able to supply prints with either type of track. This leads to another snag: different density negatives are required for each type of print to give the best x-mod cancellation.

A confusing but workable solution has been found. The negative that will work for cyan tracks may be printed using a combined yellow–cyan filter pack to produce a magenta-coloured track, which must be redeveloped in the conventional way. The high magenta positive soundtrack reproduces acceptably well on both tungsten and red LED readers on projectors.

This transitional phase allows sound studios and laboratories to adjust their negative techniques, and distributors to maintain a single inventory of prints, while theatres around the world progressively change their equipment to red LED readers.

Once the changeover is complete, the redevelopment stage will be removed from processing machines, with resultant reductions in chemical and wash water costs, as well as in reprints for applicator errors.

Black and white tracks

Black and white prints are printed without a colour filter, to expose the blue-sensitive positive print stock. Black and white images are naturally silver, so no redevelopment is needed.

See also page 52.

The soundtrack is printed alongside and ahead of the image.

Syncing Picture and Sound Negatives

Film reaches the analogue sound head in a projector roughly a second after the image gate (26 frames for 16 mm, 20 frames for 35 mm). The optical soundtrack must therefore be printed in advance of the image by exactly this amount so that picture and sound are projected in sync. SDDS optical sound heads, on the other hand, are ahead of the image gate. The required time offsets are programmed into multi-format optical sound cameras and into the projection system so that all formats are reproduced simultaneously.

Syncing with the image

During sound editing, a short (1/25 s) 'pip' is recorded in the soundtrack leader: conventionally, exactly 2 seconds before the picture starts, on the '2' frame of a standard clock leader. Before grading and printing, picture and sound negative are lined up so that this pip – visible as a short burst on the analogue sound negative – is the required number of frames ahead of the picture negative '2'. In 35 mm it appears alongside the fifth '3' frame; in 16 mm it is the last but one '4'. Printer sync marks (normally a frame with a cross mark and a hole punched in the centre) are then made in both picture and sound negatives so that they can be laced up correctly in the printer.

Sync errors can, however, creep in at any stage. Speed control problems on the optical sound camera can cause the track to drift in and out of sync. A constant error is more likely to be at the negative syncing or printing stages, and can easily be discovered by checking the printed position of the two-pip. Frequently, the error is simply the size of the loop in the projector: if it is too large, the sound will be retarded.

Since we are used to hearing sound arriving late from distant objects, a retarded sound track is often less disturbing than an advanced one. An average audience will accept sound that is one frame early or two frames late.

SYNCHRONIZED PRINTS
(1) The sync pip is easily recognized on an analogue soundtrack. (2, 3) The pip appears a set number of frames ahead of the '2' where it is heard. (4) Sync marks are placed on the sound leader so that it may be laced up on the printer correctly with the image negative. (5) The image sync mark also serves as a starting point for frame count cuing (FCC). (6) Sound from the start of reel 2 is printed alongside the end of reel 1 so that nothing is lost when the head leader of reel 2 (7) is cut off in positive assembly.

Analogue Soundtrack Quality

Compression and equalization

Analogue optical tracks have a far lower signal-to-noise ratio (the difference between the loudest undistorted sound and the background noise) than magnetic recordings, and so some compression is necessary. This boosts quieter passages and raises the average level of the track, but at the expense of losing the impact of very quiet or very loud passages.

Film resolution is the limiting factor in reproducing high frequencies; image spread and printer slippage contribute to a loss of sound level at high frequencies, and so these are boosted considerably in the magnetic print master or during optical sound transfer to compensate.

Density and volume

Both negative and print density are critical for good sound reproduction. There are no universal aim values, as the optimum densities depend upon conditions in the optical sound camera, the sound negative stock, the negative and positive processes, and the printer. A sound negative produced for printing in one laboratory may not be standard in another laboratory, and cross-modulation tests should always be included when sound negatives are shipped.

Errors in density usually result in a distorted and sibilant track – spitting esses and muddy orchestral sounds. Exposure or density problems rarely affect the volume unless the print is excessively light or has not been redeveloped, in which case distortion is also present.

Black and white print film has poorer resolution than colour, and sound reproduction is less satisfactory – particularly in 16 mm. A different sound negative is usually required, with suitable density and equalization for black and white prints. Digital tracks play equally well on black and white or on colour stock.

Where there is doubt that the optical sound process has produced the best quality, it is usually possible to run magnetic and optical tracks together, switching from one to the other for comparison. However, this will invariably highlight differences, as even the best optical track is inherently more limited in range and response than magnetic.

Loudness

Early mono soundtracks following the 'Academy curve' had a very limited dynamic range of under 50 dB. In the 1970s, Dolby introduced 'pink noise' calibration, allowing theatres to replay sounds as they were mixed. Analogue systems all had a natural maximum level, beyond which clipping and distortion were inevitable. This limited soundtracks to well within the human comfort zone.

Digital tracks are capable of well in excess of 100 dB (approaching levels of pain and hearing loss) without distortion. Restraint by the mixer (and often the producer) is required to mix tracks to a comfortable level. The issue is not a simple one. Short bursts of extremely high level sound are less aggravating than continued exposure to slightly lower levels. Loudness meters can be used to monitor levels over a scene, reel or complete feature, and report an 'annoyance factor'.

Faders in theatres and on mixing room monitors have traditionally been set to play Dolby pink noise at 85 dB. In response to audience complaints about loud passages, projectionists turn down faders by 3 or even 6 dB for the entire programme, so that normal-sounding scenes and commercials then play too quietly. This becomes a vicious circle as mixers set monitor room levels down to produce a still louder mix, and so on.

THX

The entire system from projector head, through amplifiers, to loudspeakers, and the acoustic qualities of the theatre, all govern the quality of the sound as it is replayed. A good soundtrack still needs a good theatre sound system for it to be heard properly. Standards such as THX allow a theatre to be calibrated throughout the frequency range. Note that THX is not a recording system, but a set of standards for playback, governing frequency response, level and reverberation times in all parts of a theatre.

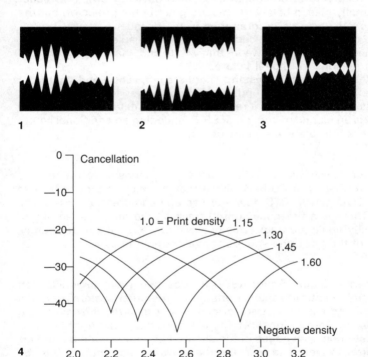

CROSS-MODULATION TESTS
In underexposed tracks (2) the black image shrinks, distorting the shape of the signal compared with a correct exposure (1). Overexposure (3) has the opposite effect, also producing distortion. (4) Cross-modulation tests measure the distortion of a test signal due to mismatched densities. Combinations of a range of negative densities printed at a series of print densities shows the best (lowest distortion in dB) combinations.

Analogue soundtrack quality **151**

Three rival systems – you may need all of them.

Digital Soundtracks

The first proposed digital sound system was Cinema Digital Sound (CDS). This was printed in place of the analogue track. However, because, as with all digital systems, any faults such as scratches or dirt would result in the track cutting out completely, the system did not succeed. All subsequent digital sound systems are printed in addition to the simpler and more robust analogue track, and they all revert to the analogue signal if the digital one fails at any time.

Dolby SR-D
The digital matrix is printed between the perforations on the same side of the film as the analogue track. Each block therefore contains 1/64 s of sound data. The track is printed to a neutral grey colour, density around 1.30, but is read with a red-lit charge-coupled device (CCD). The reader head is normally placed below the picture gate on the projector, but the precise sync delay can be programmed in the decoder.

Failure to correctly read the code in the corner markers in each block, or insufficient difference between the white and black dots, are the commonest reasons for digital failure.

SR-D is described as a 5.1 system. There are left, centre and right front channels, left and right surround, and a sub-woofer for low-frequency effects. (This is the 0.1 track as it requires much less data than the others.)

Dolby EX is an extended version of SR-D, encoding an additional centre surround track into the same block of data.

DTS
Digital Theatre Systems (DTS) also uses 5.1 channels, recorded in a proprietary format on a CD-ROM. Note that the disc cannot be played on a CD or DVD player. DTS does not use any compression in the disc recording. There is a timecode control track on the film, printed alongside the Dolby analogue track. This ensures that even if several frames are cut out of the print, the soundtrack will remain in sync.

SDDS
Sony's Dynamic Digital Sound (SDDS) adds two more channels (left centre and right centre) to the 5.1 offered by the other systems, leading to a mildly compressed 7.1 track system. Most theatres, however, fold this down to the conventional 5.1.The distinguishing feature of SDDS is that it is printed on both edges of the 35 mm film, outside the perfs. This area is subject to wear and tear, but the track is made more robust by repeating most of the information on both edges of the film. Centre (dialogue) is common to both edges. Although in general left channels are encoded on the 's' (analogue sound track) side and right channels on the 'p' (picture) side, there is enough redundant information to reconstruct left channels from the right side and vice versa, in case either track fails. In addition, while the s-side track is in level sync with the picture, the p-side is staggered several frames off-sync. Thus, no part of the soundtrack is lost if a couple of frames are cut out for any reason.

152

The SDDS track is printed cyan, and is read, like the SR-D track, with a red CCD reader. This avoids any clashes with the magenta-coloured latent image edge codes printed on the stock by Kodak. However, SDDS is particularly susceptible to edge fogging, and darkroom safelights must be minimized.

It is common to print films with three (if not all four) formats, to make all copies universally playable.

See also page 142.

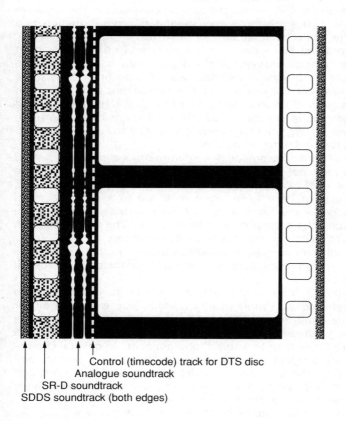

Control (timecode) track for DTS disc
Analogue soundtrack
SR-D soundtrack
SDDS soundtrack (both edges)

COMBINATION SOUND PRINTS

Not all theatres have all sound systems. One print can include several soundtracks. DTS sound is recorded on a compact disc, which is kept in sync by a timecode track printed on the film between the image and the analogue soundtrack.

The debut of the finished product.

Grading, Answer Print, Release Prints

The Answer Print

The director of photography should normally attend the answer print screening, although as this is many weeks after production has finished it is not always possible. The responsibility for approval may then fall to the director, producer or post production supervisor. Since the answer print screening is the first viewing of the final product, there are many factors to be checked. In particular, the accuracy of the negative matching and synchronization of the sound, the general condition of the negative and print (dirt, scratches or sparkle may appear), the colour grading, and the quality of the optical soundtrack.

The cost of grading the negative is incorporated in the answer print price, which is normally several times dearer than a simple release print. If there are no problems with the answer print other than some minor colour corrections, it will normally be considered acceptable. The grading corrections will be incorporated into the first release print at no extra cost. Where there are more substantial difficulties with the print, then the lab will be expected to replace the affected reels of the print, after rectifying the problems, at no cost.

Sometimes the print does not meet the film-maker's expectations, even though the lab may feel it has done its best. This may occur where the original material is of marginal quality due to exposure, sharpness, etc., or where instructions have been given to grade to a particular non-standard effect, which did not turn out as hoped. In these circumstances, the lab may expect the answer print to be accepted. The next, corrected, print struck will be charged at normal release print rate.

One person only should make grading comments or other judgements on behalf of the production company: the lab cannot print to suit all personal views at once.

Frequently, there will be a combination of circumstances, in which a print may be rejected for simple quality reasons (e.g. excessive dirt or sparkle), but the film-maker will take the opportunity to request some cosmetic grading changes, or alterations to dissolves. Any charges for a replacement print may then be subject to negotiation. In general circumstances, if a print is rejected, it will remain the property of the lab, and cannot be used by the film-maker – although where a scheduled cast screening or a dub for post production script purposes (for example) is needed, agreement may be reached with the lab.

Once the answer print is approved, the same grading data will be used for any subsequent printing from the original negative. This may include a low-contrast print for video mastering, most particularly the master or safety interpos, and possibly a limited number of release prints. By incorporating the approved colour corrections into the interpos, the ensuing duplicate negatives will need little or no scene-to-scene correction, and so will be suitable for high-speed, bulk release printing.

See also page 78.

154

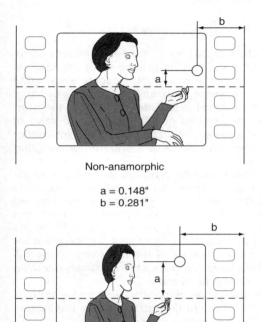

Non-anamorphic

a = 0.148"
b = 0.281"

Anamorphic

a = 0.239"
b = 0.382"

REEL CHANGE CUES

Reel change cues are punched into the top right corner towards the end of each separate reel: a motor cue 7 s before the reel end prompts the projectionist to start the second projector (laced up at a predetermined point) and at a second changeover cue the dowser vane is opened on the new projector and closed on the old one. Cues are punched in four successive frames, at standardized positions, to ensure that they are visible on all screens. They are not required in single projector platter systems.

Many copies, each one the same as the next.

Release Prints

Once the answer print is approved, orders for a number of release prints will follow. A small number of prints can be printed from the original negative, as the costs of an interpos and duplicate negative are quite high in relation to print costs. However, it is almost always advisable to print a safety interpos: in the case of accidental damage to the original negative, it is possible to make a good quality duplicate negative of the damaged section from the interpos, and cut it in to the remainder of the original. (A replacement negative could be made from a print, but the quality is unacceptably poor.)

Where more than about 10 prints will be required, a duplicate negative should be made from this interpos. Apart from the risk, it is uneconomical to print from original negative: light changes are required at every scene change, and so the printer is limited in speed (the maximum speed at which light changes can be made depends on the type of light valve fitted to the printer). If light changes are too great for the speed of printing, half a frame or more of the incoming scene will be printed before the light valves have completed their change, resulting in a colour or density flash at the scene change.

A trial print should be made from a new duplicate negative before bulk printing commences. This checks for printing errors in the duplication stages and confirms the grading and sound sync.

Major feature films will have a worldwide release of several thousand copies, and orders are often altered very late in response to early box office returns. Bulk printing laboratories therefore need printing and processing capacities on a quite different scale to smaller 'front end' production-oriented labs.

Bulk release printers run at speeds of between 500 and 2000 ft per minute. Rolls of raw stock 3000, 4000 ft or longer are used on bi-directional printers, so that once a roll of negative has been printed from the head, the next print is made onto a fresh roll of stock from the tail, and so on. The ends of raw stock rolls too short for complete rolls are often spliced together in the printing darkroom before printing, to avoid waste. As a result, some printed reels will be supplied with a splice somewhere in the roll. Some laboratories are able to control this operation so that the splices occur on a frameline.

After 40 or 50 prints in several small batches, the duplicate negative will show considerable wear and tear. In a single bulk print run, however, four or five hundred prints would be possible before replacing the negative.

Although laboratories will always screen rushes and answer prints, it is clearly impractical for them to screen every reel of every copy of a release order at real speed. However, many labs are able to project the image as film goes through the processor (albeit at several times real time) to monitor for obvious defects. A controlled sample of each print run is screened in real time, and computer quality control systems monitor the performance of the digital soundtracks of these check-reels.

156

Subtitles

Where a small number of prints is required in a foreign language territory, subtitles can be applied to ordinary prints. In the traditional method of chemical etching, each translated subtitle is made up of metal character dyes in a printer's block. The film print is passed through a wax bath, and then through the printing press in which the text is stamped out of the wax coating in each frame of image. The film passes into a chemical bleaching bath which only affects the stamped out letter areas, and finally the wax coating is washed off and the print is dried.

A more recent method uses laser etching, in which a laser 'writes' each letter onto the film print. This method is quite slow (taking up to 12 h per copy, depending on the number of titles) but viable for small runs.

For larger orders, subtitles can be 'burnt-in' to the dupe negative as a second exposure, using a high-contrast master film with all the required titles printed to the required length. Alternatively, a timed high-contrast negative (black titles on clear) is made. In release printing, this is run as an overlay: title negative, image negative and raw stock all pass through the printer together. The image negative is next to the raw stock to preserve image sharpness.

Success depends on the proper presentation.

The Film Projector

Film is projected as it is shot – as a sequence of still images, with dark periods between each one, during which the film is transported to the next frame. However, at the rate of 24 fps, the light and dark periods are long enough for the eye to detect a flicker, and so projector shutters actually run at double this rate. Each frame is projected twice before being pulled down to the next one, giving 48 flashes per second on the screen instead of 24. Some systems use a three-bladed shutter, giving 72 flashes per second.

Flicker also depends upon the image's brightness: excessively bright images flicker more. The SMPTE standard of 16 ft lamberts (ftL; 55 candelas per square metre, $Cd\,m^{-2}$) is generally accepted as giving the brightest acceptable result. In Europe, the level is set at 14 FtL ($50\,Cd\,m^{-2}$). In both standards, the tolerance is 4 FtL, with similar limits on the variation between centre and edge of screen. Prints are graded with the assumption that projection will be within the tolerance allowed: projecting at the minimum screen brightness is equivalent to projecting a print that is about two printer points dark. Any theatre used for answer prints screening and assessment must be as close to the standard as possible.

Screen brightness readings can be made with a spotmeter, from a suitable point in the auditorium – not with a cinematographer's incident light meter, which measures the total light arriving at the meter. Corrections are made by varying the projector lamp current supply.

The colour temperature of the projector lamp is also of obvious importance: the normal standard of 5400K is approximated by xenon arc lamps (although strictly the spectrum they emit is non-continuous, and so any colour temperature measurement is only an approximation).

Image size depends on the throw (distance between projector and screen) and on the focal length of the projector lens. The greater degree of enlargement required for a wider screen ratio demands a stronger (shorter focal length) lens. To find the lens required for a given screen width, divide the throw by the screen width (both in metres) and multiply by 21 mm (for 35 mm film) or by 9.6 mm (for 16 mm film). Masking for any image is achieved with a metal cut-out aperture in the film gate: the image of this should coincide with the black tabs or curtains on the screen.

PROJECTION PLATTER

Most cinemas run feature films in one long reel (up to 12 000 ft in length), including trailers, commercials, etc. The film feeds from the inside of an open reel sitting on a platter or 'cakestand', and takes up on the outside of another roll, so rewinding is never necessary. Care is needed with humidity, static electricity conditions and lubrication to ensure smooth feed from the inside of the reel.

Release Prints in Use

Programmes longer than a single spool normally have changeover cues marked at the tail of each spool: four frames with a circle or dot in the top right corner, punched in the answer print itself, or into the dupe negative for release prints. One set, 8 s before the end, cues the projectionist to start the motor for the next reel: the second set, 1 s before the end, cues the shutter changeover.

Cue marks are not required for platter projection systems, in which entire programmes are assembled into a single roll, supported on a horizontal plate. Film is drawn from the inside of the roll and fed back to the outside of the roll. Traditionally, however, film is transported in 2000 ft spools: the projectionist therefore removes head and tail leaders during assembly, and replaces them when the film is returned to the distributor.

Print care

All release prints are now made on polyester-based stock. While this material is more dimensionally stable, it does demand attention to certain conditions to ensure successful running in the projector over many sessions.

Polyester has a greater tendency to build up a static charge. Although an antistatic is added during processing, it is important to maintain the recommended relative humidity in the bio-box. This should be between 50 and 60 per cent. Drier conditions allow static to build up, while too high a humidity will cause the emulsion to absorb moisture and become tacky. In both cases there is a tendency for adjacent turns of film to cling together on the platter, causing a jam in the feed roller (known as head-wrap or brain-wrap). Since polyester base does not break, this can often lead to severe damage to the print and possibly to equipment. This is not desirable during a public screening!

Antistatic spray on rollers and platter surfaces, and wax (Johnson's Paste Wax is recommended) applied in very sparing quantity to the edges of the film may help if problems persist. Under no circumstances should other products such as WD40 or liquid paraffin wax be used, as these are liable to interact with dyes in the film emulsion.

All rollers and especially gate runners must be cleaned regularly to prevent any build-ups of deposits which will cause abrasion to the film surface. Scratches or burrs on the metal surfaces will similarly wear away the film surface. Polyester prints are more prone to this dusting because of the orientation of the molecules in the extruded base material. The abrasion forms a fine whitish powder or dust, which, when spread over the film surface, will appear as dirt on the image and, more critically, cause the digital soundtracks to fail.

See also page 52.

Length (feet)	16mm running time (24fps)	16mm running time (25fps)	35mm running time (24fps)	Diameter on 3" core (approx)
10	17sec	16sec	7sec	
36	**1m 00sec**	58sec	24sec	
37.5	1m 03sec	**1m 00sec**	25sec	
90	2m 30sec	2m 24sec	**1m 00sec**	
100	2m 47sec	2m 40sec	1m 07sec	4.3" (11cm)
400	11m 07sec	10m 40sec	4m 27sec	6.8" (17.3cm)
800	22m 13sec	21m 20sec	8m 53sec	9.1" (23cm)
1,000	27m 47sec	26m 40sec	11m 07sec	10.0" (25cm)
2,000	55m 33sec	53m 20sec	22m 13sec	14" (35.5cm)
2,160	**1h 00m 00sec**	57m 36sec	24m 06sec	
2,250	1h 02m 30sec	**1h 00m 00sec**	25m 00sec	
4,000	1h 51m 07sec	1h 46m 40sec	44m 27sec	
5,400	2h 30m 00sec	2h 24m 00sec	**1h 00m 00sec**	
10,000	4h 37m 27sec	4h 26m 40sec	1h 51m 07sec	

Length (feet)	Weight (16mm) with core)	Weight (35mm) with core
100	105g	230g
400	380g	860g
1,000	920g	2.080kg
2,000	1.820kg	4.140kg

All weights without cans

FILM RUNNING TIMES
Although each spool of a feature is nominally 2000 ft, they are usually shorter, being edited for a convenient changeover scene. Feature running times are naturally based on actual program lengths: head and tail leaders add at least 30 ft to each spool.

Preserve the fleeting images or they will be lost forever.

Film Storage and Preservation

After a production is completed, and duplicate negatives and release prints are made, the negatives may not be required for some time. However, print orders may be received after several years, or there may be a requirement (particularly in the case of documentary footage) for some shots to be re-used in a later film. Even if none of these instances arise, there is a cultural need for films to be preserved for posterity. Film, however, is a fragile medium, and invariably deteriorates over time unless stored in proper conditions.

Preservation

The original nitrate-based film has not been used since 1951. It is very flammable, and decays by shrinkage and chemical decomposition to an explosive powder. Film archives are busy copying what is left onto acetate base.

Acetate (safety film) does burn, but will not sustain fire by itself. It is also subject to shrinkage in excessively dry conditions. A problem arises when acetate-based films are stored with excess moisture, or have been imperfectly washed during processing. Vinegar-smelling gases are given off, which rapidly accelerate the shrinkage and decomposition of the film, and also all other rolls stored nearby. Acetate reels are best sealed in airtight bags, after being stabilized to 30 per cent relative humidity.

Negatives should not be wound too tight and rolls should be stored horizontally.

In the shorter term, negative stored in uncontrolled conditions may suffer from ferrotyping – a patchy glazing effect when tightly wound damp emulsion begins to stick to the base of the adjacent turn of film on the roll. This can produce a mottled appearance when printed. Carried further, damp turns of film may stick to each other. In some cases such film can be recovered by very slow winding by hand. Fungus may also grow on the emulsion (gelatine provides an excellent culture for spores), and appears as a whitish or grey–green film over the emulsion. Fungus attacks the dyes in colour film and, if detected, must be removed by rewashing the film.

Black and white (silver) images are relatively stable, but colour dyes fade in time. Different dyes fade at different rates, so colours cannot be restored satisfactorily by simple printing, although digital processes are now very successful. A relative humidity of up to 30 per cent is best to slow down dye fade, with a stable temperature as cold as possible, but certainly lower than normal room temperature. Stocks manufactured since around 1980 have dyes with much better long-term stability.

Do not store films in the garage, under the bed, in the office or leave them at the lab. It is invariably best to have negatives stored at a film archive or a commercial vault that can offer archival conditions.

	Short term storage		Long term storage	
	(up to 6 months)		(more than 6 months)	
	Temperature	Rel. Humidity	Temperature	Rel. Humidity
Raw stock	13°C	70% RH	–18°C	in sealed cans
Exposed stock (all types)	– 18°C	<70% RH	not recommended	
Processed film (acetate)	21–24°C	50–60% RH	10°C	15–30% RH
Processed film (nitrate)			10°C	40–50% RH

ARCHIVAL STORAGE CONDITIONS
Film should be stored in plastic bags in cans (metal or some plastics are accept-
able). Avoid sealing bags in warm conditions before cold storage: this will lead
to excessive humidity in the film. Rolls should be wound slightly looser than for
normal shipping, and the cans must be stored flat (not upright), to distribute the
weight of the roll evenly.

Preserve the fleeting images or they will be lost forever.

Archival Restoration

Despite the best intentions of archivists, a great many films are found to have deteriorated when, for whatever reason, the time comes around for them to be rediscovered. A number of techniques, both traditional and digital, have been refined for restoration of these casualties, which may be silent classics, home movies from a generation ago, or even relatively recent productions.

Shrinkage

Both nitrate and to a lesser extent acetate base are subject to shrinkage if stored improperly. Shrunken film will not run through conventional printers if the shrinkage is greater than 1 per cent or so. The extent of shrinkage can be quite easily measured by holding a length of the archival film against a modern film (of the same original perforation pitch). The perforations will very quickly get out of alignment: 1 per cent shrinkage means that perfs will realign, one out of step, within 100 perfs, about 18 inches.

Specialized archival printers have a range of non-standard sprocket wheels that can be fitted to suit any given range of shrinkage. Step printers also have variable pitch pull-down mechanisms. In some cases with badly shrunken (and often very brittle) reels, the film must be hand-fed into the printer and collected in a trim bin, with an assistant taking up the film by hand. A second run may be more than the material can bear. An alternative method involves treating the film with particular solvent vapours to rehumidify and restore plasticizer into the base. This occurs in a vacuum chamber, and expands and softens the film, usually temporarily, for just long enough to run it through a printer or telecine. Splices, however, can still give trouble, often causing movement or a loss of rack at the join.

Fading

Faded colour dyes cannot be corrected simply by a film grading correction. Dye fade affects the gamma or contrast of individual dye layers, resulting in crossed curves – for example, correcting red shadows would introduce green highlights. The only film method that can cope with this problem involves making black and white colour separations to carefully chosen contrasts and then recombining them. This is a difficult and expensive process, and cannot cope with the common situation where fade is varied through the length of a reel. Telecine colour correction can treat individual colours quite successfully where the final product is for television. Where the object is a restored film print, digital systems at film resolution (e.g. Cineon) can be used in the same way.

Scratch and dirt removal

Wet gate printing will minimize scratches on the archival material, but cannot remove dirt or printed-in scratches. Once again, though, telecine transfer suites are usually equipped with digital dirt removal systems, individual marks can be hand-painted out digitally, while very

sophisticated dirt and scratch removal systems working at film resolution can identify single-frame marks and replace the affected areas with unmarked information from the adjacent frames.

Sound
Optical soundtracks are often badly worn, resulting in a lot of noise on prints or re-recorded copies. This can be filtered to a limited extent, often at the expense of other information on the soundtrack.

If a print is made directly from older mono soundtracks, it is necessary to play this through a mono sound system, without Dolby noise reduction. This is often not possible in modern commercial theatres, and the alternative, of remixing the track through a Dolby licensed system, may need consideration.

Digital restoration
The digital intermediate process offers considerable scope for restoration of older films. However, it is still an expensive option, as restoration programmes are often planned in numbers of complete features, whereas digital image treatment (scanning and recording is necessary, however simple the image correction) is still budgeted in frames, or at best, minutes of screen time.

The potential for major correction, however, introduces technical, ethical and aesthetical questions for the restorer. The colourist may be able to render each scene to a very pleasing result, reversing the effect of faded dyes, but this could be quite unlike the original screen result if the film used a now unfamiliar colour process. Soundtracks potentially can be cleaned up to remove not only noise from an old print, but also much of the ground noise in the original recording. In every case it is necessary to consider whether a faithful restoration is required, or a popularly accessible new version of the film.

See also page 206.

SHRINKAGE – A QUICK MEASURE
Comparing archival film against a modern strip of fim provides a quick estimate of shrinkage. Perfs will rapidly slip out of alignment. In this example, 25 perfs of the top film line up with 24 perfs of film behind – 4 per cent shrinkage.

The photographic image is converted to an electronic one.

Telecine Transfers

Telecine Machines (1)

For many years, telecine machines were used simply for transferring finished film productions, usually prints, to videotape (or even live to air). Early telecines consisted simply of a television camera pointed at a film projector. Current models use either the flying spot system, or a charge-coupled device (CCD).

Modern telecines are geared towards transferring original negative to standard PAL or NTSC, or in some cases to high-definition TV. In addition to the basic colour correction supplied with the telecine, a powerful specialized colour corrector such as the Da Vinci Renaissance may be used. Where the transfer is of camera original negative, logging systems that read the Keykode on the film edge are fitted as well as systems to transfer sound to the rushes tape in sync. These systems are described in more detail in the following pages.

The move towards HD video has brought some telecines closer towards the operation of film scanners – devices that convert film images from original camera negative to high-resolution data for digital image processing, rather than to television.

Analogue or digital

Film scanners (whether CCD or flying spot) and monitors are analogue devices: they operate on a signal which varies in proportion to the brightness of the image. Analogue systems amplify, compress, combine or redirect the signal to achieve the desired effect. With each stage there is a slight distortion of the signal or introduction of noise.

Digital systems convert the initial analogue signal to a string of exact numbers representing the voltage of the signal at any given instant of time. Because all signal processing is applied to these whole numbers, it is possible to duplicate a digital image through many generations with much greater control, and little or no loss of quality.

Video post production is rapidly becoming all-digital: accordingly, digital tape formats are generally used for moving images from stage to stage of post production. Telecine machines have had some digital stages in their system (particularly colour correction) for some time, but the latest generation are digital throughout. This enables other digital equipment such as colour grading systems and video effects generators to be connected directly into the telecine system. The Rank Ursa Gold is entirely digital, as are subsequent high-definition capable machines. They can be incorporated with a range of colouring and effects boxes to offer most of what was previously done in on-line edit or video effects suites.

Image steadiness

The negative's position in a camera is set by pins fitting exactly into the film perforations each frame. Conventional telecine gates guide the film by its edge rather than the perforations, and this may allow very slight weave or jitter of the image – acceptable for routine transfers, but not

so for image compositing effects, titles, etc. Mechanical solutions to this (e.g. the Steadi-Film gate added to Cintel telecines) employ fixed pins in the telecine gate, similar to those in a step printer, and lock each frame in place for scanning. This, however, reduces transfer to slower than real time, and relies on frame-storing devices. Electronic systems add a sensor to the film gate to detect the perforation position during the continuous passage of the film. The result is used to make fine adjustments to the film capstan roller, and to vary the timing of the video lines, thereby displacing the image as required.

The Sony Vialta takes a slightly different approach: the film is stationary while each frame is scanned: its position is calculated by electrostatic detection of the perforations, which drives an optical repositioning system.

Illumination

Flying spot telecines provide an exceptionally sharp image, but because the spot itself, however small, is brighter in the middle, it provides a soft edge to the finest detail in the resultant image, which some people prefer to the fixed, hard-edged digital feel of transfers on CCD machines. Modern CCD machines have carefully designed diffuse light sources (the Spirit light source is designed by Kodak), which reduce the film grain structure shown so clearly by earlier machines. This also helps to hide very fine cinch marks or sparkle on the negative, giving an apparently cleaner result without recourse to digital dirt concealment.

Colour correction

The Cintel series of telecines provide primary colour correction in the form of electronic processing (either analogue or digital) of the image signal received from the photomultiplier. Where the negative is quite dark due to overexposure, this necessitates amplification of the entire signal, causing a slight increase in electronic noise. The same is true of dark areas of a print.

Newer machines provide some of the colour correction by adjusting the brightness of illumination of the negative. This may be an overall control varying the lamp output or, in the case of the Vialta, controlling solid-state shutters in each red, green and blue light path.

Considerably greater colour correction power is usually added with supplementary equipment such as Renaissance Da Vinci or Pogle colour correctors, which process the signal after it leaves the telecine, before recording.

Telecine Machines (2)

Flying spot

A focused beam from a small cathode ray tube scans the film as it passes through the gate. The beam passes through the coloured dyes of the image, and is then split through a system of dichroics into red, green and blue components and picked up by three photomultiplier tubes. Unlike a film projector, the film runs continuously, driven by a smooth sprocketless capstan. The position of the flying spot is controlled so that it scans an entire frame, top to bottom, as it passes through the gate. The exact speed and steadiness of the film movement is controlled by a servo system that detects the position of film perforations.

The movement of the flying spot can be varied to scan a smaller or larger frame, allowing easy adjustment to different aspect ratios. Ursa Gold telecines as well as the later Cintel C-Reality HD machine are capable of rotating the flying spot's pattern, so that the image can be tilted or deformed without any digital processing, avoiding the loss of resolution that such processing would entail. In many machines, the film can be run at a range of speeds (typically between 16 and 30 fps). A frame store is used to match the (non-standard) scanning rate to the requirements of the video system, by delaying, repeating or dropping fields from time to time.

CCD

A line array CCD consists of a large number (typically 1024 but 1920 for HD telecines) of photodiodes, electrically sensitive to light, arranged in a single row about 1 cm long. An optical system projects the continuously moving film image via a prism beam-splitter, through red, green and blue filters onto three such arrays. Every few microseconds, the pattern of electrical charge along the 1024 cells is shifted out and may be interpreted as a signal for one line of the video image.

Although the CCD system is simpler and less expensive than a flying spot scanner, it has certain limitations. Older CCDs had a lesser dynamic range, and the low signal from dense areas of film, particularly in the blue colours, was sometimes a limiting factor, although this is certainly not the case with newer telecines. Because scanning relies on film movement, it is impossible to view a complete frame when the film is stationary. The CCD system is inherently more stable both in the long and the short term, although the latest generation of flying spot machines have sophisticated self-calibrating systems to ensure a consistent output.

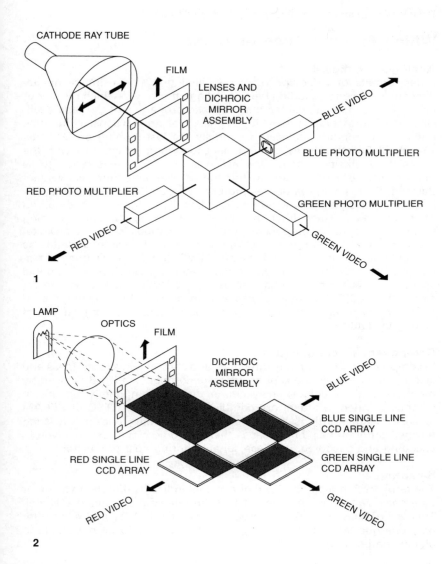

CATHODE RAY TUBE

FILM

LENSES AND DICHROIC MIRROR ASSEMBLY

BLUE VIDEO

BLUE PHOTO MULTIPLIER

RED PHOTO MULTIPLIER

GREEN PHOTO MULTIPLIER

RED VIDEO

GREEN VIDEO

1

LAMP

OPTICS

FILM

DICHROIC MIRROR ASSEMBLY

BLUE VIDEO

BLUE SINGLE LINE CCD ARRAY

RED SINGLE LINE CCD ARRAY

GREEN SINGLE LINE CCD ARRAY

RED VIDEO

GREEN VIDEO

2

TYPES OF TELECINE
(1) The flying spot machine scans film with a light beam generated by a cathode ray tube. (2) The CCD machine reads the film line-by-line as it passes an array of light-sensitive photosites.

Videotape formats vary in cost, quality and application.

Which Format: Tape or Disk?

Analogue or digital
Older formats of videotape record an analogue signal. Image quality depends on factors including tape speed and the way in which the colour image is encoded, as well as the magnetic properties of the tape itself. One-inch C format tape runs at high speed, making it expensive but quite immune to dropouts. Betacam (originally the fast-running professional version of Betamax) uses a component recording, in contrast with the 1-inch C composite system. One-inch was for many years regarded as the standard broadcast format, but the smaller and more convenient Betacam SP is now regarded as the best all-round analogue format.

Several cassette tape standards for digital recording have emerged in recent years. They differ in tape dimension, speed and encoding system. D1 records a component signal; D2 is composite. DCT and Digital Betacam use mild compression. The latter uses the same cassettes as conventional Betacam SP. Panasonic's DVC and DVCPRO (the professional version of this extremely compact medium which runs at double speed to reduce dropouts) as well as Sony's DVCam use 5:1 compression. The DVCPRO format is also known as D7. Only uncompressed digital video is entirely free of generational losses during stages of editing or duplicating.

Component or composite
In component recording, the luminance and chrominance (brightness and colour) video signals are kept as separate components (RGB as used by monitors and in colour analysers is also a component signal). In composite video, the data are combined into a PAL, NTSC or SECAM television signal. This is a reliable way of recording and broadcasting finished programmes, but because there is some slight loss involved in encoding and decoding, it is less suitable during post production.

Sampling
The term 4:2:2 in a composite digital signal indicates that the two colour difference signals are sampled at half the rate of the luminance signal. This is normally accepted as broadcast standard: 4:1:1 and 4:2:0 offer only one quarter colour sampling, and this is likely to be noticeable in digital compositing.

Applications
Because of their compactness, cameras recording directly to Digibeta or DVCPRO are frequently being used for image capture. Betacam SP and Digital formats have become popular and flexible post production formats for off-line editing, or for transferring film images into the digitized storage systems of non-linear editors. One-inch tape was the universal analogue standard for video post production and for final masters: more commonly now, masters of a finished film will be made on one of the digital formats D1, D2 or Digital Betacam.

See also page 200.

170

Format	Compression	Encoding	Signal/noise (ana) Bit depth (digital)	Tape width (in)	Tape speed (cm/s)	Max playing time (mins)	Audio tracks	Timecode track
Analogue								
VHS	A	Composite		1/2"		180	2	0
S-VHS	A	Composite	45db	1/2"	2.4	120	2	1
one-inch "C"	A	Composite	43db	1"	24.4	30–180	2	1
U-matic	A	Composite	46db	3/4"	9.5	5–60	2	1
Betacam SP	A	Component	51db	1/2"	10.15	5–90	4	1
Digital								
D 1	1:1	Component	4:2:2, 8 bit	3/4"		6–90	4	1
D 2	1:1	Composite	8 bit	3/4"		6–100	4	1
D 3	1:1	Composite	8 bit	1/2"	8.4	10–180	4	1
D 5	1:1	Component	4:2:2, 10/8 bit	1/2"	16	12–94	4	1
D 16	1:1	=D1 AT 16× resolution		3/4"		1–5	4	1
Compressed Digital								
Digital Beta	2.3	Component	4:2:2, 10 bit	1/2"		12–124	4	1
DVC (DV)	5:1	Component	4:2:0	1/4"		6–60	2	1
DVCPRO	5:1	Component	4:1:1	1/4"		12–126	2	1
DVCam	5:1	Component	4:2:0	1/4"		184	2	1

WHICH FORMAT: TAPE OR DISK?
Some digital formats use mild compression. This is not always noticeable in a single generation of recording, but is much less suitable for multi-generational effects.

A frame doesn't always equal a frame.

Film and Video Frame Rates

The difference between the 24 fps speed of film shot for the cinema, and 25 fps PAL tape or 30 fps NTSC tape, leads to more confusion than possibly any other area of post production. With the exception of a few PAL video recorders that have been modified to record and play back at 24 fps (strictly an in-house, non-standard modification), video is quite uncompromising in its frame rate. Film, on the other hand, may easily be played back at a non-standard speed, but only at the cost of altering the running time and thereby throwing pictures out of sync with separately recorded sound. Sound, in turn, belies any speed change by a shift in pitch or tone.

The most damaging problems arise when, due to the difference in frame counts, negative cutting lists are derived from non-linear EDLs with one- or two-frame errors, which are difficult to spot until the original negative has been cut. Almost as bewildering are the problems faced by a sound editor when tracklaying drifts in and out of sync. These problems can be avoided by planning the entire post production pathway in advance, and in consultation with all parties involved. Often, a process recommended by – for example – the negative matcher might produce problems for the sound editor, or the assistant editor may assume (wrongly) that the telecine operator has followed a particular procedure.

At the heart of the problem is the choice of what speed to run the film at, for the initial rushes telecine transfer.

Transferring to PAL at 25 fps

Film for cinema projection is normally shot at 24 fps. Telecine transfers may be run at the PAL speed of 25 fps to preserve the simple frame correspondence. Each video frame corresponds to one film frame. An edge number list produced from the EDL would show exactly the same cutting points as the EDL itself. This method results in fast-running video images and some difficulties in syncing sound for rushes and for editing. However, many of these problems have been addressed in some non-linear editing systems such as Avid's Film Composer, which slows the action down back to real time by displaying pictures at 24 fps. Sound is digitized and synchronized directly to the digitized images at correct speed, and can then be output from the editing system at 25 fps and synced on to the rushes tape.

Film for PAL TV is normally shot at 25 fps and transferred to tape at the same speed. For editing purposes, each frame of tape corresponds exactly to one frame of film. There is no reason for any complexity in matching film frames to video frames if a negative match or extraction is required, and similarly, sound should remain in sync with no difficulties.

In the event that the negative is fine cut and a print is made, the 25 fps standard should be followed throughout, both for picture and sound. On final projection, the programme will run 4 per cent slower and longer than the TV version, and the sound will appear nearly a semitone flat. Transferring a video finished production via kine (frequently

done to TV commercials) will have the same result. The sound can be digitally repitched if required.

Film for NTSC
Because the difference between 24 fps film and 30 fps NTSC video is so great, the PAL compromise (24 is really quite close to 25!) cannot be used. It is quite common to shoot film for NTSC television at 30 fps (strictly, 29.97 fps) to avoid any mismatch.

Digital television – 24P
A bewildering number of standards relating to frame rate, lines in the frame, and scanning styles have been established for digital television. However, in the digital world, it is possible to convert images between standards, although naturally the quality of the end result is limited by the quality of the original.

In the area of post production, a standard known as '24P' has gained some degree of consensus. The important features of this system are a frame rate of 24 fps – the same as cinema film – and a progressive scan. This means that there is no interlace. A frame is scanned line by line from top to bottom in a single pass, taking 1/24th of a second.

This system has therefore taken the two simplest features of film and matched them, considerably simplifying the future requirements of transfer from film to digital TV. As long as there remains a requirement for standard television, however, the difficulties described above must still be addressed.

See also pages 184, 186.

It's not always possible to cut film on the same frames as video.

Video Transfers: Hybrid Frames

Transferring to PAL at 24 fps
PAL video runs at 25 fps, with each frame consisting of two interlaced fields scanned one after the other, each showing alternate lines of the TV screen. Most modern telecines can run film at 24 fps and use a frame-store to insert additional fields to make up the correct frame rate for tape. Every twelfth frame of film is recorded onto three consecutive video fields, whereas all other film frames occupy the normal two fields. After 24 film frames (1 s), two extra fields have been recorded, making up 25 video frames. This means, however, that every half second, the film cycle gets out of step with the video cycle. Half the time, fields 1 and 2 of a video frame correspond to the same film frame. In the other half of each second, the video frame is a hybrid, consisting of the second field of one film frame and the first field of the next.

Transferring to NTSC
In NTSC a similar problem arises: film runs at 24 fps but must be transferred to a video system at 30 fps. Film frames are alternately scanned twice and three times ('3/2 pull-down'), yielding five fields for every two frames. Every set of four film frames follows a cycle. Only the first frame in the film cycle corresponds exactly with two fields of one video frame. This frame is called an 'A' frame: B, C and D frames in the cycle are split between successive video frames before film and video advances come back into step. Film logging systems require the ABCD cycle to be specified in the data so that film and video cutting points can be accurately matched. In many cases, logged film sections must begin on an A frame. Alternatively, some non-linear systems can be set to digitize only those fields that correspond to exact film frames, but these also require the 'A' frame to be identified correctly. Sound is once again synchronized to the 24 fps digital images.

Hybrid frames
Non-linear editing systems usually capture just one field per frame. During the hybrid half of each second, the film frame actually seen in this 'one-eyed' view depends on whether the captured field is field 1 or field 2. Conventional video editors place edits immediately before one field or the other according to their 'dominant field' setting, forcing the same distinction. It is essential that all transfer, logging, recording, syncing and editing systems have the same field dominance setting if edit decisions are to be tracked accurately even in 25:25 film transfers, and crucially so in 24:25 or 24:30 transfers. If logging data are based on field 1 dominance but the non-linear system has digitized field 2, for example, about half of the negative cuts calculated from an EDL will be wrong by one frame.

See also page 102.

Video transfers: hybrid frames

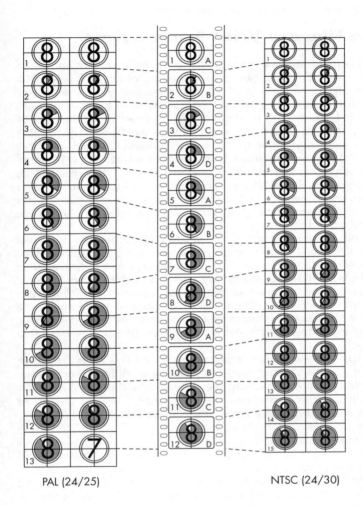

PAL (24/25) NTSC (24/30)

EXTRA VIDEO FRAMES
With film at 24 fps and PAL video at 25 fps, every twelfth film frame is scanned for three fields instead of two in order to create the extra video frame needed each second. For half of each second, video frames are hybrid. In NTSC, film frames are scanned alternately twice and three times, yielding a cycle of five video frames for four film frames. Film frames are designated A, B, C or D according to their place in the cycle.

Try out the cut on a print first: you only have one chance with the negative.

Matching Film and Video Frame Counts

Because of inserted frames, there are differences between film and video frame counts. In PAL video, two timecodes that differ by 4 s are 100 frames apart: in film running at 24 fps, 4 s represents 96 frames. Every second, one frame of film has been repeated twice in the videotape to make up the full 100 frames. If all edits were an exact whole number of seconds long, then negative matching software would have no trouble in finding the exact film frame to cut, and sound would remain in sync.

However, if the frame required is another 10 frames on (110 video frames), the corresponding film frame may be frame 105 or frame 106, depending on whether the 10 video frames include the next repeated film frame or not. Provided the location of the repeat frame in the 1-s cycle has been logged correctly, the computer can match the video cut frame exactly every time.

There is still one more problem, however: 110 frames on video last exactly 4.4 s. On film, cutting to the same frame, the shot lasts 4.375 or 4.417 s, depending on the repeat frame. A fractional frame difference is inevitable. These differences, each one less than a frame, could accumulate or cancel out as the reel progresses, causing a drifting sync problem with the soundtrack. Some computer systems make one-frame adjustments to the negative cutting list to eliminate this drift: this means, however, that the film cutting frame is not always the same as the video cutting frame.

Provided the location of the repeat frame in the 1-s cycle has been logged correctly during image digitizing, non-linear editing systems such as Lightworks are able to identify the repeated field and skip it. This method eliminates the frame errors and provides a real-speed rushes tape, but depends on accurate entry of repeat-field data.

Pos conforming

The possibility of error in these complex processes is very real: to avoid miscutting the original negative, it is best to conform the work print to the converted EDL first. The best way of checking is to run this against the sync soundtrack, or to telecine the work print, digitize it and compare it with the original edit. Only when accuracy has been confirmed should the negative be cut. If no work print has been made, it is possible to extract full takes of negative (camera-stop to camera-stop) using the EDL as a guide, and to print these in preparation for the pos conform.

As a second best option, if the negative is to be cut directly, this should be done before the sound mix is finalized: any obvious sync problems can be adjusted in sound editing.

See also page 102.

Sequence 1

VIDEO	FILM
11	11
12	12
13	13
14	14
15	15
16	16
17	17
18	18
19	19
20	20
21	21
06	06
07	07
08	08
08	08
09	09
10	10
11	11
12	12
13	13
17	17
18	18
19	19
20	20
21	21
25 FRAMES =1 SECOND	24 FRAMES =1 SECOND

Sequence 2

VIDEO	FILM
01	01
02	02
03	03
04	04
05	05
06	06
07	07
08	08
08	09
09	10
10	06
06	07
07	08
08	09
08	10
09	11
10	12
11	13
12	07
13	08
07	09
08	10
08	
09	
10	
25 FRAMES =1 SECOND	22 FRAMES =22/24 SEC

FRACTIONAL FRAMES

During transfer to PAL at 24 fps, every frame 08 is repeated twice. The exact length of film corresponding to a video shot depends on the number of frame 08s included. In sequence (1) there is only one repeat, so the film sequence runs to edited time. In sequence (2) there are three repeat frames, so the film sequence is shorter, even though the cuts are on the correct frame.

A powerful system for numbering video frames by the clock.

Timecode

Video frames are counted by timecode, whereby every frame has a unique count of hours, minutes, seconds and frames. A timecode generator creates the counting data, which may be recorded into one audio track on videotape (longitudinal timecode) or encoded as part of the video signal (vertical interval timecode or VITC, pronounced 'vitsy'). 'Burnt-in' timecode, or a 'window dub', is a copy of the videotape with the timecode displayed on the screen. Note that subsequent dubs or edits retain the original burnt-in window, even though the tape may have new timecode. Longitudinal timecode can be striped onto a videotape before or after the image is recorded: VITC must be recorded at the same time.

Additional information (typically video reel numbers and other identifying data) may be digitally encoded into the 'user bits' part of the timecode signal. Frequently, in rushes transfer, the video roll number is set into the hour value of the timecode as an aid to roll management.

Timecode is used to maintain sync between image and sound tracks on different devices. Timecode is similarly used in off-line video or non-linear editing systems to record edit decisions.

Timecode standards
There are four principal counting systems: all assume normal clock time, but differ in the frame counting.

- PAL timecode counts 25 fps.
- Film timecode (not applicable to video) counts 24 fps.
- NTSC non-drop-frame timecode counts 30 fps.
- NTSC drop-frame timecode corrects a discrepancy between timecode and clock time. For historical reasons, NTSC colour TV runs at 29.97 fps and not 30 fps. Counting 30 fps, non-drop-frame timecode runs slower than true clock time by 3.6 s per hour. Drop frame timecode skips two frame counts every minute (going from :59:29 to :00:02), except at every 10th minute. Note that frames themselves are not removed, simply the numbers (similar to leaving out the 13th floor in a building, or adding a leap day every 4 years). This ensures that timecode is never more than two frames out from clock time.

The NTSC timecode formats may be used on material running at 29.97 fps or at a true 30 fps.

While drop-frame timecode provides a correct timing for TV programmes, discrepancies can still arise when films are transferred to tape. To match the 29.97 video speed exactly, film is transferred at 23.976 fps. A film timed at exactly 1 h would overrun its NTSC TV time slot by 3.6 s, but a 'non-standard' speed of exactly 24 fps, with occasionally skips in the 3/2 sequence, may be used.

In-camera timecode
Timecode recorded during production is often referred to as 'time-of-day' timecode. The timecode generator runs continuously and remains accurate to within one frame over the course of a day. All such generators are simply synchronized each morning at the start of shooting.

178

Time-of-day code is discontinuous at each camera or sound tape stop, reflecting the elapsed time between takes. By contrast, video timecode, generated at the time of recording a tape, or striped onto the tape in a separate pass, runs continuously through the length of the roll.

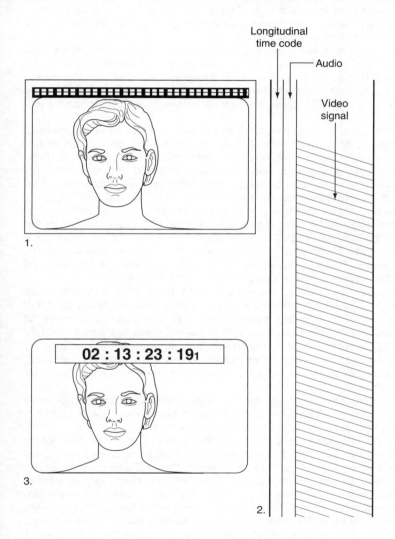

Longitudinal time code

Audio

Video signal

1.

02 : 13 : 23 : 19₁

3.

2.

TIMECODE
Timecode may be encoded into the video signal (1) as data between each frame (VITC), or it may be recorded separately alongside the video signal (2) as an audio track (LTC). In either case a display of the code may be burnt into the image (3) purely for visual reference.

Logging Keykodes and Timecodes (1)

When film is transferred to tape for editing, it is vital to build a transfer log, which shows the relationship between the film edge numbers, or Keykode, and the video timecode. These data must be of absolute accuracy – even a one-frame error will lead to miscut original negative as well as likely sound sync problems.

The negative matcher will have specific requirements for the transfer and the negative should be prepared to this specification. It cannot be over-stressed that consultations with the negative matcher, the editor and the sound editor are all vital before telecine transfer is started: they all have very specific requirements to manage edit lists and sync correctly.

In the simplest of operations, an uncut roll of negative is transferred, uninterrupted, at 25 fps (PAL). A hole is punched in one frame at the head of the roll – before the first slate. It is sufficient to record the timecode and Keykode that correspond to the punched frame: the codes for any subsequent frame can be easily calculated. It is good practice when logging manually, however, to check at the end of the roll that Keykode, timecode and frame count are still in register with each other.

The Keykode can be read during the transfer if a reader is fitted to the telecine: these data, together with the corresponding timecode, are stored in a data file created by logging systems such as Excalibur, Osc/r, Aaton Keylog, TLC, etc. Some systems such as Evertz can record and display the Keykode in a window on the video recording.

Some non-linear editing systems provide their own programme for converting EDLs to Keykode lists. While these data fall short of a full negative matching logging system, they do eliminate one stage of converting and transferring data, and allow the assistant editor to identify individual shots (which may later be required for extraction) by Keykode number to the negative cutter. When such systems are used, the Keykode numbers are logged into the non-linear system at the time of digitizing.

Alternatively, the negative can be logged separately by the negative matcher, using a bench-mounted Keykode reader and viewing a video cassette of the transfer to confirm edge numbers.

Where the transfer is at an interpolated speed (in other words, where video frame rate and film frame rate do not match), it is also necessary for the negative logging system to identify the pull-down cycle. Some telecine systems can be controlled: in NTSC, so that logging always commences on a film 'A frame'; in PAL 24/25, so that the repeated film frame is on a given frame number each second in the timecode. However, it is always advisable for the negative matcher to confirm these settings, usually by a field-by-field viewing of a few frames of the videotape. A clock leader joined to the head of the camera negative makes this operation much easier, and provides a universally recognized sync frame.

Production TO CATCH A CHICKEN Job Number 101
Date Started 09/02/1996 Page 001

NEGATIVE

Can 4 Location In
Roll A 35mm 1866 FT Length 021 09/02/1996 V 30:30 F 30:00
CAM ROLLS 11, 12, 13, 14

Scene	FCC	Length	Man	Pref	Start	End	Video timecode		F	Tape
1	0	360	??00	0000	0000–00	0022+07	15:01:15:00	15:01:26:29	A	15
2	360	85	KX34	2767	1639–00	1644+04	15:01:30:00	15:01:32:24	A	15
3	445	837	KX34	2767	1712–00	1764+04	15:01:33:17	15:02:01:13	A	15
4	1282	1688	KX34	2767	1825–00	1930+07	15:02:08:13	15:03:04:20	A	15
5	2970	1737	KX07	1311	5138–00	5296+08	15:03:18:23	15:04:16:19	A	15
6	4707	1332	KX07	1311	5304–00	5387+03	15:04:31:05	15:05:15:16	A	15
7	6039	1364	KX07	1311	5388–00	5473+03	15:05:26:20	15:06:12:03	A	15
8	7403	952	KX07	1311	5482–00	5541+07	15:06:23:15	15:06:55:06	A	15
9	8355	928	KX07	1311	5549–00	5606+15	15:07:03:05	15:07:34:02	A	15
10	9283	1216	KX07	1311	5608–00	5683+15	15:07:41:25	15:08:22:10	A	15
11	10499	452	KX07	1311	5685–00	5713+03	15:08:32:15	15:08:47:16	A	15
12	10951	612	KX07	1311	5721–00	5759+03	15:08:51:10	15:09:11:21	A	15
13	11563	648	KX07	1311	5760–00	5800+07	15:09:16:25	15:09:38:12	A	15
14	12211	748	KX27	8020	3022–00	3068+11	15:09:43:25	15:10:08:22	A	15
15	12959	1284	KX27	8020	3071–00	3151+03	15:10:15:00	15:10:57:23	A	15
16	14243	1256	KX27	8020	3155–00	3233+07	15:11:08:15	15:11:50:10	A	15
17	15499	964	KX27	8020	3239–00	3299+02	15:12:00:25	15:12:32:28	A	15
18	16463	832	KX27	8020	3305–00	3356+15	15:12:41:00	15:13:08:21	A	15
19	17295	884	KX27	8020	3358–00	3413+03	15:13:15:20	15:13:45:03	A	15
20	18179	1956	KX34	2767	0028–00	0150+03	15:37:16:10	15:38:21:15	A	15
21	20135	9736	KX34	2767	0151–12	0758+11	15:38:37:25	15:44:02:10	A	15

KEYKODE AND TIMECODE LOGGING
A negative Keykode log shows the Keykode at the start and end of each complete
section of film, together with the associated video timecodes and reel numbers
if the negative has been transferred to tape.

Logging Keykodes and Timecodes (2)

If there are splices in the negative roll then the sequence of Keykodes is interrupted. Both bench and telecine logging systems recognize this. As soon as an unexpected Keykode is read, a new record is created, re-establishing a new relationship between Keykode and timecode.

It is essential that rolls of 35 mm are joined together in rack, so that the image remains correctly framed. Any adjustment during transfer or logging will upset the relationship between timecode and Keykode.

Most logging systems also allow section boundaries to be logged at will, so that details such as slate number, scene description or comments, and even grading lights, can be recorded against each take. Where selected takes are being transferred, it is also common practice to punch a hole in a specific frame at the start of each take. This may be alongside a Keykode 'zero reference frame', but in NTSC transfers it is usual to punch the hole in the 'A' frame where the logged scene commences.

Interrupted telecine transfers

Some telecine logging systems can detect if telecine transfer is interrupted (e.g. to transfer only selected takes from uncut negative, or if the transfer operator has stopped to colour correct the image or establish sound sync). A new log record is created every time film and videotape restart and regain sync lock. However, if any frames of film are transferred twice, or if timecode is repeated, the resultant log is likely to become complex and ambiguous. Difficulties in negative cutting will inevitably follow.

For bench logging (after telecine), continuous, uninterrupted telecine transfer is essential. Where frame-exact negative cutting is required, uninterrupted telecine transfer is highly recommended.

Negative should never be 'shuttled' at high speed on telecine, to go to the next or the previous section, as this increases the risk of damage.

Telecine logs are frequently created using different software from the eventual editing or negative cutting systems. Most software, however, recognizes a common file exchange format: the FLeX file. This is a text file that contains a variety of data for each 'event' or section of film or tape. A single event has continuous, uninterrupted timecode and edge numbers: the log may optionally include scene and take numbers, colour correction data, scene description or comments, sound sync timecode and so on, as well as Keykode and timecode. Where any of these data change, a new event is defined. This may occur as often as each slate where audio (time of day) timecode is logged.

Sound may be synchronized in the telecine suite using the Aaton logging system.

See also page 186.

```
000 Manufacturer     No. 020 Equip      Version 2.2     Flex 1001
010 Title TO CATCH A CHICKEN
100 Edit 0001     Field A1              NTSC Split       Delay
110 Scene         Take                  Cam Roll         Sound
200   35          30.00 307    000022+08 Key ????  ??000000 000000+00 p1
300   55          At 15:01:15:00.1 For 00:00:15:00.0

100 Edit 0002     Field A1              NTSC Split       Delay
110 Scene A3C Take X                    Cam Roll         Sound
200   35          30.00 307    000005+05 Key EASTM KX342767 001639+00 p1
300   55          At 15:01:30:00.1 For 00:00:03:16.0

100 Edit 0003     Field A1              NTSC Split       Delay
110 Scene A3C Take 2                    Cam Roll         Sound
200   35          30.00 307    000052+05 Key EASTM KX342767 001712+00 p1
300   55          At 15:01:33:17.1 For 00:00:34:26.0

100 Edit 0004     Field A1              NTSC Split       Delay
110 Scene A3D Take 2-3                  Cam Roll         Sound
200   35          30.00 307    000105+08 Key EASTM KX342767 001825+00 p1
300   55          At 15:02:08:13.1 For 00:01:10:10.0

100 Edit 0005     Field A1              NTSC Split       Delay
110 Scene 1D  Take 3                    Cam Roll         Sound    00:08:51:07.1
200   35          30.00 308    000108+09 Key EASTM KX071311 005188+00 p1
300   55          At 15:03:18:23.1 For 00:01:12:11.0
400 Conv  30.00 Fps        At 00:08:51:07:1

100 Edit 0006     Field A1              NTSC Split       Delay
110 Scene 1E  Take 1                    Cam Roll         Sound    00:10:09:09.1
200   35          30.00 308    000083+04 Key EASTM KX071311 005304+00 p1
300   55          At 15:04:31:05.1 For 00:00:55:15.0
400 Conv  30.00 Fps        At 00:10:09:09:1
```

THE FLeX FILE FORMAT

The FLeX file format is an industry standard for exchange of logging data between editing systems. Each film section is denoted by a group of data lines. Line numbers indicate the type of information that is to follow.

Putting the right sound with the pictures . . .

Synchronizing Rushes (1)

Syncing to film
The sync dialogue sound recorded during shooting must be synchronized to the image after negative processing, for editing. In conventional sprocket editing systems, while a work print is made of the image, the sound (recorded either on 1/4-inch tape or on DAT) is transferred to 16 mm or 35 mm sprocketed magnetic film. The assistant editor then synchronizes each take of sound to the image by aligning the 'clap' sound to the frame where the clapsticks come together. Edge numbers (known as 'Acmade' or 'rubber' numbers) are then inked onto the work print and sound film, so that, during editing, picture and sound can be kept in sync: the cut and spliced sprocketed sound track then becomes one element of the sound mix.

Syncing at telecine transfer
If rushes are transferred to videotape (for non-linear editing) directly from camera negative, the first opportunity to synchronize the rushes sound is during the telecine session. It is possible to synchronize each take separately by searching for slates and clapper sounds, but this is very time-consuming during an expensive telecine session. The process becomes more practical if electronic slates are used at the shoot. These are like a conventional slate, with the addition of an LED display of timecode. A smart slate has its own in-built timecode generator, which must be synced to the sound recorder's time at the start of the day. (Take care that the correct timecode system (e.g. 30 fps drop-frame) is set for all clocks.) A dumb slate is connected to a master generator and requires no further syncing. (Some tape recorders have an internal timecode offset, so that there is still a discrepancy between recorded and displayed code, which must be allowed for.)

During telecine transfer, the operator stops at each slate and types the displayed timecode into the system. Provided the telecine suite is equipped with suitable timecode control systems, the DAT player is then controlled to transfer the sound in sync with the image for the duration of the take. There must be a pre-roll of 5–10 s (depending on the equipment used).

Timecode must be striped onto 1/4-inch sound tapes to videotape or to a digital record before it can be synchronized. DAT is automatically timecoded.

Slates are not always reliable, and a conventional 'clap' is a simple way of verifying that sync is accurate.

Syncing after telecine transfer
For more flexibility, rushes sound may be synchronized after telecine transfer, using an edit controller or synchronizing controller to dub sound from a timecoded DAT directly onto the audio track of the rushes cassettes. This is time-consuming as picture and sound are transferred separately, although edit controller time is cheaper than telecine time.

See also page 172.

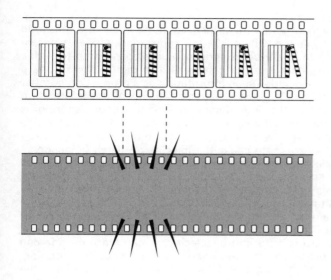

SYNCHRONIZING RUSHES

Sound transferred onto sprocketed magnetic film is synchronized by aligning the
sound of a clapstick with the image frame that shows the clapstick closing. Slates
controlled by a timecode generator display the audio timecode, which can be read
from the recorded sound tape to aid in syncing.

Synchronizing rushes (1)

. . . and keeping everything in time.

Synchronizing Rushes (2)

Timecode on film

Many cameras now incorporate the principles of the in-camera timecode system developed by Aaton. Obviously, the appropriate reader is necessary on the telecine. In this system, timecode is exposed onto the edge of each frame of negative – in the camera – in a digital checkerboard pattern. The code also includes such information as a production number and camera number, and a human-readable version of the information appears every second. At the time of shooting, the timecode generator is synced with the sound recorder's timecode. During telecine transfer, this code is read from the negative as it passes through the telecine gate, and used to force the DAT player to chase the telecine to match timecodes.

Because both telecine film transports and DAT players take time to reach a stable sync speed, several seconds 'pre-roll' is needed to synchronize each take. This time-consuming procedure may be eliminated by transferring sound takes onto a CD-ROM or JAZ drive before the telecine session, allowing almost instant synchronization of each sound take as soon as the image starts.

If used properly in the field and at telecine, in-camera timecode can make the syncing process nearly automatic, with no need for stopping, starting or shuttling of the negative. However, complications arise if the image is to be transferred at a different rate from the camera speed or the timecode standard – a common procedure to simplify later match-back to negative.

Syncing sound while digitizing

Yet another method delays syncing sound until the picture is digitized into a non-linear editing system. Sound is digitized directly onto disk separately: if picture and sound are identified by the same timecode (as with in-camera timecode), they are automatically synchronized by the computer; otherwise, an offset is programmed into the computer. After digitizing, the synchronized sound can be output from the computer and laid onto the rushes tape for screening. After editing, the sync sound-track can be transferred directly to the digital audio editing system with original quality retained, avoiding the need to go back to the original DATs to re-transfer required sections.

This last method also avoids the frame matching difficulties that arise with films transferred to PAL at 24 fps. Film is transferred to video at 25 fps, so that there are no repeat frames, and the timecode is frame-exact. Action runs fast on the videotape, but, once digitized, can be run correctly on the computer at 24 fps. Sound is digitized at its natural speed, and remains in sync during editing: however, it can be output at 25 fps immediately after digitizing, and laid back, in sync, onto the 25 fps video rushes cassette.

Syncing for rushes screening

While the first lab check of rushes is commonly picture only, the crew screening must include sync sound. If the sound has been transferred to sprocketed film for film editing, then it is a simple matter to run the

assembled track 'double-head' with the work print – that is, on a projector with a separate magnetic reader head, or one that is locked to a magnetic dubber.

However, where the sound has been digitized for non-linear editing, it will have been synced to the picture by means of the telecine timecode laid down at the time of transfer – and thus it will follow the make-up of the work print. (If the telecine transfer was from the negative, it is important that the neg remains unaltered between printing and transfer, or sync rushes will fail.) In this case, the sound may be output, with timecode, from the non-linear editor onto DAT, which can then be played in sync with the rushes projector. Alternatively, to save the DAT transfer time, a disk copy (e.g. on JAZ drive) may be played in a Digital Audio Dubber (DAD) locked to the projector.

See also page 172.

IN-CAMERA TIMECODE
Aaton in-camera timecode is exposed onto the edge of every frame of film in a digital format and intermittently in human-readable form. On 35 mm it is on the opposite edge to Keykode; on 16 mm it appears between the perforations.

Take care of the negative.

Film for Telecine Transfer

Camera negative

Film for a television finish is invariably transferred directly to tape from the negative. Similarly, many film-finish productions save work print costs by transferring 'rushes' directly from negative to tape for non-linear editing. The negative is frequently transferred immediately after processing. Film emulsion normally takes a few hours for its moisture content to stabilize after drying, and during this time it is softer than normal, and may even be slightly swollen. Care in film handling becomes crucial, to avoid rubs and scratches as well as fine dust or dirt, which is likely to become pressed into the emulsion and difficult to clean off. Telecine gates and rollers must be cleaned and maintained regularly, and the entire film environment of the telecine suite should be spotless. Film should ideally be transferred without stops and starts. If only 'print' takes are to be transferred, 35 mm negative may be cut for an uninterrupted run. If 'print' takes from the uncut negative are to be transferred, due attention must be given to the logging process and there must be minimal rewinding or shuttling on the telecine. In 16 mm, handling marks are more critical, and the recommended procedure is an uninterrupted transfer of uncut camera rolls.

Transferring from work print (if it is available) eliminates all telecine negative handling worries, and frequently turns out to be a more cost- and quality-effective procedure in the long run.

Finished productions

Positive print has a much higher contrast than negative, often too great for telecines to handle successfully. Particularly, in older telecines, optical flare and electronic noise can degrade shadow areas quite badly. A low-contrast print using stock designed especially for telecine will reduce this problem with dark or contrasty subjects.

Furthermore, it is important, when transferring from print, to ensure that the print itself is fully and accurately graded. Negative contains a very wide range of tonal information, and film grading makes a selection from this tonal range to reproduce on a viewable film print. If the print is poorly graded, then shadow, highlight or colour information may be compressed or lost completely. It would not be possible for telecine grading to recover this information.

Many colourists prefer to transfer from a fully balanced 'IP' or colour interpositive made from the final cut negative. This preserves the fullest range of image information from the negative, but maintains the benefits of transferring from a single, graded, splice-free roll. Often, a skilled colourist will obtain a better result from an interpos, but the grading session may take longer as the grading options remain more flexible.

See also page 60.

PURPOSE OF TRANSFER	FILM TYPE	TELECINE TYPE	FEATURES NEEDED	COMMENTS
Rushes transfer for non-linear editing and film finish	Original negative	Dixi, Cintel MkIII, Ursa, FDL 60,90	Sound syncing, Keykode logging, only basic primary colour correction	Low-cost image transfer with off-line quality is required. Avoid shuttling negative.
	Work print		Syncing, logging as above. Older tubes and CCDs may struggle with dark prints	Protects original negative. Keykodes may not print through well.
Rushes transfer for TV finish	Original negative	Ursa, Spirit, Shadow	Syncing, logging Primary colour correction for 'flat' transfer	Transfer to component digital tape for tape-to-tape edit and grade
Rushes transfer for HDTV finish	Original negative	Spirit, C-Reality, Millenium, Vialta	HD transfer and recording	May be transferred to HD and STV simultaneously on some machines
Film scanning for digital intermediate (& film finish)	Original negative	Spirit, Vialta, film scanner (e.g. Genesis)	2K resolution is used for digital grading. Perf registration for steadiness if compositing	Slow transfer (typically 6fr/sec) for maximum steadiness, colour and resolution
Finished product for video mastering	Interpositive	Ursa, Spirit, etc.	Colour corrector, sound transfer. may need transfers to various formats (e.g. NTSC, PAL, HD)	more colour correction possible (e.g. secondary, power windows etc.) so takes longer but better result
	Low contrast print			successful compromise between IP and print
	Answer print			cheapest, quickest transfer with less scope for colour correction

TELECINES FOR DIFFERENT PURPOSES

Not all telecines are suited to all purposes. Choice of telecine or of film stock may also be influenced by peripheral equipment such as secondary colour graders or noise reducers, and by the film materials that are available.

Highlights and shadows can be adjusted to get the best video image.

Grading on Telecine: Rushes Transfers

Colour correction for tape is far more flexible than film grading. In primary colour correctors, often an integral part of the telecine itself, overall colour quality is determined by three controls, each of which can adjust any one colour or all of them.

The gain control can be adjusted to make white and highlight tones lighter, darker or to change their colour balance. Mid-tones and shadows are proportionally less affected by this setting.

The lift control has a similar effect on black and shadow tones. Variation can compress and even crush thin shadows to black, or lighten deep blacks to grey, sometimes revealing more shadow detail. Shadows can be given an overall colour cast (or have one removed) with less effect on mid-tones.

The gamma control lowers or raises the mid-tones, giving the image an overall lighter, darker or different-coloured look without affecting the white or black levels. While gamma in film terms is a measure of the overall contrast of an emulsion, in video terms it is more to do with apparent brightness than with contrast.

It is also possible to vary the chroma, or colour saturation, of an image. At one extreme, this yields a pure monochrome image; at the other extreme, even subtle shades become bright poster colours.

Video monitors display a much lower brightness range than film projection (around 20:1, compared with over 100:1 in an average theatre), and so much more careful placement of the image in the available tonal range is necessary when transferring negative to tape. Corrections are usually necessary.

Unfortunately, this can be misleading where no film work print is made, as the inherent negative problems are not revealed. In particular, as telecine grading controls are not calibrated in any way that relates to film exposure, it is rarely possible for a colourist to report on just how much contrast or colour correction has been applied.

Flat or compressed transfer

When film is shot for a TV finish, instead of selecting negative and re-transferring it after editing, it is increasingly common to transfer all the material to a digital tape format, then use the EDL for on-line editing and final tape-to-tape grading from the digital tapes. In this case, the first grade must be very flat, preserving the full range of tones of the original negative so that unrestricted grading choices can be made at the later tape-to-tape stage. The image after the film transfer is visually dull, and can give a poor impression of the image quality. Some telecine houses are able to simultaneously record a flat digital master tape and a 'rushes graded' cassette for viewing and editing purposes. Noise reduction should only be applied at the final tape-to-tape grade.

Delaying the creative grading until the tape-to-tape session allows shots to be graded in final sequence. The job is usually done by a senior colourist, and more time is allowed than for the overnight rushes transfer.

See also pages 42, 58.

190

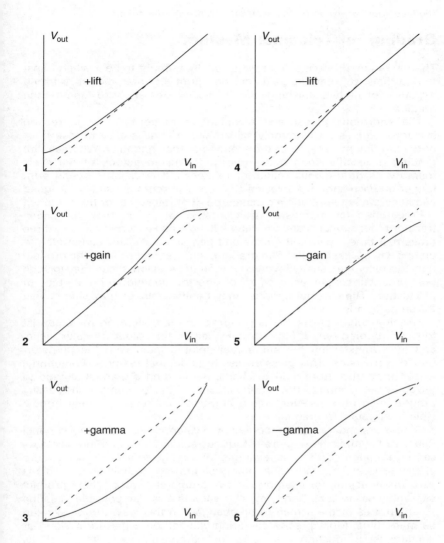

GRADING ON TELECINE
(1) Increasing lift lightens blacks; decreasing it (2) may crush very dark tones to black. (3) An increase in gain pushes whites to the limit, and may clip; decreasing gain (4) will render whites as grey. (5) Increasing gamma flattens shadows and darkens mid-tones, increasing highlight contrast; decreasing gamma (6) lightens mid-tones.

Digital colour correction brings even more power to the colourist.

Grading on Telecine: Masters

The full range of telecine controls is usually brought to bear when transferring finished material (e.g. answer print or interpos) or selected negative for on-line finishing. Similar techniques apply to tape-to-tape grading.

The enormous power and flexibility of modern colour correction systems requires an extremely skilled colourist. It is easy to lose track of the original material or of the scene-to-scene continuity. Whereas film grading is usually done quite quickly, taking advantage of the eye's memory of the previous scene for reference, it is usual to spend a lot longer on each shot in a telecine session. The room is usually designed and lit carefully to provide a constant point of reference for the colourist.

Preparation for a transfer usually takes far longer than the actual transfer time; simple scene-to-scene balancing takes a minimum of three times real time – with full effects and pan and scan, this can stretch to up to a day per reel. Unlike film grading, representatives from the production company are usually involved during the session: these may include post production supervisor, editor or director, depending on the type of production. The cinematographer may be available, or may simply visit for an early briefing.

Telecine colour correction is pre-programmed, allowing the colourist to run through a reel of film, carefully setting the colour for each scene, and then transferring the entire reel uninterrupted with the predetermined corrections. This gives access to additional features. Frequently, a shot may track from light to shade, demanding a gradual change to the colour correction as the lighting changes. This 'dynamic grade', easily programmed on a telecine colour corrector, is, however, quite impossible in simple film grading.

Digital secondary colour correction systems such as the Da Vinci Renaissance offer many more colour correction features. Single colours can be targeted so that, for example, all orange tones are made more yellow or less saturated, while other colours remain unchanged. This is particularly useful, for example, in TV commercial work, where product packaging has to consistently match a sample. It is also possible to define a certain area of the screen to be changed: in this way, a grey sky can be made blue. More precise colouring still can be achieved in video or digital post production colouring and compositing systems, such as Paintbox or Inferno.

See also pages 42, 78.

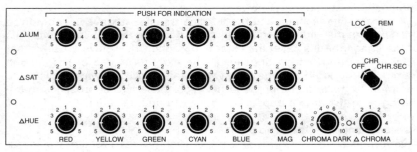

1

2

PRIMARY AND SECONDARY COLOUR CORRECTION

(1) Primary correction: separate joysticks control shadow and mid-tone, and high-light levels and colours. (2) Secondary correction: independent adjustments can be made to any of six basic colour zones, varying the brightness, saturation (purity) or hue, without affecting other colours.

The picture doesn't always fit the frame.

Masking for TV

Safe area
Many domestic TV sets display less than the full image area. To allow for this, standard areas within the standard TV frame area are defined as 'safe action' and 'safe title' areas. All essential parts of the image, and all titles, must appear within these areas. Anything outside may or may not be visible on any particular receiver.

Standard TV
All conventional TV systems have the same screen ratio: 1.33:1 or 4 × 3. When widescreen films are transferred to video, a different masking is required. Since most film cameras expose the full negative area, it is theoretically possible to transfer the entire image, filling the video screen. However, this reveals areas of the frame not seen in the projected cinema version. Cinematographers need to keep the additional top and bottom areas free of artefacts such as microphone booms, dolly tracks or the tops of sets. Cinema and television frames may have a common centre, or a common headline. The latter is often preferable for reasons of both composition and sound boom.

An alternative technique at the telecine transfer stage is to zoom in to the height of the widescreen image, thus cropping the left and right sides of the image. In this case, the cinematographer must have ensured that no essential information appears at the extreme edges of the cinema frame. Titles should also be kept within this restricted width. It is quite common to make a compromise between these two approaches, minimizing both the area cropped and the extra area included.

Pan and scan or letterbox
Anamorphic (2.35:1) pictures present an even greater problem with cropping from left and right of the image. Nearly half the image is lost. The technique of 'pan and scan' allows the telecine operator to frame either in the centre of the film image or to either side, and even to move across the screen during a shot – following a character, or showing just the speaker in a two-shot, for example. However, this frequently upsets the pictorial composition. Pans and scans are programmed during the grading session. It is desirable, though not always possible, to have the director of photography attend this session.

An alternative is to transfer the image in 'letterbox' format, showing the full width of the film frame, and with a black mask area at the top and bottom of the TV screen. TV audiences often complain about the smaller picture this produces, although 'art-house' films are often preferred in this format.

Super 35 and Super 16
Both these formats expose negative that is normally in the 'sound area', and special telecine gates are needed.

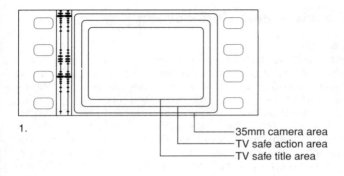

1.

35mm camera area
TV safe action area
TV safe title area

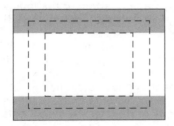

2.

3.

MASKING FOR TELEVISION
(1) Areas near the edge of the film frame (outside the TV safe areas) may be cropped on domestic TVs. (2) Only part of a Cinemascope image can be shown on conventional TV screens: some images may be seriously compromised. (3) From widescreen or Super 35 film, the correct height of image can be shown with left or right cropping, or a larger area of image can be shown, with letterbox masking at the top or bottom of the screen.

Many ways of fitting the screen.

Digital Television and Widescreen

Widescreen (16 × 9)
Television broadcasters in all countries have for many years faced compromises when showing widescreen or anamorphic films. This has now become a more complex problem, as new television aspect ratios are introduced as part of the general transition to digital TV.

Digital television, whether high definition or standard, has the wider aspect ratio of 16 × 9 (1.77:1). There are also analogue standards for widescreen television. Many programme distributors are therefore now demanding TV product in widescreen ratio. While 35 mm film productions shot for widescreen at 1.85:1 fit fairly well, standard 16 mm productions will suffer cropping from top and bottom, and a loss of resolution from the smaller film area used. Super 16, at 1.66:1, is a much closer fit, and as it uses the full width of the negative, offers better resolution with a less grainy image.

To minimize the letterbox effect, a compromise transitional ratio of 14 × 9 or 1.55:1 was introduced by the BBC, and it has been adopted, with some variations, by some but not all other broadcasters. As a result, there is considerable confusion, both in television production and in film for television, over framing conventions both in shooting and in transferring film to tape. Productions may be mastered in a wide variety of compatible or compromised formats.

Widescreen for standard TV
Transferring from Super 16, for example to standard resolution video, it is possible to record the full width of the frame, squeezed, onto Digibeta tape. This will finally be broadcast (on standard TV) stretched out and with the edges cropped. Because only three quarters of the image width is used, there is some loss of resolution, but the entire image is available for upward conversion to HD at a later stage.

Alternatively, the initial transfer may be to HD format (e.g. D5 tape), preserving the entire width of the image. Downconversion to PAL or NTSC for standard TV broadcast will result in some edge cropping (less if a slightly letterboxed 14 × 9 frame is used), but will retain better resolution.

As long as the majority of broadcasting remains in the standard 4 × 3 format, there may be a tendency simply to transfer the centre part of the image to standard 4 × 3 NTSC or PAL tape, and to regard the original negative as a 'future-proof' master, for re-transfer at a later date when required. Quite apart from the additional cost and inconvenience of the re-transfer, this would also require all the colour correction, EDLs, video effects and inserts to be preserved with the negative, and exactly replicated. This may quite possibly not happen, and the 4 × 3 master may be further cropped (top and bottom) to fit a future 16 × 9 requirement!

Issues of safe title areas further complicate the difficult problems of correct framing for television. The best recommendation is to obtain a copy of the guidelines used by the particular studio or broadcaster in question. It is not safe to assume that their methods will be the same as anyone else's, or even if they are, that they will use the same terminology.

See also page 124.

Shot 4 x 3 : displayed 4 x 3

Shot 16 x 9 : displayed 16 x 9

Shot 4 x 3 : displayed 4 x 3 on 16 x 9
(pillarbox)

Shot 16 x 9 : displayed 4 x 3
(edges cropped)

Shot 4 x 3 : displayed 16 x 9
(cropped top and bottom)

Shot 16 x 9 : displayed 16 x 9 on 4 x 3
(letterbox)

Shot 16 x 9 : displayed 14 x 9 on 4 x 3
(minimal letterbox)

SHOOT AND PROTECT

Framing for either 4 × 3 or 16 × 9 television may result in cropping parts of the image to fit the other format. Different networks have evolved different framing conventions to manage this. It is usually necessary to frame the image so that the edges contain usable but not essential parts of the scene.

Digital television and widescreen **197**

'Every hair on his head is numbered.'

Digital Processes

Digital Resolution

Pixels

It is estimated that a well-exposed fine-grained 35 mm negative of a focus chart can resolve to the equivalent of about 3000 pixels across the frame. To sample an image adequately, the scanning resolution must be some-what finer than the detail in the image, so as to avoid sampling artefacts (such as the Moiré patterns formed by striped shirts seen on TV). Because of camera movement, image movement, depth of field limitations and printer slippage, images on film rarely approach the negative's own resolving power.

According to the system used, data in digital film systems may have between 2048 and 4096 pixels per line, and a proportional number of lines (for a full frame image, up to 3112).

Bit depth

Charge-coupled devices (CCDs) produce a linear analogue signal: the output of each element is a voltage proportional to the light falling on it. For image processing purposes, this voltage is digitized, or assigned an exact number within a range. In digital graphics, the numbers 0 to 255 (which can be stored in eight bits, or one byte, of computer memory) have been used for the scale from black to white.

Now, the human eye, like photographic film, can just distinguish a change in brightness of about 1 per cent. For brightness values greater than 100, a change of 1 (e.g. 150 to 151) is indistinguishable. However, at the darker end of the scale, a change from 50 to 51 is about 2 per cent, and clearly detectable. Clearly, an eight-bit scale is not really enough. The visible steps between adjacent values mean that a smoothly gradated shadow would appear instead as a series of bands, or contours. Accordingly, 10 bits (1024 steps) or 12 bits (4096 steps) are generally used to store images in film systems. Greater bit depths are used in scanning in some systems. Furthermore, when values are multiplied (a common operation in image rendering, compositing and so on), some rounding errors occur, and so these processing operations are also done at a greater bit depth.

Kodak's Cineon system digitizes the CCD signal into a logarithmic scale, similar to film density. This matches the eye's proportional response, so that a change of one value is a little under the just-notice-able difference throughout the scale from shadow to highlight. This makes more efficient use of tone-space, but necessitates a greater amount of mathematical processing for many normally linear imaging functions such as shading and rendering.

Apart from the time taken to scan, transfer and record each frame, the size of files is the limiting factor in using digital imaging technology. A full-resolution frame (4K × 3K 10-bit pixels per colour) is represented by over 50 megabytes of data. One second of film requires 1.2 gigabytes of storage (enough for a full commercial at TV resolution).

See also page 56.

198

Aperture/ format	2K half resolution	MB per frame (10bit)	4K full resolution	MB per frame (10bit)
Full Aperture	2048 × 1556	19.1	4096 × 3112	76.5
Anamorphic	1828 × 1556	17.1	3656 × 3112	68.3
Academy	1828 × 1332	14.6	3656 × 2664	58.4
35mm 1.85:1	1828 × 988	10.8	3656 × 1976	43.2
Super 35	2048 × 872	10.7	4096 × 1744	42.8
Vistavision	2048 × 3072	37.7	4096 × 6144	151.0
Super 16	–	–	2048 × 1240	15.2
Standard 16	–	–	1728 × 1240	12.9

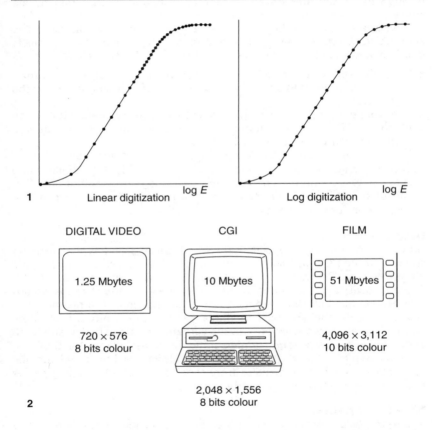

1

Linear digitization $\log E$

Log digitization $\log E$

DIGITAL VIDEO

1.25 Mbytes

720 × 576
8 bits colour

CGI

10 Mbytes

2,048 × 1,556
8 bits colour

FILM

51 Mbytes

4,096 × 3,112
10 bits colour

2

DIGITAL RESOLUTION
(1) Digital data stored in logarithmic space cover the tonal range from shadows to highlights much more evenly. (2) As resolution increases, the amount of computer memory required to store each frame increases dramatically.

Different horses for different courses.

Digital Origination

Despite advances in digital video capabilities, the resolution and colour depth of 35 mm negative remains considerably greater than the best digital video currently available. It is generally estimated that a fine-grained negative would need at least 4K pixel resolution to match it (i.e. a digital image 4000 pixels wide), and in fact spatial resolution of fine detail is considerably increased by the random nature of film grain. A fine detail that may fall between two pixels in a digital system will be recorded by the grains, if not in one frame of film then in the next. Digital resolution is limited by the speed at which data can be transmitted through the circuit and stored on tape or disk, and to an extent by the sheer volume of data to be stored.

Nevertheless, a number of advances have brought digital video cameras to the point where they are used with success on some projects which would previously have been shot on film. These include:

- Developments in the capability of some video cameras to accommodate a greater brightness range and finer detail, coming closer to the 'film look'.
- The development of recording formats that compress data without too much loss of information (although complex scenes with fine moving detail can still produce anomalous results).
- The improved quality of video (or digital) to film transfers.
- The realization by film-makers and audiences alike that while some subjects will continue to demand the best image quality that only film can offer, other subjects are for various reasons well suited to video origination, despite the lower screen quality.

Digital video

Digital Betacam, DV and DVC-Pro are all compressed digital formats working at the CCIR 601 specification of 720 pixels per line (conventional TV resolution). Compression is between 2.5:1 (Digibeta) and 5:1 (DVC). Digibeta uses 4:2:2 sampling (which effectively means that the colour information has half the resolution of the luminance or brightness information), while the DV formats have one quarter colour resolution. However, the relative smallness of the cameras (particularly DV and DVC) and the low cost and long running times of tapes (40 min for Digibeta, twice as long for DV and DVC) provide real attractions. For some 'guerilla' productions, the cost of transfer from tape to 35 mm film is as great as the entire production cost up to that point!

Mixed origination

Where the video format is used for a complete production, it is naturally simpler to complete all post production in video at video resolution and, where a film finish is required, to transfer the finished product. In many other instances, individual shots, scenes or sections of a production are captured on video, to be cut in with film-originated material. This approach is most successful where the obvious difference in image quality is justified within the film. Remember that in the case of 25 fps

PAL video, the transfer to film will end up with a 4 per cent slowdown: any sync sound must be slowed down before it is included with 24 fps film sound in editing and mixing.

24P

24P was promoted as a universal digital post production format. Unlike conventional (interlaced) video formats, a complete frame is scanned every 1/24th of a second, making it completely compatible with film in this regard. The resolution is 1920 × 1080 pixels and the aspect ratio 1.77:1 (or 16 × 9) which suits digital television but is also close to widescreen 35 mm film (1.85:1).

This format comes as close to looking like film as any digital format has, and it has been extended to image capture, with a series of cameras designed around the format. Although some important differences remain, it provides one alternative to film origination for television productions.

Because the CCD chip used to capture the image in the camera is much smaller than a 35 mm film frame, the depth of field at the same lens aperture is very much greater, and this presents a creative disadvantage where cinematographers want to use differential focus. Cooperation between Sony and Panavision has produced a more film-like camera with a faster, wider aperture lens, giving more film-like depth of field.

So far as production for cinema is concerned, the advantages of portability are not present in the current generation of 24P cameras – the camera with a film lens fitted is bigger and heavier than the equivalent 35 mm camera, and the image resolution still falls short of film performance. A number of effects are possible that can only be achieved in post production when shooting film. These include colour correction, desaturation and a range of in-camera digital effects, such as edge enhancement, electronic diffusion and so on. However, the system cannot run at the much higher speeds required for slow motion effects.

Finally, it is generally recognized that the archival properties of digital formats are not yet well established, whereas film has excellent keeping properties: the absence of any long-term version of the original negative would have serious consequences for those interested in keeping more than the final cut of a film.

See also pages 20, 170.

Painting by numbers.

Scanning and Recording

A full digital imaging system for film consists of three stages: a film scanning device, where each film frame is converted to a digital frame; the image processing stage (computer software for manipulating the images); and an output stage (film recording), where the digital images are recorded back onto negative film stock. In function these correspond to telecine, video effects and kine recording. However, the much higher resolving power of film necessitates profound differences to the equipment.

Scanning

Full-resolution digital scanners use CCDs with up to 6000 photosites. The film is scanned one complete line at a time before moving fractionally forward to scan the next line. It takes several seconds to scan each frame. The result is an array of several million red, green and blue values, which are then reduced to the required working resolution of the image – up to 4096 × 3112 pixels. Initially, the data are scanned to 12 or up to 16 bits per colour, but then reduced to 10 bits for file storage.

Because of the long time this takes (and correspondingly high cost), as well as the enormous demands on storage, full resolution tends to be used only for very carefully selected scenes in well-budgeted projects. Lower resolution scanning (typically on a datacine) is used for other work.

Negative to be scanned will usually have been selected by the editor from work print or a non-linear editing system, in the form of an EDL. This must be converted to a list of frame counts so that full takes can be extracted and only the required frames scanned in.

Clips (sequences of frames) are stored on disk within the computer system, but may be backed up or transferred between installations on tape or removable disk. The Tar (Tagged Archive Record) system creates a separate file for each frame, numbered in sequence. A number of file formats are possible, each native to a different effects software system. Conversions are usually possible, but it is important to contact your chosen effects house before work starts.

Recording

CRT film recorders use a monochrome high-resolution CRT screen with a pin-registering camera. These are much slower than conventional kine recorders (which also photograph a monitor), but are capable of much finer resolution on film. The high-resolution tube displays up to 4096 lines. Mounted with the tube is a conventional pin-registering optical printing camera. Red, green and blue signals are scanned in sequence, and photographed through corresponding colour filters onto colour negative film. The spot size and brightness are limited so as to preserve maximum resolution and minimize flare, and therefore scanning must be very slow: several seconds per frame. Even to achieve this speed, original camera negative is normally used (although one high-powered system is bright enough for intermediate stock). A 10-s clip could take up to 2 h to record onto film.

Scanning and recording

The Arri system uses a laser film recorder, in which the image is exposed directly onto the slower, but finer-grained, colour intermediate negative stock by a set of coloured lasers. The lasers are chosen with exactly the wavelengths that match the sensitivity of the film emulsion layers, and the three beams, modulated by the signal from the image data, are deflected by a rotating mirror assembly. At 4K resolution, it can be seen that very high precision is required of the moving mirror assembly. However, the brightness of the laser beam means that much faster exposure times are possible, although these are still several seconds per frame.

Digital effects

Fixed resolution systems, such as Kodak's *Cineon*, form an integrated system: film input, image work station and film output. Images are complete film frames. Additional image components such as titles or 3D graphics objects can be imported in files in an appropriate format and composited into the image.

An alternative approach uses stand-alone resolution-independent tools such as *Inferno* for image processing. These can be used with images of any size, or any number of pixels per frame. In the fixed-frame size context of motion picture, a larger image is simply a more finely resolved image when it is finally output to film.

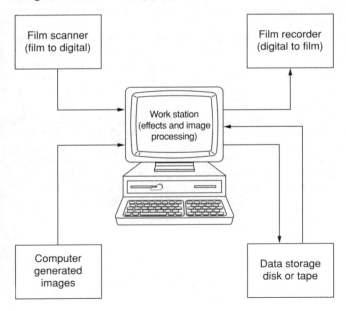

DIGITAL FILM EFFECTS
Film images are scanned into the digital domain and then manipulated to produce special effects. Computer-generated images can be incorporated as well: the final result is output to film again using a film recorder.

The digital image is prepared for film.

Calibrating the Film Recorder

The simple requirement of a digital system is that a print from the output digital negative is identical (apart from the effects) to one from the original negative. The system as a whole should not alter contrast or density at any point in the tonal range, for any colour. Because many projects involve scanning and recording by a number of different companies, each individual scanner or recorder should have a 'unity' transfer characteristic, so that they can be matched in any combination.

Digital systems have almost complete flexibility in mapping digital tone values onto film exposures, by means of a look-up table, or LUT. This translates tone values into the appropriate voltage for the CRT signal or laser beam in the film recorder. The values in the LUT compensate for the form of the digital image data (e.g. log or linear values), for the output characteristic of the CRT or laser, and for the sensitivity characteristics of the film stock being used.

The overall exposure level in the recorder must be set first, so that a 100 per cent exposure patch produces the required density on negative. The density must be great enough so that it produces a clean white when printed, and the printer light chosen must also produce a good black from clear negative. Placing exposures higher up the characteristic curve of the negative may increase the tonal range, but flare on the CRT will offset this advantage, and some experimentation is necessary to find the best exposure level.

Next, frames with a series of tone values are exposed using a linear LUT, and the negative densities are read. The LUT may now be adjusted so that a repeated test, using the new LUT, produces the required density for each step. The required densities depend upon the internal tone space of the digital system, which may be linear, gamma corrected or logarithmic. Grey tones would be represented by a different series of values in each case. In practice, assuming that the input system (telecine or scanner) is well adjusted, a grey-scale card may be shot onto negative and scanned into the system to determine what tone values represent various percentage reflectances. As in film duplication, it is not necessary that the output negative is identical to the original input negative, but the density differences, step to step, must be the same to produce a print with the same contrast characteristics throughout.

See also pages 56, 58.

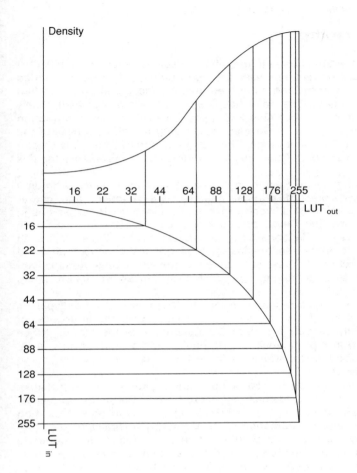

LOOK-UP TABLES

Look-up tables correct each grey-scale value in the computer's tonal space, so that a uniform progression from black to white is produced on the output film stock.

Painting by numbers.

Digital Grading

The latest generation of high-definition telecines, such as the Philips Spirit, are increasingly being used for digitizing negative that is intended for digital colour correction and other simple effects, and output to film for theatrical release. The Spirit has line array CCDs of 2K (1920) pixels to capture luminance, but only 960 pixels for each colour. Information may be stored in 10-bit log format, maximizing the effectiveness of the data across the full tonal range. The machine runs at 6 fps. This resolution must be considered the very minimum that is acceptable for this purpose.

The transfer may be treated in the same way as a telecine grading session: select takes of original negative are scanned, and colour corrected by a colourist. Instead of the conventional RGB corrections in film grading, the full range of telecine colour correction is available through 2K versions of standard colour correctors. This allows looks such as secondary colour correction, desaturation, contrast change, tinting and selective correction of areas within a frame, previously only possible with special processing techniques such as bleach bypass, or custom filters and matte box effects.

Great attention must be given to monitor calibration, as the display is (as with film grading) not the actual end result, but a digital preview of what will finally be output to film. Characteristics of the output device (film recorder) and print stock must be taken into account. Some facilities have installed digital projectors for this purpose to simulate the large cinema screen image.

Once the material is scanned, simple digital effects work is possible: such effects include speed changes, freeze frames, dissolves and wipes, simple 'opticals' and titles. More advanced effects involving compositing or complex image manipulation such as morphing really require full-resolution (4K) data, and so should not be attempted at this moderate resolution. However, repairs such as dirt or scratch removal are possible.

Finally, the film is output via a film recorder to negative or interpositive stock, in sections or in full reels. It is also possible to generate trailers or alternative versions.

This technique has great potential for projects such as archival restoration, where footages are too great to consider full-resolution work. It is also possible to use this technique to achieve a blow-up or squeeze from Super 16 or Super 35 original negatives, respectively, or to integrate film and video source materials.

It is worth remembering though, that while the cost of this process will progressively fall to meet the current prices of optical blow-ups, the resolution of the final print will never exceed that imposed on it by the 2K (1K of colour) scanned data.

See also page 164.

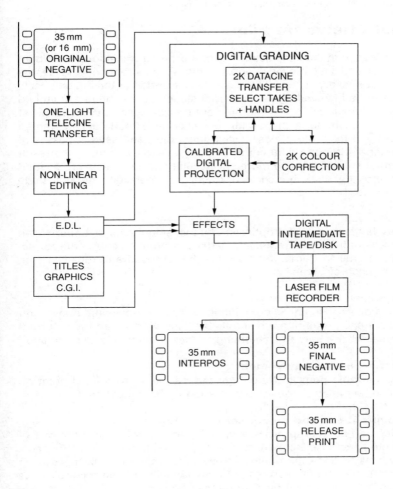

THE DIGITAL INTERMEDIATE PROCESS

Full colour grading effects such as desaturation or optical filtering are carried out during the datacine transfer. 'Optical effects' such as speed shifts and fades may be done in the digital mode while conforming to the EDL.

Digital Effects for Film

Digital effects may be spectacular – e.g. morphing transitions from man to wolf – or undetectable – e.g. adjustments such as removing TV aerials from a historical drama. In either case, it is essential for the digital effects designer to be involved right from script stage: digital effects are limited only by the imagination, but require very precise specifications for what is shot. For example, a procession of tanks on a road can be created from just one tank, but a clear background shot, and several passes of the one tank at slightly different angles and speeds, will make the result much more successful. The more spectacular special effects are beyond the scope of this book, but some of the basic undetectable tasks include the following.

Wire removal
An everyday task in digital opticals. Clamps, safety nets or trapezes can be painted out from one frame, and pattern recognition copies the correction from frame to frame. Jet trails can be removed and replaced with a nearby patch of blue sky.

Image repair
Scratched or dirty negative, occasional fog or underexposure may otherwise ruin a shot, requiring a reshoot. The digital artist can retouch from clean areas of the frame or adjoining frames to eliminate the damage.

Eliminating camera movement
Any recognizable point of the image can be locked to a fixed point on the screen, eliminating movement in a jumpy hand-held shot.

Rotoscoping, cut and paste, set extension
To replace a boarded-up window with a glazed one just like the rest of the building, increase a crowd, or simply put an image onto a TV screen, it is possible to trace the outline of one object, then pick it up, resize it and copy it to a different part of the frame. Ancient or fantasy city skylines shot from a model or old photograph can be composited with the location landscape. Key points are locked to each other so that elements move together.

Colour manipulation
For a day-for-night shot, the sky is darkened separately, colours drained and windows lit up. Just part of a shot can be colour corrected to change summer trees to autumn, or make a pair of eyes a bit bluer.

Motion blur and grain
Many film artefacts are missing from trick shots. Stop frame animation (e.g. clay models) look a little less jerky if digital motion blur is added; grain needs to be added to a computer-generated spacecraft to blend in perfectly with its film background.

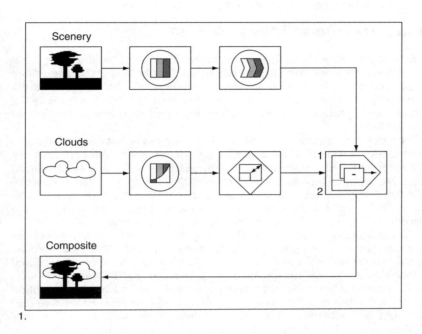

Scenery

Clouds

Composite

1.

PAINTING	cut		stencil	outline		DRAW STENCIL	USE STENCIL			
GRAPHICS	only	1		surround		save picsten	display sten			
EFFECTS	style	100.1		solid	40%	old	new	reverse sten		
PASTE-UP 3D	stick	copy		shadow	%		wipe pic	bgnd clip		
ANIMATION	unzoomed			emboss	8	restore pic	do it			
LIBRARY	del	auto				75	of 100	←	→	try it

2.

DIGITAL IMAGE MANIPULATION

(1) Cineon: each stage in image manipulation is laid out in a flowchart, signified by icons. Various processes such as colour correction and resizing are applied to each shot and they are then combined. (2) Domino: menus appear on the screen, with selections and painting carried out using a graphics pad and pen.

Kine Transfers: Video to Film

Conventional kine recording – transferring TV images to film – has been accomplished since the start of television simply by filming the image displayed on a video monitor. Before the days of videotape, it was the only way of recording television programmes, so that many early TV shows were performed live-to-air, and recorded onto film at the time of transmission.

The dot matrix pattern of colour TV phosphors is not very compatible with colour film sensitivities, and so the triniscope was developed for colour TV recording. Red, green and blue components of the image are displayed on three separate monitors, and combined through colour filters onto a single film frame. However, the flare and image spread characteristics of real-time CRTs are the limiting factors, so that these kine transfers are recognizable by their limited contrast range and shadow detail.

In the electron beam recorder, red, green and blue components are recorded by a scanning electron beam onto sequential frames of an electrically sensitive black and white film. The frames are then printed and recombined onto colour negative stock in an optical printer.

All these real-time transfer devices are also limited by the resolution or line structure of the original video image: 35 mm film can resolve four to eight times better. Although the actual raster lines are not usually distinct in the film image, artefacts such as 'jaggies' on diagonal lines give away the source very quickly. For all these reasons, real-time kine transfers are rarely suitable for cutting in with original film material but, in view of their lower cost, are sometimes the best alternative for lower budget, long-form productions.

Film recorders

However, many completed TV commercials – often rich in special effects difficult to replicate on film – are transferred to 35 mm film for use in the cinema. Some transfer facilities use digital image systems and film recorders to transfer video images to film, with a number of special techniques to optimize the image. While this cannot ever match the results from high-resolution digital images originating on film, the telecine/digital post production/digital film transfer route can provide a very acceptable intermediate step between film and video resolution.

Adapting the TV image for film

Digital imaging techniques can be used to intelligently interpolate between the 500-odd video lines, filling the gaps in the information. The system calculates what the image information might have been by mathematical reference to the adjacent lines and pixels. In this way, a much finer resolution image can be built up. This cannot add any new information to the picture, but tonal gradation and detail are much finer and smoother.

Titles often still display the familiar 'jaggy' edges on sloping lines. The best way to avoid these is to work with a textless video version of the programme and to generate new, high-resolution titles from film or from a digital graphic system, to be superimposed after the interpolation process.

PAL originals are normally transferred at 25 fps and played in the cinema at 24 fps, thus running 4 per cent longer. There is no need to slow the track down during the transfer process: it must be transferred to optical sound negative at 25 fps. The slowdown (on projection at 24 fps) is normally acceptable, although the soundtrack can be digitally re-pitched to restore music to the correct key if required. Some degree of re-balancing the stereo TV track for cinema may be necessary.

Video images consist of 50 (PAL) or 60 (NTSC) interlaced fields per second. Each pair of fields will be combined to a single film frame. If the image was originated on video, the two fields actually represent different instants of time, and objects moving rapidly across the screen will appear to ripple or flutter across. Digitally created images and titles are particularly susceptible to this effect, and should be created in 'frame' mode rather than 'field' mode in the original production. NTSC video runs at 30 fps and so one field in six must be skipped in order to maintain correct speed. This also leads to jerky movements, particularly noticeable if the video is already subject to a 3/2 pull-down telecine transfer from film originals. These problems can sometimes be partially corrected digitally prior to the film transfer.

Standard TV commercials are framed for conventional 4 × 3 screens, and so will have the top and bottom of the frame cropped on cinema screens. Selective positioning may be necessary from scene to scene to avoid losing headlines, titles or other essential parts of the image.

Filter wheel

R, G, B in sequence

TAPE TO FILM TRANSFERS

In the film recorder, red, green and blue components are displayed in sequence on a single tube and photographed onto colour negative through filters. To minimize flare from phosphor afterglow, a very slow scanning speed is used, taking up to 30 s per frame.

Kine transfers: video to film

Digital Cinema

The author believes that the photochemical and mechanical processes of film described in this book will be in use for many years to come. Despite the rather arcane nature of the technology, developed by specialists over the course of a century, it remains an astonishingly powerful means of capturing, recording and preserving visual information, with sensitivity and data density that the most advanced digital systems still struggle to emulate. However, it is fitting to conclude with some notes on digital developments in the most public aspect of motion pictures – the cinema.

Video projectors have been available for many years, but limitations in their light output and contrast have restricted their use to non-theatrical venues such as museums and aircraft. Recently, however, two different systems have emerged, both using conventional film projector light sources. The Texas Instruments Digital Light Processing (DLP) system uses three chips each carrying an array of two million micro-mirrors. Each mirror can be tilted up or down according to a voltage applied to it, so that light from the xenon projector lamp is either reflected along the light path towards beam-combining dichroics and the projector lens, or it is lost elsewhere. Although each mirror can only therefore be either 'on' or 'off', the brightness of the corresponding pixel can be varied by the length of the 'on' pulse in each 1/24th of a second.

In the Hughes JVC Image Light Amplifier (ILA), an image is projected from three CRTs onto three ILA devices. These consist of a light-sensitive layer, a liquid crystal layer and a mirror. The CRT image varies in intensity as the beam scans across the frame, and the resultant variation in light falling on the ILA causes the liquid crystal layer to rotate its degree of polarization at each part of the image. Projection light from the xenon lamphouse is directed at each ILA, and is either transmitted towards the lens and screen, or reflected back to the lamp, according to the intensity of the CRT light at any given moment. Light transmitted from the three ILAs is recombined by dichroics and focussed to produce a scanned image on the theatre screen.

Both these systems are capable of projecting HD quality images to large theatre screens and producing results acceptable to the public. In fact, they are free of the problems of below-par film projection: images are steadier, and free from the dirt and scratches that accumulate on a worn print. A number of questions remain to be resolved, both the technical ones of finding the best storage and replay system in the theatre (tape formats such as D5 and disk arrays have been used) and perhaps more critically the best system of distribution and delivery to the theatres (fibre, satellite or D5 tape are likely candidates). Any systems must be secure from piracy, must be robust enough to require minimal maintenance after installation, and must come down in cost quite substantially without compromising image quality.

The next questions to be resolved still concern the cost of changing to digital projection. The substantial cost of making and distributing multiple 35 mm prints to theatres around the world is borne by

distributors. They have much to gain from digital projection, once the costs of satellite or other delivery of digital versions of film are established. However, the expenses in the changeover are all to be borne by the theatres, and at the time of writing, the cost of a digital projector alone, without the storage system, is several times greater than a film projector (which existing theatres already own).

The cinema started a century ago with individual showmen taking films and projecting them in their own theatres to local audiences. A single print would be played for as long as it would last. Around the middle of the century, television was established as a way of delivering images – instantly – over wider areas. It has developed to the point where many millions of homes each see their own 'copy' of a TV show, but (with the exception of periodic repeats of some comedy shows) a show, once broadcast, has seen its day. Despite early predictions of the death of cinema, however, television has not replaced the social experience of 'a night out' at the movies. Broadcast television, in fact, is facing changes on its own programming, although forecasts that the internet will cause the death of television seem equally premature.

Meanwhile, feature films in the cinema are distributed simultaneously to ever larger numbers of theatres around the world, where they tend mainly to enjoy quite short runs. Multiplexes offer the choice of several programmes. The distribution pattern, in other words, is getting more and more like that of television. It seems inevitable, therefore, that digital technology, which has formed the bridge between film and television or video in so many technical areas of production and post production, will eventually bridge the gap as film and television converge in the final stage of delivery to the audience.

Glossary and Index

bumper, *see* handle.

CCD, 166, 168, 206. Charge-Coupled Device: method of capturing image in video camera, some telecines, etc.

cels, 130. Transparent sheet on which single frames or elements of animation are painted.

change list, 104. List generated by a non-linear editing system showing only those cuts which have been altered since the previous list.

changeover cues, 160. Holes punched in corner of frame near end of a reel to prompt the projectionist to start the other projector.

characteristic curve, 60, 204. Graph relating exposure to density of a film emulsion. Shows the image contrast and other properties.

checkerboard cutting, *see* A- and B-rolls.

chinagirl, *see* LAD.

cinch, 84, 88, 94. Minute scratches on film surface caused by slippage between turns of the roll.

Cinemascope, *see* anamorphic.

clock leader, 180. Countdown head leader marking 1-s intervals.

colour, 42, 44, 48.

 analyser, 76. Video system for previewing negative to assess colour correction required for printing.

 drain, 136. Desaturation of colour image to black and white.

 grading, *see* grading.

 temperature, 38. Proportion of yellowish to bluish light in a light source. A bluer balance corresponds to a higher temperature.

compressed grade, 26, 190. Low-contrast telecine grade, preserving the entire tonal range for creative grading later on.

compression,

 audio, 150. Reduction of volume range in sound recording, boosting quieter passages.

 data, 24, 170. Reduction of data used to store digital images. Usually results in loss of detail.

contact printer, 74. High-speed film printer used for rushes, answer and release printing.

contrast, 40, 58, 60, 64, 66. Density difference between tones in an image.

cross-processing, 68. Processing reversal stock as negative.

CRT, 210. Cathode Ray Tube. Monitor or video display device, also used in some telecines and film recorders.

cutting copy, 22, 98. Edited work print used as a guide for negative matching.

dailies, *see* rushes.

DAT, 24, 184, 186. Digital Audio Tape.

delivery items, 142. Film elements and documentation required by distributor to be supplied by production company.

density, 56, 82. Darkness, or light-absorbing measure of a film image or filter.

digital,
- **camera**, 20, 200. Video or HD camera.
- **colour correction**, 192. Full range colour correction of scanned film images.
- **dirt removal**, 86. Digital systems for hiding film dirt on video image.
- **intermediate**, 114. Scanned film images forming master prior to recording back to film negative.
- **soundtrack**, 142, 144, 152. Systems of encoding soundtrack on release prints.
- **television**, 196. New TV production and broadcasting system. Uses 16 × 9 screen in a variety of resolutions.
- **video**, 200. Newer video recording systems, storing data as numbers rather than varying voltages.

dissolve, 102, 108, 136. Gradual replacement of one image with another.

double-head screening, 144. Projection of image and sound in sync from separate sources, e.g. at film rushes.

drop frame, *see* timecode.

duplication, 38, 40, 110, 156. Manufacture of copy of original negative, usually by printing.

edge numbers, 22, 96, 98, 102, 180, 182. Numbers appearng on edge of film, incrementing once each foot, used to identify frames for negative cutting. Also Keykode.

EDL, 24, 26, 98, 100, 102. Edit Decision List. List of all edits in timecode format.

emulsion, 38. Light-sensitive layer coated on one side of film.

ENR, 72. Silver enhancement process named after the film technicians who developed it – Ernesto, Novelli and Rimo.

exposure, 56, 60. Light falling on film. Product of intensity and time.

fade, 102, 108. Dissolve from image to black or white over a few frames.

FCC, 76, 78. Frame Count Cues: data for controlling grading or light changes between scenes during printing.

ferrotyping, 162. Mottled glaze on film emulsion caused by damp storage.

field (video), 168, 174, 211. One scan of frame in interlaced video: includes either all odd- or all even-numbered lines. Two fields make one frame.

film chain, 166. Telecine, usually older style video camera devices.

film conform, *see* pos conform.

film recorder, 202, 204, 210. Device to transfer video or digital image onto film. Usually higher resolution than kine recorder.

film scanner, 202. Device to transfer film image to digital data. Usually higher resolution than telecine.

fine grain, 40, 136. Black and white positive duplicating film – equivalent to colour interpos. Also slow-speed camera negative film stock.

FLeX file, 182. Common file format for logging Keykodes, timecodes, etc. from telecine system.

flying spot, 166, 168. CRT-based telecine system.

frameline, 122, 124. Blank area of film surrounding image or between frames.

frame rate, 24, 140, 172, 174, 176, 186, 210. Running speed of film or video in frames per second. Differences between systems can cause difficulties in syncing or rendering motion accurately.

gamma, 40, 64, 204. Measure of contrast in any image reproduction stage.
 digital, 58. Property of Look-Up Table (LUT) for display or recording.
 film, 58, 110, 134. Slope of characteristic curve.
 video, 58, 190. Primary colour control on telecine.
generation, 110. Each stage in a copying or duplication process.
geometry, 112, 138. A- or B-type emulsion position.
grading, 76, 78, 80, 110. Adjustment of colour balance and density of each scene prior to making a film print.
grain, 62, 114, 208. Single dye cloud or silver clump in image. Graininess – perception of grainy structure to image.
green film, 95. Freshly processed film, with emulsion not fully hardened.
grey scale, 58, 92, 204. Series of uniform areas of neutral grey tone progressing from white to black.

handle, 100, 108, 116. A few frames left on each end of a cut shot.
head-wrap, 160. Tangle of film in projection platter system, usually caused by 'static cling'.
high definition, 166, 196. Digital resolution above standard TV but usually below that of film.
hue, 44. Attribute of colour that identifies its position in the spectrum.
hybrid frame, 174. Video frame consisting of fields from two different film frames.

Imax, 122. 70 mm, 15-perf horizontal film format.
intermediate, 38. Film stage between camera original and print.
internegative, 38, 110. Negative made from positive print or reversal image.
interpositive, 38, 80, 110, 116, 118, 128, 156, 188. Positive duplicating stage made from original negative, and from which a dupe negative is made.

Keykode, *see* edge numbers.
kine transfer, 210. Film transfer from video resolution material.

LAD, 76, 82. Grey density patch derived from 18 per cent reflectance card.
laser recorder, 203. High-resolution device for transfer from digital to film.
latent image, 50. Invisible image on exposed, undeveloped film.
letterbox, 194, 196. Method of displaying widescreen images on 4 × 3 TV with black bars at top and bottom of screen.

light, *see* printer point.

light vane, 76, 156. Colour controlling device in printer.

logarithmic, 56, 198, 204. System of numbers used in measuring density, exposure, etc., based on adding numbers not multiplying.

log E, 56, 60, 76. Logarithmic unit of exposure.

logging, 24, 30, 96, 98, 180, 182. Recording scene details, edge numbers, timecode, etc. at telecine transfer or prior to editing.

low-contrast print, 154. Print made for telecine transfer.

mask, 158. Aperture plate in projector gate.

masking (integral dye), 48. System of orange colour couplers in film emulsion that compensate for imperfect colours of dyes.

matte, 128. High-contrast silhouette on film used for optical effects.

monitor, 190. Calibrated TV display device.

negative matching, 22, 32, 80, 100, 102, 104, 180. Process of cutting and splicing original negative to match edited work print or EDL.

NG takes, 92. Unwanted takes removed from camera negative rolls before work printing or not transferred to telecine.

nitrate, 46, 162. Flammable film base used in some formats until 1951.

non-linear editing, 24, 90, 98. Computer-based editing systems in which scenes can be arranged and played in any order.

NTSC, 170, 174, 178, 211. US standard TV system.

off-line, 26. Low-quality image editing system, but not leading to the final image.

on-line, 26. Full quality image editing system.

optical,

　effects, 74, 110, 118, 126, 128. Image effects produced by duplication on an optical printer.

　sound negative, 22, 134, 142, 144. Photographic soundtrack, analogue or digital.

　soundtrack, 74, 146. Area close to perfs on release prints where optical sound is printed.

PAL, 174, 178, 211. British and Australian standard TV system.

pan and scan, 194. Selecting parts of widescreen image to fit into 4 × 3 TV frame. Alternative to letterbox transfer.

panchromatic, 40, 136. Black and white film emulsion sensitive to all colours.

pillar box, 196. Method of displaying 4 × 3 images on widescreen TV with black bars at either side of the screen.

pink noise, 150. Dolby audio test signal of exact frequency distribution.

pitch,

　perforations, 34. Distance between successive perforations on film.

　sound, *see* sound: pitch.

pixel, 198, 200, 203. Single spot of an image in digital system.

polyester, 38, 46, 107. Break-resistant film base commonly used for release prints and dupe negatives.

pos conform, 24, 90, 100, 104, 176. Method of cutting work print to match EDL prior to cutting original negative.

post production supervisor, 28, 32. Specialist employed by production company to understand and resolve all problems in post production.

primary colour, *see* additive colour.

print master, 22, 142. Final sound mix recorded in format ready to transfer to optical sound negative.

printer point, 76, 78. Single increment of printer colour grading – an exposure step of 0.025 log *E*.

push processing, 30, 66. Overdevelopment of negative to compensate for underexposure.

redeveloper, 52. Viscous developer solution applied to soundtrack on colour prints to produce a silver analogue soundtrack.

register pins, 34, 74, 106, 130. Precisely fitting pin in camera gate that ensures steady images.

release print, 110, 118, 156. Finished print intended for distribution and exhibition.

repeat frame, 174, 176. Frame that is scanned twice in 24/25 fps telecine transfer.

replenisher, 54. Fresh processing solution that is added steadily to working solution during processing.

reprint, 154. Replacement print, usually as a result of defects in the first one supplied.

resolution, 198, 202. Fineness of detail that is clearly reproduced in an image. Expressed in film as line pairs per millimetre, in digital as number of pixels in screen width, in video as number of lines.

reversal, 38. Camera original film that produces a positive image after processing.

rewash, 86, 94. Running film through processor a second time, usually to remove dirt or heal scratches in emulsion.

rostrum camera, 126, 130, 132. Camera mounted vertically over table for copying artwork onto film.

rotoscope, 130, 208. System of tracing off outline of part of image, frame by frame. Originally in pen and ink, also a digital process.

rubber numbers, 22, 100, 184. White opaque serial numbers stamped onto film prior to editing, to aid in syncing.

running times, 157. Film footage/time conversion chart.

rushes, 22, 24, 90. First copy mute prints or video cassettes from camera original, used for checking and editing (US = Dailies).

safe action and title area, 194, 196. Area of TV screen, usually 5 per cent and 10 per cent inside full frame, within which essential information should be framed, to avoid cropping by inaccurately adjusted TV sets.

saturation, 44, 136, 190. Degree of richness or purity of a colour.

scanning list, 104, 202. List of shots described by frame count within a negative roll for scanning to high-resolution digital data.

scene, 78, 80, 92, 98, 102, 106. (1) A single shot, splice to splice, in a cut negative. (2) A sequence of shots in edited film that cover action in a single time and place.

scratches, 84, 86, 88, 94. Surface damage to film base or emulsion.

screen brightness, 60, 78, 158. Measure of luminance of projection screen with no film in gate.

secondary colour, 42. Yellow, magenta, cyan. Colours of dyes used in subtractive colour mixing system.

secondary colour correction, 192. Correction of individual colours on telecine, by altering chroma or purity without affecting other hues.

sensitometry, 56. Relationship between exposure and density in photographic systems.

shot, *see* scene.

signal-to-noise ratio, 150. Ratio (in dB) between loudest undistorted sound and background noise.

skip printing, 128. Omitting some frames when printing on optical printer, to increase speed of action.

sound,
> **final mix**, 22, 142, 144. Operation and result of combining all sound elements together at required levels.
>
> **music and effects track**, 142. Delivery item required in case of overseas sales when foreign language dialogue must be dubbed.
>
> **pitch**, 144, 211. Operation and result of combining all sound elements together at required levels.
>
> **redeveloper**, s*ee* redeveloper.

soundtrack,
> **analogue**, 146. Variable area optical track printed alongside image.
>
> **black and white**, 134, 147, 150. Analogue or digital soundtrack on black and white print.
>
> **digital**, *see* digital: soundtrack. Dolby, SDDS or DTS soundtrack printed as a digital matrix alongside image.

sparkle, 84, 94. White specks on positive image usually caused by fine dirt on negative.

splice, 106, 116, 118, 156. Method (tape, cement or ultrasonic weld) of joining two pieces of film together.

squeeze, 120. Reduction of image to half width, using anamorphic lens, for eventual unsqueeze in Cinemascope projection.

stock shot library, 138. Collection of general and documentary scenes on film or tape, available (at a cost) for use in other productions.

stretch printing, 128. Also step printing: repeating some frames in an optical printer to extend action or produce jerky effect.

subtitles, 157. Superimposed text across bottom of screen showing dialogue, usually in alternative language.

subtractive colour, 42. System of overlaying dyes or filters of yellow, magenta and cyan to produce full range of colours.

Super 16, 36, 114. 16 mm film gauge where frame is exposed right to edge of non-perf side of film, to give 1.66:1 aspect ratio.

Super 35, 120. 35 mm film gauge where frame is exposed across full width of film from perf to perf.

synchronising, Locking picture and sound together in correct time:
 prints, 148, 154. By means of pips on picture and sound negatives.
 rushes, 22, 172, 174, 178, 184, 186. By means of timecode or clapper-board.
sync pip, 148. Audible 'pip', visible on analogue soundtrack, recorded at '2' on clock leader.

telecine, 166, 182, 184, 188. Device for transferring film images to video-tape.
throw, 158. Distance between projector and screen in theatre.
timecode, 100, 102, 178, 184. System of counting individual frames in video, in hh:mm:ss:ff format. Used for syncing and for editing.
 drop frame, 178. Version of 30 fps timecode in which two counts are skipped every 10 s to compensate for true 29.97 speed of NTSC.
 in-camera, *see* Aaton code.
timing, *see* grading.
titles, 110, 118, 130, 132, 210. Text at start and end of film – usually includes credits of cast and crew.
tone (tint and tone), 136. Colour enhancement of black and white images using tinted base print stock and chemical tinting of image.
trailer, 140. Short promotional ad for film, usually cut from scenes in the feature itself.
transfer speed, *see* frame rate.
trial print, 156. Separate red, green and blue records of colour image on three separate black and white rolls of film.
tri-separation, 40, 138. First print from dupe negative, to check grading and negative condition.
two-pip, *see* sync pip.

ultrasonic cleaner, 84, 94. Film cleaner using organic solvent and high-frequency vibration to remove dirt and grease.

Vistavision, 122. 35 mm format with eight-perf, horizontal frame, usually used for background plates.

wax, 160. Solid paraffin lubricant for release prints in projection.
weight of film (table), 161. Shipping weight of prints.
wet gate, 88, 118. System of printing with negative immersed in a fluid. This hides any scratches or cinches on the negative.
widescreen, 34, 36, 122, 124, 194, 196. 35 mm format with aspect ratio between 1.66:1 and 1.85:1. Also digital TV format 16 × 9 (1.77:1).
work print, 22, 24, 90, 92, 100. First printed copy of camera negative, used for editing.

zero-close cutting, 116. System of cutting A- and B-rolls with several frames overlapping to avoid printing near splices.
zero frame, 96. Film frame exactly alongside Keykode marker, occurring once every foot.

Focal Press

www.focalpress.com

Join Focal Press on-line
As a member you will enjoy the following benefits:
- an email bulletin with **information on new books**
- a regular **Focal Press Newsletter**:
 - featuring a selection of new titles
 - keeps you informed of **special offers, discounts and freebies**
 - alerts you to **Focal Press news and events** such as author signings and seminars
- complete access to **free content** and reference material on the focalpress site, such as the focalXtra articles and commentary from our authors
- a **Sneak Preview** of selected titles (sample chapters) *before* they publish
- a chance to have your say on our **discussion boards** and **review books** for other Focal readers

Focal Club Members are invited to give us feedback on our products and services. Email: worldmarketing@focalpress.com – we want to hear your views!

Membership is FREE. To join, visit our website and register. If you require any further information regarding the on-line club please contact:

Emma Hales, Marketing Manager
Email: emma.hales@repp.co.uk
Tel: +44 (0) 1865 314556
Fax: +44 (0)1865 315472
Address: Focal Press, Linacre House,
Jordan Hill, Oxford, UK, OX2 8DP

Catalogue
For information on all Focal Press titles, our full catalogue is available online at www.focalpress.com and all titles can be purchased here via secure online ordering, or contact us for a free printed version:

USA
Email: christine.degon@bhusa.com

Europe and rest of world
Email: jo.coleman@repp.co.uk
Tel: +44 (0)1865 314220

Potential authors
If you have an idea for a book, please get in touch:

USA
Lilly Roberts, Editorial Assistant
Email: lilly.roberts@bhusa.com
Tel: +1 781 904 2639
Fax: +1 781 904 2640

Europe and rest of world
Christina Donaldson, Editorial Assistant
Email: christina.donaldson@repp.co.uk
Tel: +44 (0)1865 314027
Fax: +44 (0)1865 314572